Digital Blur

Digital Blur

Creative Practice at the Boundaries of Architecture, Design and Art

Paul Rodgers and Michael Smyth

First published in 2010 by Libri Publishing

Copyright © Libri Publishing

Authors retain copyright of individual chapters.

ISBN 978 1 907471 01 8

A CIP catalogue record for this book is available from The British Library

Typeset in Gravur and Quadraat, and first imprint features 1,000 individual digitally printed covers
featuring discrete images generated using Processing, an open project initiated by Ben Fry and Casey Reas.

Printed in the UK by Butler, Tanner and Dennis

Libri Publishing Tel +44 (0)845 873 3837
Brunel House www.libripublishing.co.uk
Volunteer Way
Faringdon Design by afterthenews.co.uk
Oxfordshire
SN7 7YR

Contents

Introduction

Paul Rodgers and Michael Smyth

The nature of design is constantly changing and currently this transformation is exemplified by a number of practitioners whose work transcends many of the traditional disciplines associated with the field. A new generation of practitioners is emerging and their work is cutting across areas such as product design, architecture and fine art. Indeed, Tony Dunne, Head of Interaction Design at the Royal College of Art, London states: "New hybrids of design are emerging. People don't fit in neat categories; they're a mixture of artists, engineers, designers, thinkers. They're in that fuzzy space and might be finding it quite tough, but the results are really exciting." (West, 2007)

The characterisation of design as a bridge between art and technology is not a new position (Flusser, 1999). What is new is that currently this relationship is being increasingly exercised by the complexity of many of today's products and services. Designers have responded to this situation by adopting and utilising new techniques and approaches that have been appropriated from a variety of other disciplines. This situation is further exacerbated by the field of design experiencing change as a result of shifts in the professional, economic and technological landscapes. These shifts can be characterised as follows:

• Professional Shifts – a blurring of traditional design disciplines.
• Economic Shifts – the transformation of funding and employment patterns.
• Technological Shifts – developments in computing and manufacturing power.

The creative practitioners who have contributed to this book exemplify contemporary inter-disciplinary working practice. They have sought to embrace the changes in the field and routinely transcend disciplines such as product design, architecture, fine art and film-making. Today, many of the working practices exhibited in what would traditionally be seen as fine art are now being found in design. Alex Coles has articulated eloquently this blurring of boundaries between art and design in his writing on the subject (Coles, 2005; Coles, 2007). But where does art finish and design begin? Moreover, is this distinction merely an issue of semantics?

Economic transformations and opportunities continue to contribute to the DesignArt debate. In an era where designers and architects choose to exhibit their work at international fairs such as Art Basel Miami Beach and where designed products such as Zaha Hadid's prototype Aqua table sells at a New York City auction for almost $300,000, what does this say about the value placed on utility? It is ironic that by returning to the traditions of artisanship and patronage that designers are commanding such value in the market. With the rise of the collectables market, designers can now make more money selling one or two pieces than they can from the royalties paid on mass-produced objects. Nowadays artists and designers are almost indistinguishable in their respective working practices. According to the designer Jaime Hayon: "Design is not really design anymore. For a long time art has

been questioning what is art? Now we're asking what is design, and the funny thing is that design sometimes looks more like art than art does." (Hayon, 2007)

The third notable change affecting creative practice is the development and blending of information and computing technologies in and across creative disciplines that has enabled individuals to transcend what we've historically seen as distinct and separate creative disciplines. Iconic buildings are now designed using applications that were originally intended for use within the aircraft industry and at the opposite end of the spectrum developments in the area of microcontrollers have moved the potential of physical computing into the hands of designers.

This book will reveal how these emerging computing and manufacturing technologies are being exploited and how this work is exploring the intersection of digital technologies and creative practices and is subsequently pushing the examination of how best to create environments, objects, services and experiences in a truly creative fashion.

On 26th June 2008 a one day symposium entitled inter_multi_trans_actions was held at Edinburgh Napier University. The symposium brought together, for the first time, a number of leading practitioners from the fields of art, architecture and design who share a common desire to exploit the latest computing and information technologies in their creative practice. The editors, Paul Rodgers and Michael Smyth, were interested in exploring how the practitioners exploited the nebulous intersections between the worlds of art, design and technology [figure 1] and also where and how they viewed and located their practice.

Figure 1. Art, Design and Technology Intersections

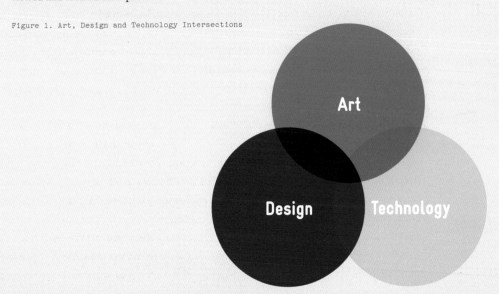

The goal of this book is to capture the spirit of that day, to give the reader a sense of what it was like to be present at this unique event. Each section has sought to stamp the personality of the speaker as they provide a personal insight into their practice and in particular how that work blurs traditional boundaries of art and design practice and exploits emerging technology. As a means of contextualising this work, three essays from leading commentators of this new field have also been included within the book.

Our hope is that this book will inspire and inform a wide audience of creative individuals from architecture, design and art of the significance of this trans-disciplinary research and its impact for creative practice. At a general level it will appeal to a wide audience including practitioners, researchers, educators, and industrialists involved in the greater sphere of creative industries.

Crispin Jones

Crispin Jones is a London-based designer whose work is chiefly concerned with exploring the social impact of technology. Since graduating from the Royal College of Art with a Masters Degree in Computer Related Design in 2000 he has worked for a number of companies including Casio Research, Philips Design and IDEO London. He has also worked independently and in partnership (as one half of Robson & Jones) on interactive projects for a number of high-profile clients including The BBC, Tate Modern, The V&A, and The Science Museum. He currently designs and produces his own range of products under the Tengu and Mr Jones Watches brands alongside a number of commercial design projects. Jones has also produced a range of more experimental works exhibited internationally at events such as the Prix Ars Electronica, the Japan Media Arts Festival, Tokyo, the Digital Arts Festival, Tokyo, the Salone Del Mobile, Milan, 100% Design Tokyo, and as part of "On Time" at the Museum for Design in Zurich (2007) and at the exhibition "Design and the Elastic Mind" at Museum of Modern Art in New York (2008). Jones' work negotiates the fine line in how consumers use technology, particularly computer technology, as a sort of predictive tool to help us make decisions and to help take away the responsibility that comes with making decisions. As he states, "I think one of the fundamental things I'm interested in and explore in my work is the idea that technology both gives us something and takes something away."

Greyworld

Greyworld were founded in Paris, in 1993 by Andrew Shoben. Since then, Greyworld's key objective has been to create works that articulate public spaces, allowing some form of self-expression in areas of the city that people see every day but normally exclude and ignore. The majority of Greyworld's work focuses in on these spaces that are the in-between zones of the city. These zones are called "liminal spaces" or "threshold spaces". Consequently, a significant amount of Greyworld installations are to be found "in the road just beside the shopping centre or the street that went just around the

back of the important place." So rather than creating work for the Town Squares or installations in Galleries, Greyworld tend to create things that can be found in the spaces that people move through a thousand times a day that are actually non-spaces. To Greyworld this is fertile land for creating interesting, fun experiences and interactions. As Shoben has declared, "the grey zones, the non-areas are the main focus for us." Greyworld do not merely look at liminal spaces, however, but frame those spaces. Perhaps Greyworld operate in this zone as a kind of rally against liminal spaces, by actually pointing attention at them. Whichever is totally accurate, this effort has a lovely side effect, which provides opportunities for the Greyworld team to work in these kinds of grey zones.

HeHe

Helen Evans and Heiko Hansen from HeHe explore the territory that they believe is common ground for designers and artists. This fuzzy territory is significant for HeHe as both have come from a design-orientated background, but both now call themselves artists. HeHe feel that this important distinction "offers them a freer space in which to work, and also the economy in which we work is more of an artist economy, in that we work on a lot of projects that are self-initiated." HeHe do not often work for a client brief. Together, they have developed a concept of "cultural reverse engineering", which raises political, economical and sociological questions. "To study a device or software in order to modify its initial function is a way of re-appropriating the technology, in a world where most of us have no idea of the way everyday objects actually work nor how their cultural position has changed over time", claim Evans and Hansen. The workshops that HeHe regularly organise "teaching basic DIY technologies, to students, artists and designers", can be seen as a concrete application of that concept. HeHe is clearly related to the Lo-Fi philosophy (and it happens to be the title of one of their works), with its playful, yet serious, issues. HeHe's main aim, however, is to "use technology as a medium". As they claim, "it's not really the technology that's interesting for us but more the ideas that we're trying to express."

Owl Project

Owl Project make sculpture, music and sound art, notably the Log1K, Sound Lathe, Sound Chair and iLog. Drawing on influences such as woodworking, hobby style electronics and open source software to create music-making machines, they take a craft-based approach to designing their own interfaces and objects. The result is a distinctive range of musical and sculptural instruments that critique human interaction with computer interfaces and our increasing appetite for new and often disposable technologies. Owl Project "exists in this kind of strange zone where we make technology that's desirable, but then there's not very much of it because it's really hard to make and no-one can really buy it" says Simon Blackmore, one of the members of Owl Project. They see themselves as artists and are chiefly concerned with how they can augment old technology – perhaps a bit like traditional craftworkers who make their own tools all the time. Blackmore goes on to say that, "the tools that we do make, we give away to the public where it is possible, which mirrors early craft traditions of making

your own tools and sharing them amongst a community." He continues, "we find that when we meet people who are working like this in sofware or hardware or working with other hand tools, we feel an immediate affinity for the way they're talking and the relationship they have with their tools and the relationship that has with their product."

Jason Bruges Studio

Jason Bruges Studio is a Shoreditch-based studio producing a diverse range of work that includes interactive light sculptures, interactive environments, events and screen-based installations. Jason Bruges Studio explores the use of interactivity with the public and environment through the use of highly imaginative technologies. The Studio specialises in "interactive light environments", from installations on the streets of New York to London's South Bank. When asked to define his work, Bruges stated: "I have always been interested in architecture, ephemeral architecture that can change opportunities...,but really to me the work is the same, it is the same process, for me the same outcome, whether it's a stand alone art work in the gallery, right through to an intervention in a public space, or a collaboration with an architect, or a limited edition piece, or even a piece of consultation." The Studio undertakes projects from very small-scale to large architectural one-off projects and is comprised of an eclectic collection of people. Commenting on this rich mixture of individuals Bruges has stated: "It is more often about personality and a mixture of skills, rather than any particular discipline. If you are going to get someone in and make them useful then they have got to be wide ranging enough to be useful on a few projects at the same time. People need to have quite a few different interests, so quite a lot of us programme, quite a lot of us render, quite a lot of us sketch, we do all of those things at the same time. I quite like unusual hybrids and unusual mixes of things, so we have architects who are interested in interaction design and set design, for example. So you kind of get all of these interesting hybrids, which are very important to pull out a really rich vein in the work we create."

Bengt Sjölén

Bengt Sjölén is a Stockholm-based software and hardware designer and hacker with roots in the ATARI - Amiga demo scene in the late 1980s and early 1990s. He currently works with several networks of collaborators all over Europe on projects merging media art, technology, architecture and science, experimenting with social and physical spaces. The majority of Bengt Sjölén's work is truly collaborative involving his Stockholm studio, Teenage Engineering, where the individuals all have very diverse backgrounds and experiences and include the likes of film directors, industrial designers, and music and games producers. Teenage Engineering successfully collaborate and contribute to the thriving media arts scene by connecting such things as VJ software, music and sound technology, building hardware, product design, and event marketing campaigns. Sjölén states "all of these projects are made by different constellations of people...it is not a one hundred per cent commitment,

we share the space, we cross breed ideas, some do projects together, but everybody works on their own projects as well." Sjölén collaborates with many prominent practitioners in the field of interactive arts including Adam Somlai-Fischer, Danil Lundbäck and Usman Haque where the idea is that there is no one author or creator or artist, but rather the network itself is the artist or the creator. In this way, you have to give up the idea of being the individual creator. The project does not belong to any single author or specific artist's identity.

Moritz Waldemeyer

Moritz Waldemeyer is at the forefront of mechatronics, a combination of mechanics and electronics that helps create innovative design ideas for concept cars, smart furniture and domestic machines. Waldemeyer has worked with Zaha Hadid, Ron Arad, Tord Boontje and Hussein Chalayan who have all availed themselves of his expert technical knowledge. Originally he trained and worked in engineering research and development before finding himself in the middle of a creative collaboration with Ron Arad and Swarovksi who were working on a text message chandelier for a show in Milan. Later that year, after widespread press and publicity of this project, Waldemeyer explains: "everybody knew about it, it was published all over the place and all of a sudden I was like right in the middle of this design world and projects kept coming in." Waldemeyer's work appears to be moving increasingly in the direction of design and he believes this is because design is reasonably broad and it covers various elements that he is interested in. When asked what he sees himself as, however, he has stated: "It is really difficult isn't it? It's impossible to say right? I guess that's why we're here in this book because none of us really know what we are. This is what this book is all about isn't it?" For now it would appear that Waldemeyer is happy to concentrate on working on projects where "you always have new ideas and some of the ideas are so intriguing that you just want to realise them and so you're looking for ways of doing that and so I guess the ultimate goal is to realise as many of my own ideas as I can until I retire and then not do anything else at all after that."

BigDog Interactive

BigDog Interactive explore non-navigational spaces and interfacelessness. They use less technology, not useless technology and they like extreme prototyping. BigDog Interactive also prefer to build rather than blog. BigDog Interactive is a young company with a wealth of experience in computer programming for mobile applications, interactive art installations, advertising and live events. BigDog Interactive's team of programmers has 40+ years combined experience in software engineering, user interface design, computer networking and hardware development. BigDog Interactive work one-on-one with clients and end-users to design, develop and build interactive installations that are tailored for specific target audiences. Jennifer Sheridan, one of the founders of BigDog Interactive, states: "We are interested in unexpected spaces where we can develop things that are highly portable, things that can be put together and deployed in a space very, very quickly – perhaps built in a day, with a very

small budget, and with very tight time constraints on the project." Several of BigDog Interactive's projects are intended to provoke questions about how our obsession with technology is affecting our environment. Furthermore, BigDog Interactive are motivated by not just making installations but by creating events and performances around what they do. In this context, BigDog Interactive conduct a lot of work they call Digital Live Art, the intersection of Live Art, Computing and Human-Computer Interaction (HCI). But, as Sheridan explains, whereas conventional HCI looks to increase efficiency in the office or workplace, BigDog Interactive look at non-task based uses of technology such as how you use computing in a club environment. Sheridan explains: "We look at what is called playful arenas, contexts like clubs and festivals where spontaneous interaction and improvisation is encouraged, and we look at this notion of Paidia, or pure play, playing for pure pleasure rather than competitive games."

Troika

Troika is a multi-disciplinary art and design practice founded in 2003 by Conny Freyer, Eva Rucki and Sebastien Noel, who met while studying at the Royal College of Art. Troika have backgrounds in graphic, product design and communication, which allow them to engage in work that is at the intersection of several disciplines, where they like to think of design as communication art. Troika develop a variety of self-initiated and commissioned projects that are both engaging and demanding to the intended audience, from printed matter to product design and custom installations. Their approach focuses on the contamination between the arts and design disciplines and is born out of the same love for simplicity, playfulness, and an essential desire for provocation. Sebastien Noel states: "we don't really care so much about the distinction between the art and design. What we find interesting is bridging art and design and bringing our concepts into a design field. So, we like using product as a medium or an installation, which we try to do more and more." In a lot of Troika's work is a keen exploration and examination of the ambiguity between fascination and concern and how this impinges on technology in a broader sense, as a kind of double-edged sword. According to Noel, another motivation for Troika "is the aspect of recombination. How you can get access into electronic culture and magnetic culture by acting and recombining and making open-ended objects." In this respect, the SMS Guerrilla Projector is a good example of highlighting an exercise in creating a tool for mass response to issues. It is a projector that integrates a Nokia 3310, which is a conventional mobile phone. The SMS Guerrilla Projector is made with regular components from products such as projectors, phones and photographic equipment. Troika love the physicality of technology and, according to Noel, particularly admire the work of people like Athanasius Kircher, a German scholar from the 16th century who devised things like the cat piano.

Lucy Bullivant

Lucy Bullivant is an architectural curator, critic and author. Lucy has worked internationally with leading museums, galleries, cultural institutions, publishers and corporate bodies since 1987. Her

latest book, Responsive Environments: architecture, art and design (V&A Contemporary, 2006), explores the hybrid discipline of interactive architecture and design. She regularly contributes to Domus, The Plan, a+u, Volume, Architectural Record and Indesign, some of the world's most authoritative international architectural magazines. One reason for Bullivant's fascination with this field of work in general, and the practitioners in this book in particular, is that their work explores more than the mere conventional applications of HCI (Human Computer Interaction) by envisaging alternative uses of digital technologies, instead of narrowly commercial, control or task-based applications. Bullivant states: "Projects are fundamentally bespoke because their software is virtually all hand-made, both made and coded, in a way that evokes sort of 21st-century digital craft scenario." The urban spaces of our modern cities, Bullivant suggests, provide blank canvases to the growing breed of interactive artists, architects and designers. Many of the new and emerging technologies enable objects and spaces to respond to external stimuli such as biological data, meteorological data, electromagnetic fields, and other programmable data like mobile phone calls, which facilitates a dovetailing of creative pursuits. Thus, architects are turning to interactive projects, while media artists, are turning their attention to environmental projects such as can be seen in this book. Artists, architects and designers now see urban spaces as manipulable, places where technology can be used as a creative medium to further greater emotional and social engagement. Creative practitioners, including those within this book, are now regularly building alliances with software engineers, while interaction designers and mechatronic specialists are similarly operating in multidisciplinary networks. Bullivant says: "In a relatively short period of time, the discipline's language of mutability...has through a bottom-up process of creating and testing prototypes, evolved a spatial practice that has focused both on the electronic screen and the challenge of going beyond it to create bio-digital narratives."

John Marshall and Julian Bleecker

Marshall and Bleecker, in their essay, propose the term "undisciplinary" for the type of work prevalent in this book. That is, creative practice which straddles ground and relationships between art, architecture, design and technology and where different idioms of distinct and disciplinary practices can be brought together. This is clearly evident in the processes and projects of the practitioners' work here. Marshall and Bleecker view these kinds of projects and experiences as beyond disciplinary practice resulting in a multitude of disciplines "engaging in a pile-up, a knot of jumbled ideas and perspectives." To Marshall and Bleecker, "undisciplinarity is as much a way of doing work as it is a departure from ways of doing work." They claim it is a way of working and an approach to creating and circulating culture that can go its own way, without worrying about working outside of what histories-of-disciplines say is "proper" work. In other words, it is "undisciplined". In this culture of practice, they continue, one cannot be wrong, nor can practice elders tell you how to do what you want to do and this is a good thing because it means new knowledge is created all at once rather than incremental contributions made to a body of existing knowledge. These new ways of working make

necessary new practices, new unexpected processes and projects come to be, almost by definition. This is important because we need more playful and habitable worlds that the old forms of knowledge production are ill-equipped to produce. For Marshall and Bleecker, it is an epistemological shift that offers new ways of fixing the problems the old disciplinary and extra-disciplinary practices created in the first place. The creative practitioners contained within the pages of this book clearly meet the "undisciplinary" criteria suggested by Marshall and Bleecker in that they certainly do not need to be told how or what to do; they do not adhere to conventional disciplinary boundaries nor do they pay heed to procedural steps and rules. However, they know what's good, and what's bad and they instinctively know what the boundaries are and where the limits of the disciplines lie.

Daniel West

Daniel West, in his essay "The Work of Art in the Age of Mechanical Interaction", raises an interesting and challenging issue by claiming that interactive new media art presents a paradox. West, citing the influential Slavoj Žižek who is a professor of philosophy and psychoanalysis, coins the term "interpassivity" to describe many so-called interactive projects. Žižek states: "It is commonplace to emphasise how, with new electronic media, the passive consumption of a text or a work of art is over. I no longer merely stare at the screen, increasingly I interact with it, entering into a dialogic relationship with it…Is, however, the other side of this interactivity not interpassivity? Is the necessary obverse of my interacting with the object instead of just passively following the show, not the situation in which the object itself takes from me, deprives me of, my own passive reaction of satisfaction (or mourning or laughter), so that it is the object itself which "enjoys the show" instead of me, relieving me of the superego duty to enjoy myself? … Is to be relieved of one's enjoyment not a meaningless paradox, at best a euphemism for simply being deprived of it?" West suggests that true interactive architecture, design or art requires a consequential exchange that stimulates, provokes or questions its audience. He goes on to state that through provoking and questioning, interactive architecture, design or art can redeem itself from the ubiquity of thoughtless mechanical interaction, and return cognitive sovereignty to the individual. West states that to avoid being labelled "interpassive", new forms of interactive architecture, design or art must provoke the audience to reflect on their social, political and philosophical values. If the object, space or experience does not then it is merely entertainment that exploits magical novelty to achieve false consciousness.

The editors, Paul Rodgers and Michael Smyth, believe Digital Blur: Creative Practice at the Boundaries of Architecture, Design and Art will be an important addition to the new but growing field of books exploring practitioners involved in areas such as interactive architecture/ design/ art. Each of the creative practitioners' contributions here is in the form of a rich and revealing text backed by images of their creative practice. Furthermore, three invited essays from expert authors working in this emerging area, Lucy Bullivant's "Softspace: The Emergence of Interactive Design Installations",

"Undisciplinarity" by John Marshall and Julian Bleecker, and Daniel West's "The Work of Art in the Age of Mechanical Interaction", make this a necessary book for anyone involved or interested in the creative industries in general and in interactive architecture/ design/ art in particular.

References

Coles, A. (2005) DesignArt, Tate Publishing, London.

Coles, A. (2007) Design and Art, The Whitechapel Gallery Publishers, London.

Flusser, V. (1999) The Shape of Things: A Philosophy of Design, Reaktion Books, London.

Hayon, J. (2007) Documents..., Icon, 47(May), pp. 83 – 96.

West, D. (2007) A New Generation, Icon, 43(January), pp. 56 – 64.

Crispin Jones

remembe
you
will di

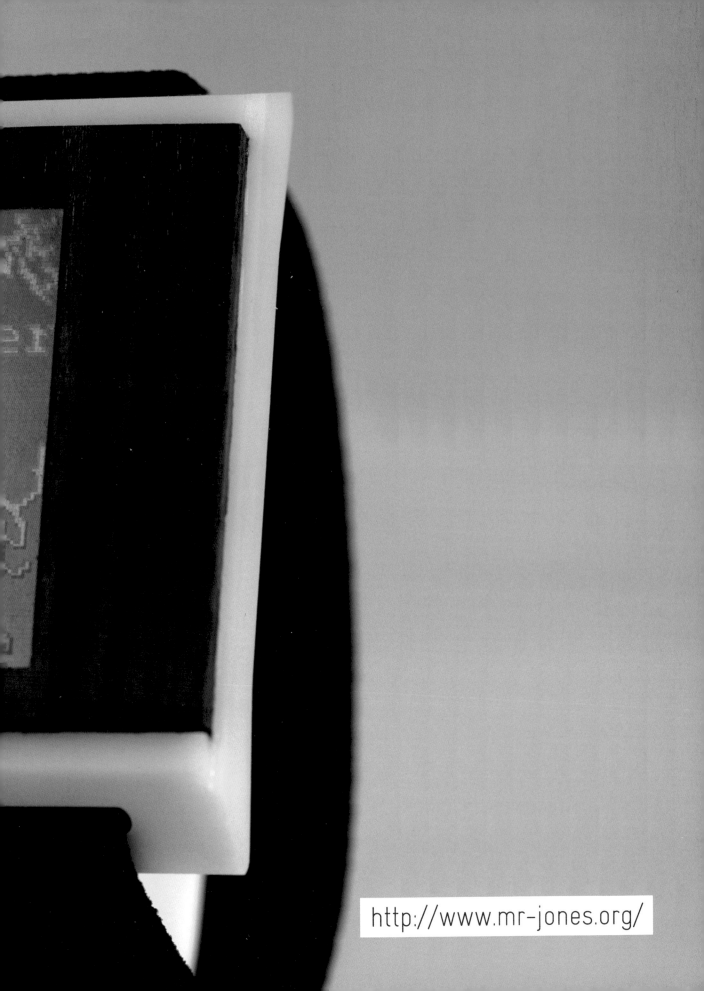

Crispin Jones

"ultimately I was neither artist nor designer"

It is interesting picking up on the point Moritz Waldemeyer made in his presentation regarding disciplinary labels. I used to always start talks and say, I kind of started off studying sculpture because I was interested in fine art and then I studied on a design course and I was really interested in the intersection between the two but ultimately I was neither an artist nor a designer. I think actually recently I've become more involved in the commercialisation of the projects that I do so possibly I'd add to the Venn diagram in the introduction a business element, because that's where I see myself heading. I don't know, perhaps you'll see in the course of my work where that element kind of fits in.

Originally I studied sculpture and later I studied for an MA at the Royal College of Art (RCA) on a course called Computer Related Design (CRD). Initially I was concerned when I was on the course to understand where I fitted in and how I could contribute because I wasn't really a designer, I wasn't particularly interested in that. I was wondering how I could bring my fine art background into the work that I was making and this first project was probably the first time I felt like I found a kind of voice. I found the sort of things that I wanted to make. One of the first things we had to do on the course

was make something that was functional, something that solved a problem.

So this is a device that I made to play the 1980s arcade game Track & Field. The idea was that it would help the player go through the entire game unbeaten. Track & Field is an Olympics-themed game where essentially you have to press the Z and X buttons alternately to make your game character run 100 metres or do the long jump or throw the javelin. The ZXZX device controls the character in white at the bottom of the screen, so it enables your character to run the 100 metres in 8.29 seconds and the idea was that he'd go through every event and get the world record in each of them. I was interested generally in what does that mean if you pitch one computer against another? Computer games have this whole history of cheating devices, that's sort of central to the experience of video gaming whereas of course in the Olympics the idea of cheating is absolutely anathema to the notion of fair competition. So it was interesting that in these video games we play we're allowed to cheat, we're expected to cheat, that's part of the experience but then what does it mean when you've got one machine playing against another machine, when the human element is removed? One

of the things as well was I wanted the device to be a self-running object. I would just press "play" and it would run through all the events. However, because the game is being played under emulation there's a kind of inconsistency with the timing so off screen I'm pressing a button to make him jump, so it wasn't a totally automatic system. So that is the thinking behind the ZXZX device and with this project it felt like I had a voice with it.

This next project was the final piece I made at the RCA. This was a project called "An Invisible Force". Largely, I'm interested in how we use technology and particularly computer technology as a sort of predictive tool, to help us make decisions and to help take away the responsibility that comes with making decisions. So this was a device that answered questions. It was all dressed up with this theatricality to do with horoscopes and

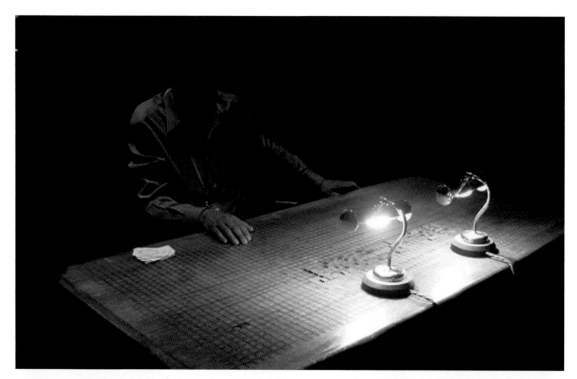

fortune telling. The way that it worked was you had a pack of cards, and each card was printed with a different question. You take your card and you drop it into a metal slot on the left and then you press down and hold it down. As the answer is brought up on the table your fingers get hotter and hotter through the metal plate. So at a certain point you have this dilemma do I want to see the whole answer enough to endure the pain or do I want to take my hand off and stop the whole thing? And I thought that was a manifestation of the very rational computer fighting against this very superstitious human thing of wanting to know answers to these questions. All of the questions and answers came from an existing horoscope system called "The Mystic Oracle". So, for example, this was the first question – "Tell me if my love will be returned". The table has this relatively small, articulated area where it

IMAGE: Crispin Jones with IDEO / Social Mobiles (SoMo5)

can bring out the answer and this emphasises the pain-endurance element because it takes a while for the metal plate to heat up. It breaks the answer down into small pieces, "Yes if... you stay... true to... your...", and for each question there are 30 different answers which, as I said, came from an existing horoscope system. The complete answer reads, "Yes if you stay true to your ideas" and finally at the end of each answer the table displays "That's all" and then it resets itself. I wanted to make something that didn't feel obviously like a piece of technology. I didn't approach it as a piece of technology. It was literally an old table that I found, I had the top surface laser cut into a grid and then there is a section within it that is articulated. So the table had quite a non-technological aesthetic to it.

"they were funding research projects that weren't client-driven"

Another example question here is "Tell me what my friends think of me" and the table answers "they're... more... concerned... about... someone...". So the display is kind of torturous because it's only got the ten characters it can display at one time. Interestingly though it completely fails with the aim of making the user question their superstitious beliefs because once you put a barrier or obstacle to reading the answer, the user invests the answer with even more credibility.

After I left the RCA I worked for some time at Philips Design and I also worked one day a week at IDEO in London. IDEO at that time were quite buoyant because they had a very successful 1990s and so they were funding research projects that weren't client-driven. These projects were a way for them to explore different areas that they wouldn't get a chance to explore doing a client project. So they asked me to come in and propose a research area and to lead the project there. So this was at a time when it felt

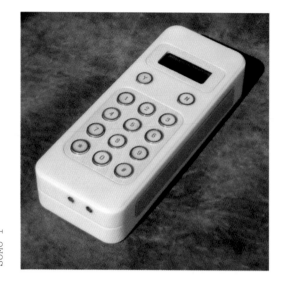

SoMo 1

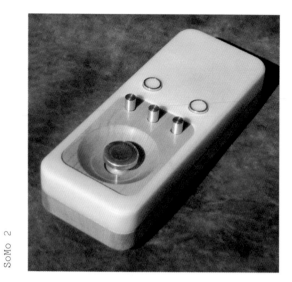

SoMo 2

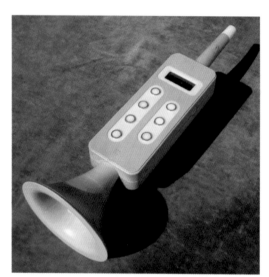

SoMo 3

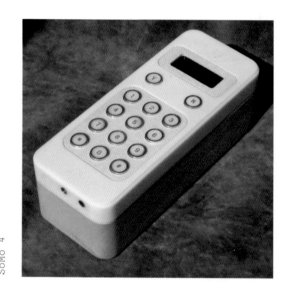

SoMo 4

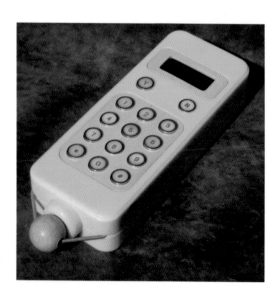

SoMo 5

like mobile phone use had really exploded and it felt like suddenly everyone had a mobile phone. To take a bus journey was intolerable because you'd hear endless people speaking on their new phone and it was incredibly irritating so the subject area I proposed was to look at mobile telephony but look at it more as a social problem that needed a solution rather than something to be celebrated and something to create new functionality for. So working with Graham Pullin and a team of other designers and model makers at IDEO we designed five mobile phones that each altered their user's behaviour to make it less disturbing to the people around them.

So in the world of social mobiles we imagined a situation where you had to have a mobile phone licence and where you could get penalty points for being disruptive too often. Ultimately this device (SoM01) would be imposed upon you as a kind of retraining sanction. This one (SoM02) we conceived of as being the mirror image of text messaging. Text messaging is very good at specific factual information but very poor at emotional nuance. So SoM02 is the mirror image, and it's very good at emotional nuance but very poor at specific factual information. With this one (SoM03) we were interested in Sadie Plant's research that looked at how the mobile phone was used culturally in different cities, in different countries and one of the things, one of her observations about mobile phone use in London was that when people gathered at outside cafes or tables outside pubs there was this kind of one-upmanship where each person would put their phone on the table and if you had the worst phone, this was a subliminal thing, it wasn't conscious; if you had the worst phone you'd discreetly remove it from the table and we conceived this as the ultimate phone to put on that pub table and all the other phones would depart. With SoM04 here we were thinking phones are actually worse than a door, at least when you come to a door you can knock very gently if you were

concerned about disturbing a person or you can pound with your fist if it's really urgent that you need to come in.

I feel that with the mobile phone you just press the button and your call is announced however the other person has set their phone up. It's worth saying at this stage that we built all of these SoMo prototypes as working GSM phones. This one, for example, packaged the knocking up in a text message and sent it to the receiving phone, which in turn unpacked the message and replayed it. With hindsight I question the enormous amount of effort we put in to make them work and to make them because almost no-one experienced them in reality, most people have only ever seen the video but then I'd argue that they're more intriguing as objects because they're working. It seems harder to ignore if someone's gone to that effort. This one, SoM05, probably creates a whole world of other problems and doesn't really solve anything, but it does communicate some of the frustration of listening to someone else's boring mobile phone conversation. I think one of the fundamental things I'm interested in and explore in my work is the idea that technology both gives us something and takes something away.

The next project, called Katazukue, was made for a Japanese exhibition and represents the ultimate encapsulation of this two-handed nature of technology. So Katazukue is a table which clears itself periodically. So it gives you something – you don't have to tidy up, but then it takes something away – you don't know when it's going to tidy itself. So the danger is if you have stuff on the table then you'll lose it. It was about this time that I was starting to get concerned that I really liked making projects like this and it gives you an opportunity to travel and to meet new people but you actually don't make any money and it was starting to frustrate me a bit that I was putting all this effort into all these different projects but it seemed

unsustainable as a way of working, certainly
for me and I couldn't really make it work. So
around this time I started also making some bits
and pieces for another Japanese company called
Elekit who make electronic kits. They asked me
to propose some things for them that could be
produced as kits. A lot of their kits don't really
have any programming element and it seemed
to me that all the fun of the kit was in building
it and then once you'd built it, it just wasn't very
interesting as a toy. So I tried to incorporate
both a programmed element and also make sure
that they had a bit more longevity as devices.

Initially I developed and prototyped a parrot
that listens to whistled tunes and repeats them.
These kits had to be made with extremely low-
cost components and this was the first time that
I had ever had to work in that way. So it's not
perfect, the light flashing means that the parrot
has recognised the note. The parrot needs to
hear really pure whistling tones as well, so you
need to whistle as clearly as you can. Because it
was not quite perfect the replay from the parrot
is done at double speed to sort of mask the
errors a bit. It's kind of alright, it has character.
So the projects I produced for Elekit were all
sound-orientated. I was interested in making
stuff that was sound reactive so the other thing
that I made was a spinner that has a microphone
and two lines of LEDs. This responds to sound
with animations so you see they have different
patterns that they are displaying. Ultimately
Elekit decided they didn't want to release these
as commercial products.

IMAGE: Crispin Jones / Katazukue / documentation image

"He's asleep at the moment, so to wake him up I have to blow on his face"

One of the other companies that I met in Japan was a company called Solid Alliance and they made a lot of money from making the USB Sushi drive. It's a memory-stick shaped like a piece of sushi, a terrible kind of visual pun but they made quite a lot of money from it and what I thought was interesting was that they invested a lot of the profit from that in making a device called the Ghost Radar, that detects whether there are ghosts in your environment. They released this as a product and I was intrigued because I thought it was a special company that would do that because obviously it doesn't sell that many Ghost Radars. So I decided to make something for them that was part ghost and part USB device, and I made this little character called Tengu that you plug into your computer. He's asleep at the moment, and to wake him up I have to blow on his face. He's got a microphone underneath so he responds to any sound around him. So the idea is if you play music he'll appear to sing along with it. He has different faces as well and I wanted to keep the interaction simple, so in order to change his expression you simply blow on his face. Can you imagine blowing into a microphone? It creates a very loud noise and Tengu works in a similar way. If he hears around one second of his maximum sound level it will change his facial expression. So he has different expressions that you can match to different styles of music. When I was developing Tengu, I looked at a lot of prehistoric Japanese sculptures and I thought I'd like to make something with the same kind of dynamism and energy and also the same playfulness. Tengu started off as a much more traditional ghost form because I really wanted to make this ghost plus USB idea clear.

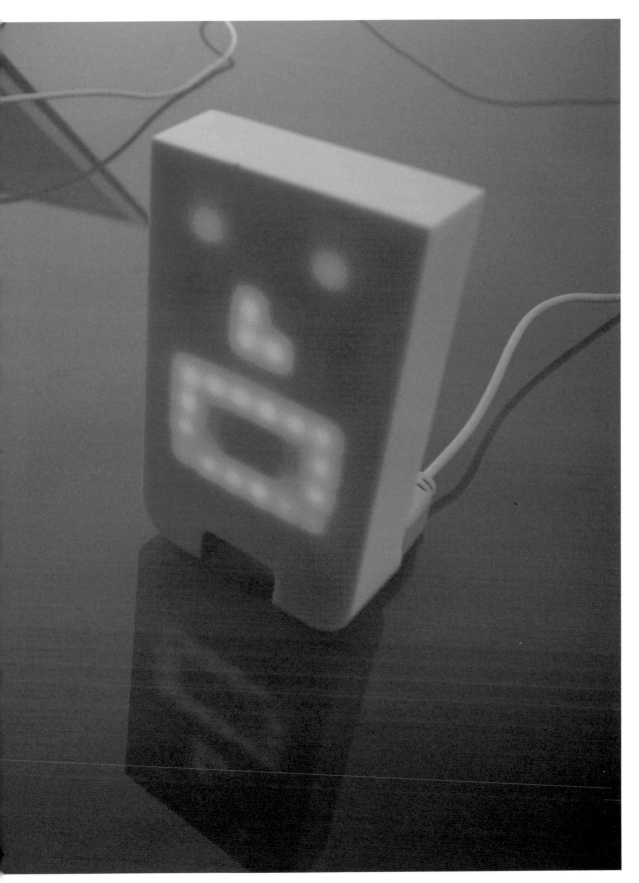

IMAGE: Crispin Jones / Mr Jones's Tengu / promotional image

I made many different Tengu prototypes and it was incredibly tedious because they took a really long time to make on the little milling machine that I've got and they didn't work very well and I tried to make some with a fabric cover but they didn't look very good. So I tried to really simplify the form down. The original one had this data link back to the computer so if my friend has one and I've got one, I can send a message and it will be displayed on my friend's Tengu. I wrote a little piece of software for editing different animation patterns. For me, it was a satisfactory process to edit this functionality down to one aspect of the original unit that was the sound reactive thing, which ultimately became the central element. This was the first one that had the microphone on the bottom and this was an early production one so the USB cable had moved to a different place. So for me this is a really satisfactory product

IMAGE: Crispin Jones / Mr Jones's Tengu / promotional image

because it ran the full gamut: I had the idea, I did the prototype, I wrote the software and I designed the packaging.

Around the same time as the Katazukue project, I produced a series of one-off wristwatches. These were in a way a bit similar to the social mobiles – there was a series of seven different wristwatches in this case. I was quite interested in the wristwatch because it is this really old

piece of technology and moreover wearable technology, which is really difficult to do – almost all wearable technology products fail. Yet the watch has had this position on the wrist for hundreds of years now, which makes it quite unique. Additionally the watch carries all these social signifiers and also communicates something about your status or your aspirations, so it's quite loaded as an object. I wanted to make something that was a bit more playful

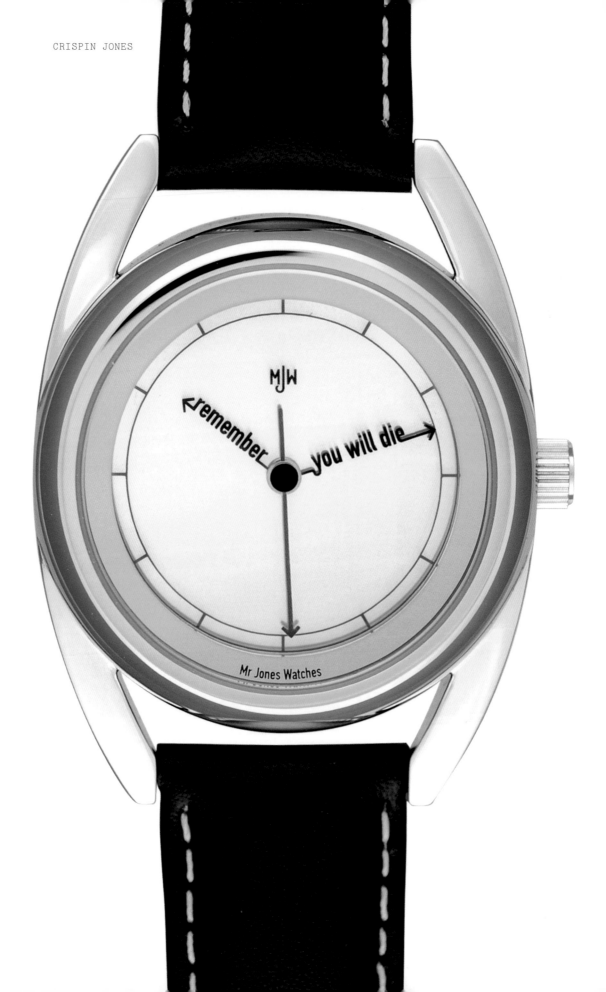

that would kind of play with the ideas of what your watch communicates about you. Currently, there are seven watches in the series but I was revisiting this project and I was thinking the "Remember you will die" model appears to be the most un-commercial watch I could imagine and no-one would ever buy it and then I started to think that maybe if I made it as a nicer, more desirable object then there might be an audience for it. So I went through a process to find a factory in China that would let me make a quite small order quantity, that would let me make my own case and I found one that seemed quite amenable and the quality looked great and so began the process of producing my own line of watches (Mr Jones Watches). To make the dial in the original, one-off "Remember you will die" model, I took the backing off an LCD and put a mirror behind it and this then transformed quite directly into the production model where the hour hand reads "remember" and the minute hand says "you will die" and indeed this has gone on to sell very strongly.

To conclude, I would say that my focus at the moment is to make more of my own products, where I can have complete control over the creative process. The watches are doing well one year on and there is a new series coming. The business part of doing my own products, that I thought would be really horrible at first, is actually quite interesting as well as rewarding.

Q&A

Q The narrative on your video is very important to the way you understand social mobiles and your other projects and I was wondering do you exhibit the objects themselves alongside the video narrative; and the people that buy your watches, are they buying them because they've seen the original watches or the social mobiles, or were they a different public or the same public?

A The narrative of the videos alongside the objects – I mean for me the videos came about because the objects are kind of dead on their own, like the social mobiles are uninteresting as just a set of objects. They just look like a weirdly designed set of phones so without that narrative alongside them they're sort of meaningless so it became kind of essential to link the two together so, yes I would tend to try and show the both at the same time. The people that buy the watches no I don't think they've seen the other projects that I've done necessarily. They were featured in several American design magazines so most of them go to American buyers – Americans and Russians actually are my two main markets – but it's weird because I don't really have a very strong relationship with them, I don't know who they are, the people that are buying them, because a lot of them are online sales so I just get an address and send it out. It's kind of intriguing.

Q So there is no real connection between the watches and phones?

A I don't think so. For the first set of watches I did five designs, 100 pieces of each just a kind of limited edition. They were all numbered on the case and then the ones that I have here are like an open edition based on them, but the limited edition was just because I could make a reasonably small order and it seemed logical to make it sound kind of exclusive.

Q You were talking earlier about how you see yourself as an artist or a designer or something else and I was wondering how you see these objects, as art or a device? It's interesting that you've done this in Japan because in Japan there's a genre or field of art called Device Art and...

A ...there's one guy, Ryota Kuwakubo.

Q And there are others as well. Without delving too deeply into types of Japanese culture it seems that there's more of an acceptance of that boundary between commercial practice and art dissolved and artists working with corporations and introducing objects that are both commercial objects and artwork, but that's mainly harder so do you see them as artworks? How do you position them? Are they designed objects? How do you see yourself in that realm?

A To me it's not super-meaningful as a distinction. There are others like Ryota Kuwakubo such as Maywa Denki who have a really nice little cascade of things they produce. They'll do little key-rings, novelty key-rings right up to one-off fine art pieces and I thought that was kind of interesting and that's not something that happens here. Damien Hirst, for example, doesn't really do the key-ring end of the scale, it doesn't really fit our understanding of what an artist should produce. But to me, ultimately the distinction about whether they're design objects or fine art I don't really care.

Q But I mean it's not just like whether you care but you know you probably have to deal with those multiple institutions of art and put it to them and everything, do you try and question, do you find that people... you know, it goes back to how do you engage

an audience, like "who's the audience?" is another way of putting it. Do you show it in gallery shows? Is it accepted how people will respond to it because a lot of people see that as problematic don't they?

A Yeah well certainly things like Tengu I have never exhibited in a gallery situation. I don't think it would be meaningful simply because he is like the little device you plug into your computer. The watches, for example, sell in jewellery shops, in traditional watch outlets, and in design stores. The Tengu, similarly, doesn't really sell in toy shops. It sells in places like the Museum of Modern Art (MOMA) in New York, Urban Outfitters in the US and UK, and places like that. They're not high-end design stores, they're more mass market than that but for me I'm very happy to have as wide an audience as possible for the things I make. I'm not bothered about being in a very high-end store necessarily as long as people are interested in my work.

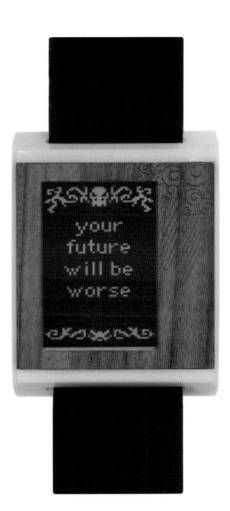

IMAGE: Crispin Jones / Adsiduus Personality Watch / promotional image

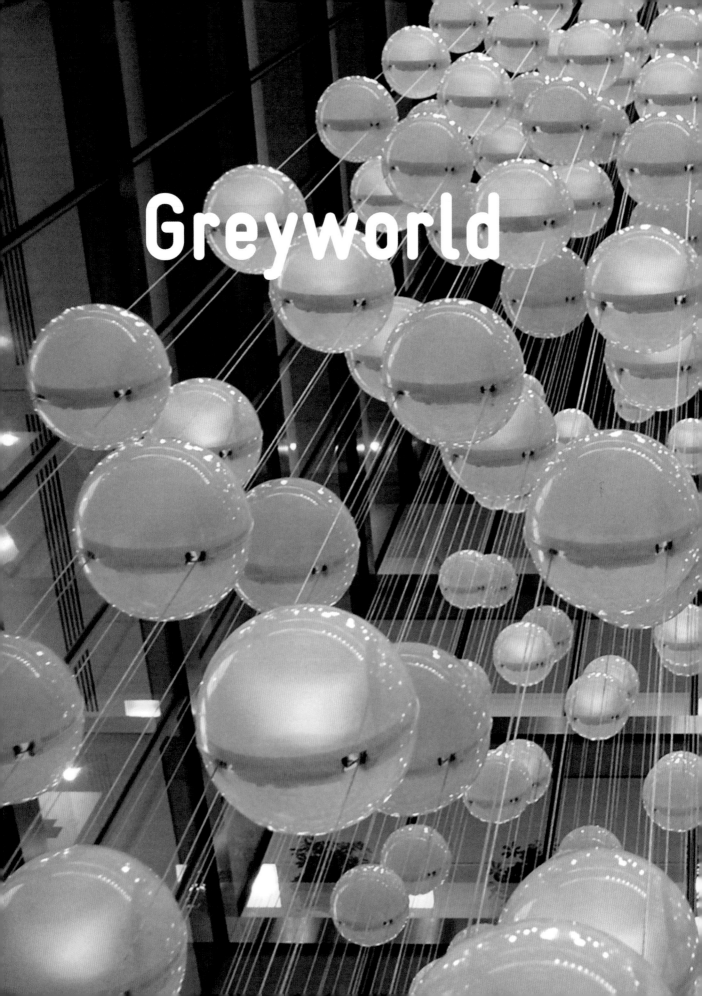

Greyworld

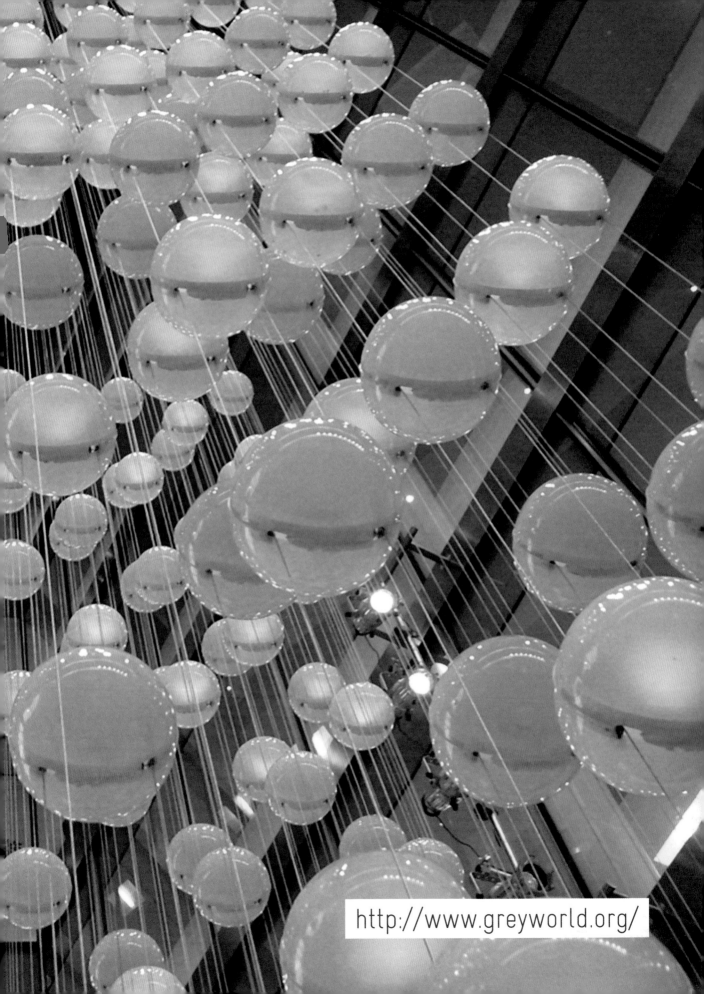

http://www.greyworld.org/

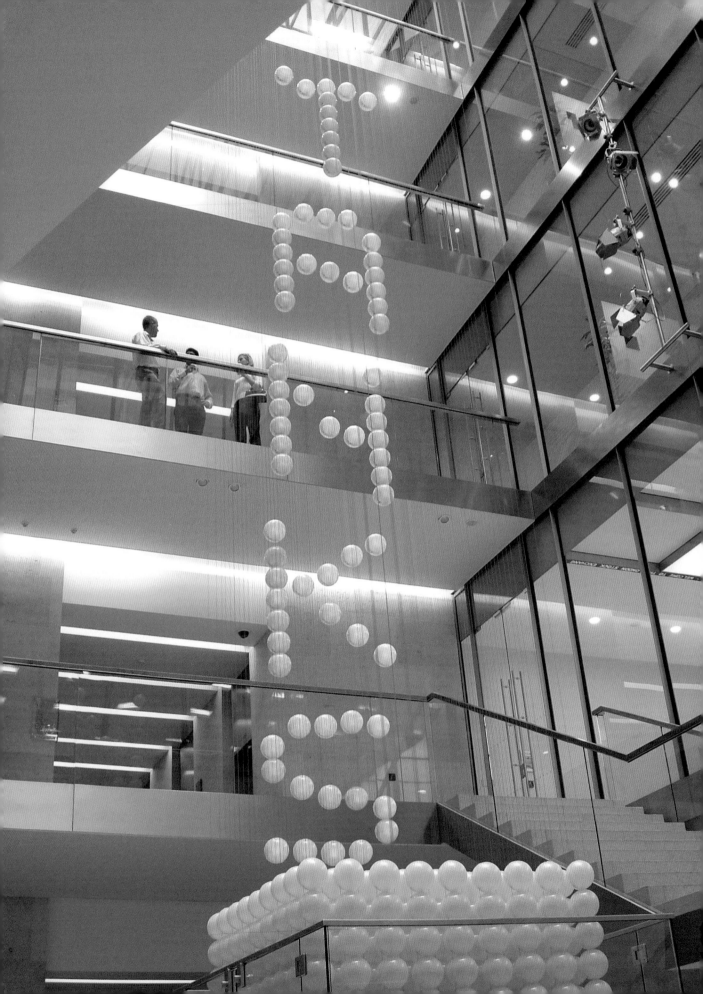

Greyworld

"these grey zones were the
main focus for us."

My name is Andrew Shoben, and I'm part of a group of artists called Greyworld. We're not called Greyworld because we're manic depressives! We're called Greyworld because of the reasons why we make our work and because of the spaces that we choose to work. I am going to illustrate the work of Greyworld through a set of installations that will hopefully give a sense of why we do the work that we do. It has always been my view that cities are designed with usage very much at the front, there are places where you live, places where you eat, places where you sleep, places where you go to get drunk. The focus of a lot of Greyworld's work is in those spaces that are in between those zones, in what academics call liminal spaces, threshold spaces. So a lot of our early installations particularly went on in the road just beside the shopping centre or the street that went just around the back of the "important place". So rather than being work for the town square or installations in galleries or things in supermarkets, it tended to be in the spaces that you moved through a thousand times a day that are actually non-spaces, they're really only there to get you through to the other "important" space. These areas actually seemed very interesting, lots of fun to be had there, and these kind of

grey worlds, these grey zones, these non-areas were you know, the main focus for us.

Before Greyworld, music was my thing and I wanted to be a rock star and was failing miserably. But as a consequence of that, a lot of Greyworld's early work and all the way through really, was very sound based. The first installation that we did, and it's something you did as a child I'm sure, probably as adults too, you walk through the park and you pick up a stick and run it along railings. You get that lovely tsch, tsch, tsch, tsch sound? Well we took a set of railings and we tuned them, so when you ran a stick along it, it played "The Girl from Ipanema"! Now from our point of view it was really satisfying as an artwork, because what it wasn't was a big bronze guy on a horse, holding a sword just sitting on a horse in the middle of town, or a big Modernist fifties sculpture in the middle of town. It's just a set of railings, it's still something that you can chain your bike to or it stops you getting into the park or whatever; but, as far as, for that moment of play, just that delightful second when you were just doing it anyway and suddenly, "The Girl from Ipanema" starts ringing out, that was something for us that was just an exalted action! Something that

IMAGE: Railings (1996) in a town near you. (c) greyworld 2009

was lovely and should be rewarded. So a lot of Greyworld's early work was based on sound.

"my audience is not academics"

Another example of Greyworld's early work was a project in Dublin, on a bridge across the River Liffey, where we carpeted it, a bright blue carpet. Tiny little sensors in there generated sound as you walked across them. So as you walked across you heard the sound of walking through crunchy snow, or sploshing through water or you walked through crunchy leaves. Now I mean, as far as the Greyworld zone idea is concerned, this is a really satisfying location because mostly a bridge is not somewhere you hang out, a bridge is where you go to go somewhere else. Suddenly the bridge becomes very popular, everybody is standing in the middle of the bridge generating sound. And as a method of interaction... I mean, of course there are lots of really interesting ways of picking up movement, you can have light beams that you break and you can have cameras that track you, and you can have all kinds of technologies like that, but if you have installations like this, where really the interface is "friction based", you know, you move, it generates sound. My mum understood what was going on here when we made a little one, and if my mum gets it it's a good public art installation. This is really important: my audience is not academics, my audience is not art galleries, my audience is people who are going off to buy cans of beans from the supermarket, and so generating and creating artworks which are legible immediately is very, very important. An installation like this which had a little two-page description of it at one end of the bridge explaining to you what was going on would be a complete failure and I would feel very bad about that.

I learnt a valuable lesson when we did a project at the FACT Centre in Liverpool, UK. So we have the sense of Greyworld being a fiercely

public artist group which is so important,
so like I say the idea of not reading a text to
understand the work was something that
we all felt very, very strongly about. The
people at FACT said "Can you write us a
bit of text to explain some of the elements
that are going on in the work" that we were
doing, and I said "no, I refuse, this is rubbish,
absolutely not!" And I realised after a good
conversation with the people at FACT that I
was actually an inverted snob, that whilst I
was so fixated on making sure that people
could get into the work, those that wanted
a text to read, those that wanted something
to understand, I was excluding them, so
actually now we grudgingly do that and there's
no... you know, I got over myself, it's fine!

"of course the floor makes music"

So a lot of our work now is permanent, like the
installation at the Yorkshire Sculpture Park. It's
an unusual place for us as it is a stately home
with lots of bronze figures and lots of lovely
old sculptures. It is an installation where we
tried to create a space. All of our work is very
site specific and this one is particularly so. A
pergola had been there for hundreds of years,
and we dug up the centre of it and installed a
floor area, and put some park benches in there
and little signs that suggest that this maybe
was some old game that the original owners of
the house used to play. I mean, you don't really
know and you go in there and think "oh what's
going on? Maybe there's some old game that
used to be played here that we don't know
the rules of", and again, as you move across
that space, tiny sensors embedded in the floor
create generative soundscapes based on the
position and the movement that you're doing,
that create a 270 degree sound arc around you,
which is lovely, great fun. Children tend to
unlock these installations for adults. Children
are like: "Well of course the floor makes music,
I mean, you know, Doh!" Whereas parents tend
to be a bit more sceptical, I'm not sure why but

IMAGE: Playground (1999) in the Yorkshire Sculpture Park. (c) greyworld 2009

always make things say "hello", but they
do, so inevitably our tank says "hello" too.

So anyway, while we were making the Bubble
Jet Printer, the London Stock Exchange came
to us. The London Stock Exchange wanted
to differentiate themselves from other stock
exchanges, so they approached Greyworld
to make an artwork that would be situated in
their atrium. So as we were working on the
Bubble Jet Printer, we wanted to give them a
35-metre tank of water basically, which would
have been really stupid. Somebody told me
that, you know, just the weight of water itself
would have fallen right through the floor and
a floor below and the floor below that, so what
we did was with cables. They are eight storeys
high, on each cable there's nine spheres and
so there's 9 x 9 x 9 balls so there's 729 balls on
the installation. Each sphere or ball can move
up and down independently on its own cable,
the idea being that we would create an infinite
sculpture, that you could model the rising sun
or DNA or a word or whatever you like, just by
sending these spheres to the right height in
the atrium. Like an abacus, a 3D abacus. You
see I thought everybody would basically get
the idea, but they didn't get it! I went in there
with bits of string with marbles on the end.
We did this and they didn't really get the idea
and eventually they got it but it took months!

What is really interesting about the piece is as
the spheres come back down to earth, some
of them are left behind, this is the interesting
thing about the system that we only really
discovered so stuff is going on but you don't
know what it is until the very last moment...
when in this instance it says London! So
we presented this idea to the London Stock
Exchange and they didn't get it so more
marbles on strings, and eventually they said
"Yes okay." It was 1st February 2004, they said
we need it done by 24th June and by the way the
Queen is coming! You cool with that? That was
going to be a nightmare but of course we had

IMAGE: The Source (2004) in its dreamtime state. (c) greyworld

to say yes and well, we'd have been silly not to. It was reported on the News that the work of art was a rather beguiling sculpture and, eighty million people watched the opening. The Queen pressed the ball and all the spheres took off. It was the most heart-wrenching moment of my entire life when she put her hand on the thing because nothing happened, It did really, but it just felt like it took a month, which was actually just about a quarter of a second. I was like wooow, I'm never going to work again! So all the spheres took off and they danced! During the day they model different shapes, they strike poses, it goes online and grabs RSS news feeds and it will write bits of the news in the atrium. One of the other interesting things it does is each sphere itself is illuminated from within, so we can illuminate them in a certain fashion so that we can see an arrow shape, which is showing you that the market has gone up, what we do now is that now it can take off and become a physical arrow in space. So we still kind of play with it. All of our work is generative, it causes us trouble because we are in complete control of it, but at the same time if you're going to make a public artwork and it's going to live somewhere, generative systems are the most interesting things from our point of view, because they flow and generate, they create difference. I have heard every ball joke you can ever imagine!

"I would not believe anyone in the room who says they don't want a tail"

Anyway, so that's "The Source" and yes, it's been really great for us. I mean, it's been not so good for us in some ways as well, but it's now become an icon, not just for the London Stock Exchange but also for the City of London. If you were an accountant or a big accountancy firm, what do you put on the front of your prospectus really? Somebody

filling in a form or typing at a computer is not very interesting so they tend to use images of "The Source" now which is great. The upside is that, you know, if we want to be "Atriumworld" and hang things in your atrium, we're the people for you! If you do talks and you say how you're involved in public art and how it's always outside and then you show three installations in atria, you look a little bit stupid. I could talk about lots of atria work at the moment, you know, we are "Atriums R Us" at the moment! Anyway, so I just wanted to talk about "The Source" as that is perhaps Greyworld's best-known work.

More recently Greyworld has made a big bronze statue – "Monument to the Unknown Artist". I just told you we never do bronze statues – the client asked us for a something on a plinth, we thought, what would Greyworld do if we were going to do a bronze statue? This is what we did, it's a bronze statue. As you walk past he has a look at you and then he tries to copy the pose that you're in, before going back to being a bronze statue. He's actually a giant animatronic bronze figure outside the Tate, and a permanent work. The sculpture has five different plaques that are regularly changed. They're always in Latin; one said "Quid Latine Dictum Sit Altum Videtur" which translated means "Anything written in Latin sounds clever!" Which is good, we couldn't think of anything else so…

I shall briefly talk about this project, it is completely ridiculous this project. If anybody here tells me that they don't want a tail, I don't believe you! We've just made ourselves a couple of animatronic tails. Basically, the idea here is that it does absolutely everything that you'd want to do, but you're too ashamed to do: it'll pinch girls bums, it knocks beers off tables, it's just basically your naughty side. When we filmed the tail being worn in East London everyone in the video pretends to not notice the tail at all! They're all so god damn

IMAGE: greyworld's Tail (2008) visits Tesco. (c) greyworld

cool! The tail is fully controllable, it has about seven different modes. I want to make this into a product, a proper product, it's incredibly easy to read this as an emotional object, For example, I might pick up a magazine: "ah" I'm thinking "that's not very interesting" and down goes the tail, "not very interesting!" I turn the page, "Oh look at that she's much nicer" and Whoop! up comes the tail! I mean, suddenly you read these things, you read these things very, very quickly. We did an installation in Cambridge which is over now, which was six bins and six benches and you could whistle to them and they would come over to you. The idea was that you lived in a town square where, rather than them being in your area, you're in their area. It had issues, it had some problems but essentially it didn't take anything at all for people to start to emote with these objects. In the studio we had three chairs: imagine these two big chairs with really good motors in and the sensors and the microphones for detecting noise, you'd whistle to them and they'd come shooting straight over, and then we had a kind of rather crappy broken old chair with a tiny little broken leg and the motor that we found outside in the rain and the battery that wasn't very good and the wheel that was a bit broken, and of course, you'd whistle to it and that one would limp towards you. And of course the others would shoot straight over. Everybody wants to sit on the little chair! Everybody wants to sit on the little chair and it takes almost nothing at all to emote, to feel a love for these kind of inanimate objects and one of the things that Greyworld has done with its technology is hopefully to view these objects with a certain kind of charm and a certain creative opportunity. Thank you very much!

standing in front of him doing this, trying
to get him to copy you, no-one can see the
sculpture but they can see lots of people doing
these funny shapes with their body, which
is really lovely and you look down the street
and see them. I would argue with you slightly
and say, actually, the interaction is in the play
which isn't really being shown here, these
are just I'm really outlining the ideas and the
methods, when you're actually watching the
installations being used and manipulated they
tend to have a much wider, broader, spread
if you like. But you're right, in the end, like
I say, I suppose we are not just looking at
liminal spaces but we're framing liminal
spaces, so I suppose, really yes in some senses
we are doing what we're setting out to rail
against, but I think by pointing attention at
those spaces, it has a lovely side effect which
is an ability to create in those kind of zones.

http://hehe.org.free.fr/

HeHe

"I think I can say that we are artists"

IMAGE PREVIOUS PAGE: Bruit Rose (Pink Noise), photo by HeHe, 2004
IMAGE LEFT: Light Brix "93" edition number 6, photo by HeHe, 2006

Hello everybody. HeHe is two people, myself and Heiko Hansen. HeHe is a shortening of our two names. Since, at this symposium, everybody seems to be very interested in this question of categorisation, then, I think I can say that we are artists, although we have trained in design. Both Heiko and I trained at computer-related design at the Royal College of Art, and I had originally trained in something called technical arts design, which was a kind of experimental form of theatre design, and Heiko trained in design, as well as in mechanical engineering. So from this design-orientated background, we both have come to call ourselves artists as we feel like that offers a freer space in which to work, and also the economy in which we work is more of an artist economy, in that we work on a lot of projects that are self-initiated. We don't often work for a client brief.

Today I am going to present some of our recent work. In the biography, I noticed that we were defined as low-fi artists and that's another interesting question as to what might be high technology and what might be low technology – as we all know, tomorrow's low technology is today's high technology. I would say that many of the examples that we have seen at today's symposium are actually technologies that already

existed in the sixties, so it's just a question of how available and how democratically those technologies were available to us. The projects that I am going to talk about today all focus on the problem of pollution, which is one of the themes throughout our work. Our work is often about light in public space, transportation and also on the question of pollution. We use technology as a medium, but it's not really the technology that's interesting for us but more the ideas that we're trying to express.

The first project is called Pollstream, which comes from the two words "pollution" and "streaming". We gave it that title in 2002. I think I'd give it a different one now. It's a project that started during an artistic residency on Makrolab which is a project by Marko Pelijan. Makrolab is a mobile laboratory for artists and scientists to come together and work in isolation in a completely connected environment, where you could monitor 200 international cable TV channels, have high-band Internet access, and could listen to various AM frequencies, radio frequencies, all connected by satellite, but from within this very small, isolated community. During this residency we came up with this concept at that time called Pollstream, which was the idea of finding ways to materialise pollution.

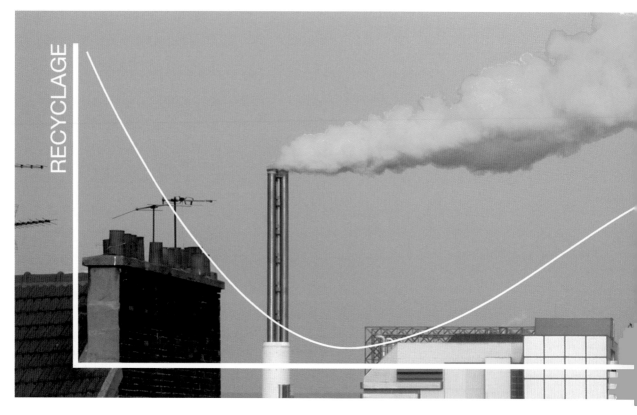

IMAGE: Pollstream, photomontage by HeHe, 2004

RECYCLAGE

"create more subjective entry points into this information"

Pollution in a way only exists for us as a kind of scientific model, measured using apparently objective monitoring techniques. We wanted to find ways to create more subjective entry points into this information, to materialise it. And since we had already done a lot of projects that were reactive in some form, for example using electronics, we were interested in the possibilities of how you can speed up the reaction that it takes between cause and effect, and how this might impact on the way we behave in our society. For example, we can smoke cigarettes for 40 years until it kills us, but suppose we reduce that reaction to one minute?

The other concept that interested us was the idea of making the ugly beautiful, so throughout the project we were looking at the visual metaphor of clouds as a lens through which to view the idea of pollution. In 2002, HeHe moved from the city limits of Paris to outside Paris in the suburbs, and we had a fantastic view out of our window onto an incinerator. We used to look at it each night and gaze at it as it was a very beautiful object because that cityscape was particularly flat and not much to look at, and this incinerator had this wonderful plume, this wonderful vapour, which would change direction with the wind and allowed us to tell the atmospheric pressure and see the direction of the wind and its speed. And so we would fantasise in the evening, about colouring it and that this beautiful thing should be somehow rewritten, turned into a sculpture. And then one evening, the direction of the wind changed and this vapour started coming towards

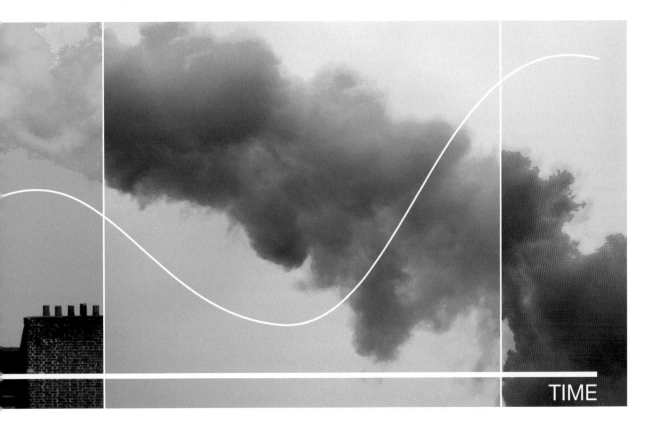

TIME

us. At this point we thought that this plume wasn't so beautiful and was pretty terrifying, so we connected ourselves to the Internet to find out what they were burning and what was in this cloud. We discovered that it was a household waste incinerator, so everything that we threw into our bin was being burnt in this incinerator. At that time, we didn't recycle very much.

We became interested in this role that we had as residents close by to this factory, and how we could implicate our role using this smoke. Originally we wanted to colour the smoke to show the level of recycling by the local residents who lived nearby, including ourselves, so the idea would be that the more we recycle it would go to green, or as we recycle less it would go to red. After a few telephone calls to find out how we could throw tracing dyes into the incinerator, we discovered that this wasn't a very sustainable

solution – because it would leave a coloured fall out on the surrounding houses, which could be very beautiful, but it would be much harder to convince the local residents to participate in the project. One of the main challenges of this project was always that we wanted to work with the factory, we wanted to persuade them to do this project with us. But of course, the last thing a factory wants to do is to highlight their emissions – since this is always perceived as the ultimate icon of pollution. We did eventually write to the power plant in Saint-Ouen, we wrote them a very long letter. We worked very hard, writing the proposal in French, explaining all the reasons why it would be very interesting for them to participate in such a project. We received a letter saying I'm sorry, we think your idea is very creative – which is always a bad sign; if someone calls you creative then you've really got to start worrying – but this

doesn't fit into our communication strategy.

So, the project was put on hold until 2005 when we went to Helsinki. We were invited to do an artist in residency by Pixelache festival, and to develop Nuage Vert. It was very difficult because we arrived in a new city with a very large-scale project proposal and were not at all sure how to realise it. We arrived and discovered these two wonderful power plants in the city centre. We entered into a negotiation process with the power plant owner, which was to last another three years. The factory burns coal to produce electricity and heat energy, so it's a combined heat and power plant. By this time, we were working on solutions using laser technology to project colour onto the cloud vapour and a system to track the form of the cloud. The aesthetics of the traced outline and the tracking of the cloud was very important to us – which would be a totally utopian goal; to try to track the form of a cloud. So meanwhile, whilst we were negotiating with Helsinki Energy – it was a very long process – we also entered into other discussions to develop the project in Dunkirk in the north of France, which is a heavy industrial zone. The city of Dunkirk was very, very interested in the project and willing to support us on the condition that we got the agreement from the factory owner. The company we were trying to convince was Arcellor-Mittal – the largest steel maker in Europe – and steel is a product which is consumed not locally but globally. Obviously that fact changes completely the nature of the project, so for this site we were proposing to show the actual air condition, locally, through the cloud. We were not able to convince Arcellor-Mittal to do this. But nevertheless, this process helped us eventually, as it speeded up the process in Helsinki.

Whilst we were working on Nuage Vert, it being a large-scale project which took many years to complete, we were also thinking about how we could translate this project into a much smaller scale, and so what would be our personal

smoking emissions, so obviously, we began thinking in terms of cigarettes. We decided to make a lamp that changes colour when it detects cigarette smoke. To do this we had to engineer our own system for detecting smoke. We started by taking apart a standard smoke detector, but obviously our application was quite different because we were making a lamp and we wanted to change the colour of the ring from white to red. We wanted to illuminate the smoker, their smoke, and to create a situation where there's a debate about the right and the opportunity to smoke in public places. Without taking a position, without saying this is for smoking or against smoking it could be an alarm, to say you've transgressed the code, or it could also be an invitation to smoke.

It was shown in lots of different places and in a way, we wanted to get back to this moment in time – which is what we call reverse cultural engineering – which is returning to a former state of culture; when for example tobacco was introduced in Britain by Sir Walter Raleigh. Smoking was a totally unknown activity and the phenomenon of smoke was such a strange spectacle, so we wanted to go back to looking at the culture of the phenomenon itself, and precisely at this moment, when there is a European-wide ban on smoking in public spaces. So we showed it… in one case on 30th June 2007 at Gunpowder Park in Essex on the last day before the smoking ban was implemented in the UK. The event was the 2nd International Artists Airshow, it was in a woodland area, so we had to protect it, as electronic objects don't really like the rain too much, we had to build a little canopy for it. So when people came under the canopy they were asking, is this an enclosed space or is this an open space? We created a debate about that situation and someone who hadn't smoked for 20 years suddenly said, "oh go on, I'll have a puff". So it was a kind of social event. What's interesting for us is how the meaning of smoking changes over time, in that in the 19th century people like Lola Montez

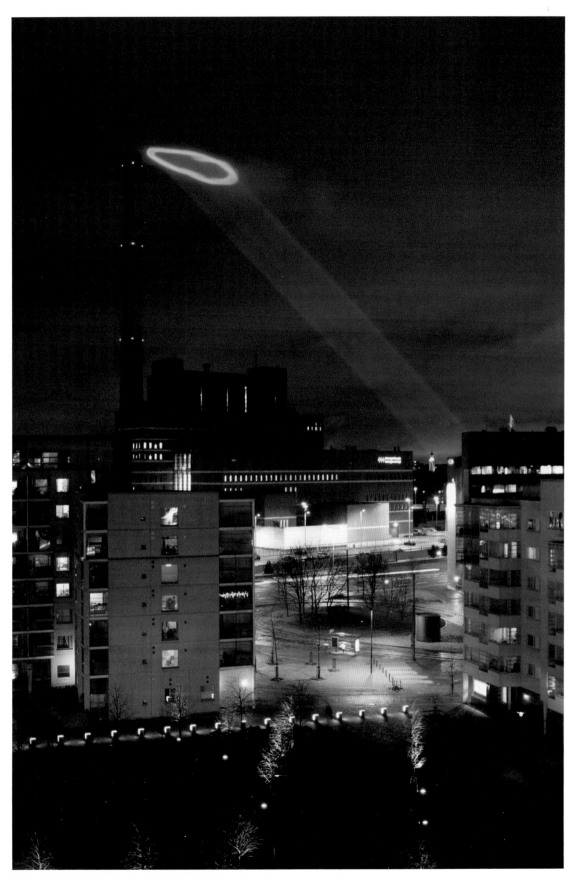

IMAGE: Nuage Vert (Green Cloud), photo by Antti Ahonen, 2008

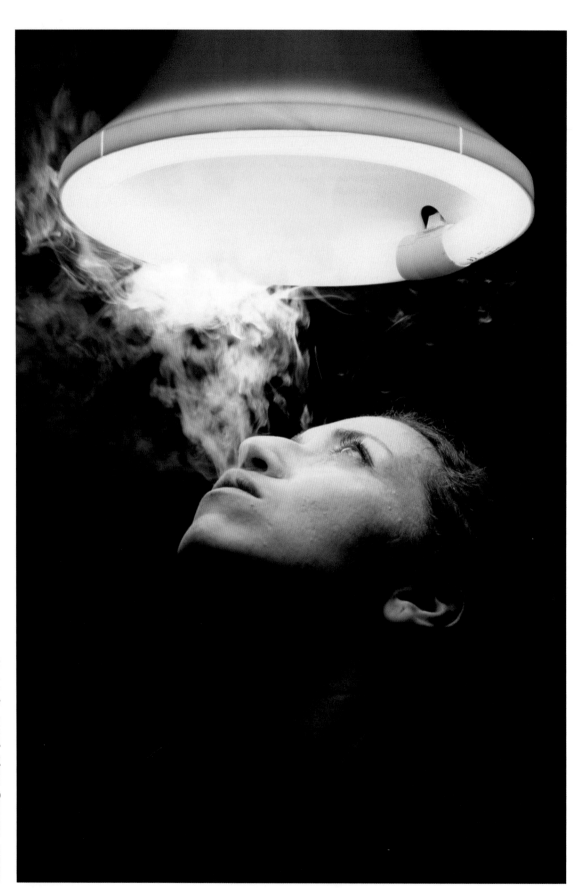

IMAGE: Smoking Lamp, photo by HeHe, 2006

or Georges Sand were using smoking as an expression of their liberation, as free women, or the revolutionary status of smoking in Prussia in the early 19th century during the democratic rebellion, or even the last culture to ban smoking in public spaces was actually the Nazi regime in Germany. So it's very interesting the way the cultural meaning of smoking changes over the time and what it will come to mean in the future.

Another project that we created was a site-specific installation called Champs d'Ozone (Ozone fields), that was realised in 2007 in the Centre Georges Pompidou in Paris in an exhibition called Airs de Paris, which was a show about how city life in Paris was evolving. We created an installation which reacts to the current air quality in Paris by installing sensors in Les Halles that measure ozone levels that are updated to the website of Airparif, which is the non-governmental but state-sponsored organisation for monitoring air quality in the Paris region. We worked with them to understand issues based around air quality in Paris, and used their data as a live feed to determine the colour of our artificial cloud. An installation was installed on the 6th floor of the Pompidou centre and if you've ever been there you will know it's a fantastic view out of the windows onto the city. The installation uses that view so you can see the real city in front of you, and then there's an aquarium box where above the horizon you have this floating cloud which is a computer-generated video projection, but there's a filter so that you can't see the real sky. So the result is that you see this artificial sky, superimposed on the real city. So the higher the level of pollutants, the indication will go up to red, and if it's a very good day it will go down to blue, so there's a colour scale, which is also used by Airparif on their website. It's just that we think there is a problem in mapping and cartography, in that there's always a very distant scientific pointed view, very objective, and what we wanted to do was to put the map into the sky that related directly to the information. So you see the city through its pollution.

In February 2008 this year, we finally managed to realise Nuage Vert in Helsinki, which was a very complex project because, well, for many reasons, most notably as I already mentioned, the problem of convincing the factory to participate. To realise the project we had to work with many different stakeholders in the city. We worked with a group of environmental activists alongside the people who operated the factory and that was a very interesting process because there was a lot of tension between these two particular groups. Also we were very concerned that the project should not be instrumentalised by either of these parties, that it should remain an artwork that was apart. We also worked with a governmental advisory agency for energy efficiency and we had to raise funds from the city of Helsinki and from the Ministry of Culture in France. We worked also with Sydväst School, a polytechnic in Helsinki with a department of cultural management, so these students helped us in many ways including developing slogans for the project. And of course, there was Pixelache, the festival in Helsinki, which is curated by Juha Huuskonen and produced by Nathalie Aubret, who devoted enormous amounts of time and resources in order to make this project happen. So that's just a few of the partners in this project.

Of course, it was very important for us to engage the local community in the project. We had to design a communication campaign to understand and interest them in what was going to happen in the skyline of Helsinki. We developed a poster and a flyer. The flyer said, "Is it the northern lights of Helsinki?" We had a little sticker, in the form of a little green heart, that was distributed to 4,000 homes in the local area. So these stickers invited people to unplug, to unplug their home from the factory on the Friday night between 7 and 8 o'clock and to come out onto the streets and to watch the green clouds grow. And that's quite a big thing in Helsinki when it's very, very cold at night. There was also a debate organised in the French Cultural Centre, there were visits to the factory, there were also

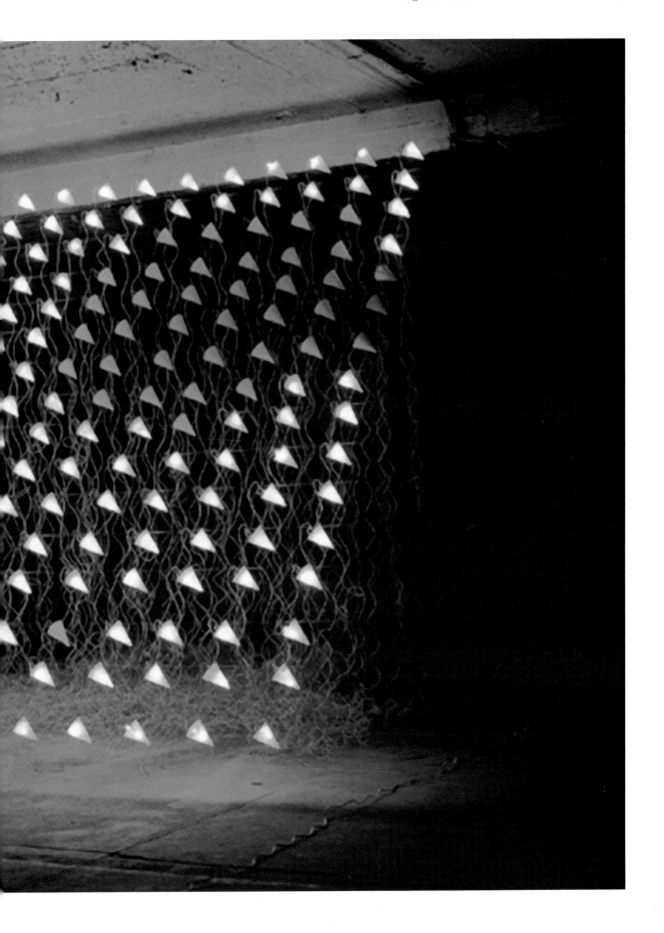

presentations by environmental activists in local schools to engage the children. It was interesting because the first question that all the children would ask was, "so how much energy does the laser consume?" which is a very good question. So I shall tell you the answer: it consumes 8 watts, which is less than a household light bulb, but in terms of lasers it's extremely high-power.

"To realise the project we had to work with many, many different stakeholders"

It was very difficult to source a laser for this project, it's actually a medical laser. If you put your hand in front of it, it would burn your hand, so to install this in public space is complicated. There's a lot of inspections that have to be made from the nuclear and radiation safety authority of Finland. We also needed authorisation from the aviation authorities in Finland. The design of the system to track the cloud was complex, in that we had to use an expensive thermal graphic video camera which detects heat, but even that's not easy because when there's a kind of warm mist coming in, then even for this camera it's quite difficult to detect. We also had to develop a tracking system, a custom-built interface that enabled us to then scale our graphical, vector image onto the real cloud, a scanning system, a very fast high resolution scanning system, using X Y mirrors to be able to make the image in the sky. To develop this laser system, we worked with Esa Räikkönen, a doctoral student at the technical University of Helsinki, who was wonderful in helping us to integrate this high power laser together with our system. We also collaborated with Joey Hagedorn, a student at the University of Illinois who wrote a Processing driver, so that anybody can now control a laser in real time using Processing. Before this project, this wasn't possible.

The other thing that was very interesting for us was that this was the first time that local information about energy consumption had been made public. Before this project, this information was there, it always existed within the information networks of private companies, but had never been made public at any time. So this local consumption data was also published in real time on the nuagevert.org blog. Of course, looking at the green cloud, it would be very difficult to tell what the actual consumption was. That was also the goal of the project, it is ultimately unattainable, a fantasy to ask people to read the image on the cloud.

Q&A

Q It seems that you've reached the main goal of the project with Nuage Vert. Are you planning to develop it elsewhere?

A Yes. Lots of people ask us, can we do Nuage here, can we do Nuage there? And it's a very, very difficult project to realise for technical and political reasons. So yes, we do want to realise it again, but at the moment, we're trying to go back to Paris and to realise it next year in May. We hope that this happens. There are many factors that could mean it won't happen. But we will also continue with the theme of transportation as well.

Q I was just wondering, the earlier project where I think it was in Paris, showing the city, is that one that you can easily reproduce?

A So long as there's a view of the city. Yes. So long as there's a view of the city. That's always the problem. You get a gallery space which doesn't have a view. You have to have a high point where you can see. Then, in that case it's reproducible. Most cities do have air monitoring nowadays.

Q Did you observe any results from the pollution project? Did people become more aware of environmental issues?

A Yes. For the unplugged moment we had a reduction of energy by 800 MVA, which is a considerable reduction given that we could only communicate with 4,000 homes and yet the data that was isolated was actually for another 10,000 homes that we didn't have the budget to talk to. So that's quite a good reduction. It is the equivalent of one windmill running for one hour. It created a big debate in the city and it received a lot of attention, it

coincided with a public discussion, in the Helsinki Sanomat, which is an important local paper, about CO_2 emissions in Helsinki and the problem of reducing CO_2 emissions and the problem of meeting the European objective to have 20 per cent of our energy sources from renewable resources, by 2020. This objective is absolutely impossible if demand is increasing at the rate it's increasing. On the nuagevert blog there is a graph that shows how consumption is increasing: so from 2004 to 2008, consumption in Helsinki grew from 30 MVA to 40 MVA. So if consumption keeps on rising at this rate, it's impossible to reach those goals.

Q Yes. I was going to go back to the point about how you managed to assemble such a team, you actually got a programmer living in the States and so on. Are you the centre of a large network of people you regularly work with, or is it much more ad hoc?

A No. The core of this project was really realised by four people, which was Heiko, myself, Natalie and Juha. They were the four, well, plus two students, who were also helping with production issues. Juha did a lot for the programming but that's not how it often happens with us. In this case, it happened that we would make the first initial prototypes, which would work, be a bit rough around the edges, and Juha then helped us to build some nice refined tools because it was happening at a time when we were too busy on other things because the project was just too big, when the software was at that stage there were so many other issues that needed to be resolved. There were so many people involved in this project it's impossible to… I don't know… It's like 50 people who did something and everybody is giving their energy for free basically, so it was something that was like a

real... like a machine that at some point... we didn't get any agreement from the company until November, but we had started working on it much earlier, even over the summer we were working on it. And then we came to Helsinki in September, we came again in October, we came in November, and then in November we got the official agreement. But we had already raised a lot of funds and took the risk and said – to ourselves – it's going to happen. We'll get the rest somehow. But the company could have said "no" and then we would have been in trouble.

Q And was that a major part of the learning process?

A That's how we learned along the way. I think when we first had the idea we didn't know how to realise it because we didn't know how to play the politics of it. We had one person inside the factory who was personally supporting the project even though his company wasn't. And so he would advise us and say, well if you can get the aviation authority to say this was possible, that would help. So we would go off and we'd do that. And then, okay, so maybe get Motiva, the governmental agency for energy efficiency. So we had a meeting with Motiva, and Motiva loved the project, they supported it, no question. They can't give us any money, but it doesn't matter. They're on the list of partners and that has a weight. So we had to learn this process so I think next time it will be much easier, but it's still quite tough.

Q You described yourself as artists. You're not the kind of artists who sell paintings to someone who puts it on the wall, so how do you fund yourself? How do you make your money?

A I think Marcel Duchamp said something like... it's not a matter of... it's a question of how much money do you need to live, and then you live on that. If you choose to do your own creative projects and you're prepared to not go out and buy the next cool product. You kind of have an existence where you're not so much interested in consumption but more interested in production, so your resources go into production. But I mean, we don't... I mean somehow... Nuage for example, was financially disastrous, except actually now that we've won two prizes for it, so fortunately it paid off, but we didn't know that was going to happen.

Q Would you like to be more financially successful?

A: Yes, sure, great but I mean... but I mean without compromise... the question is how far you are prepared to go. We still want to make work that interests us. Our problem is that work that interests us is often work which is very ephemeral in public spaces so, in fact we need commissions, and they don't fall out the sky too often.

IMAGE: NUAGE VERT (Green Cloud), photo by Niklas Sjöblom, 2008

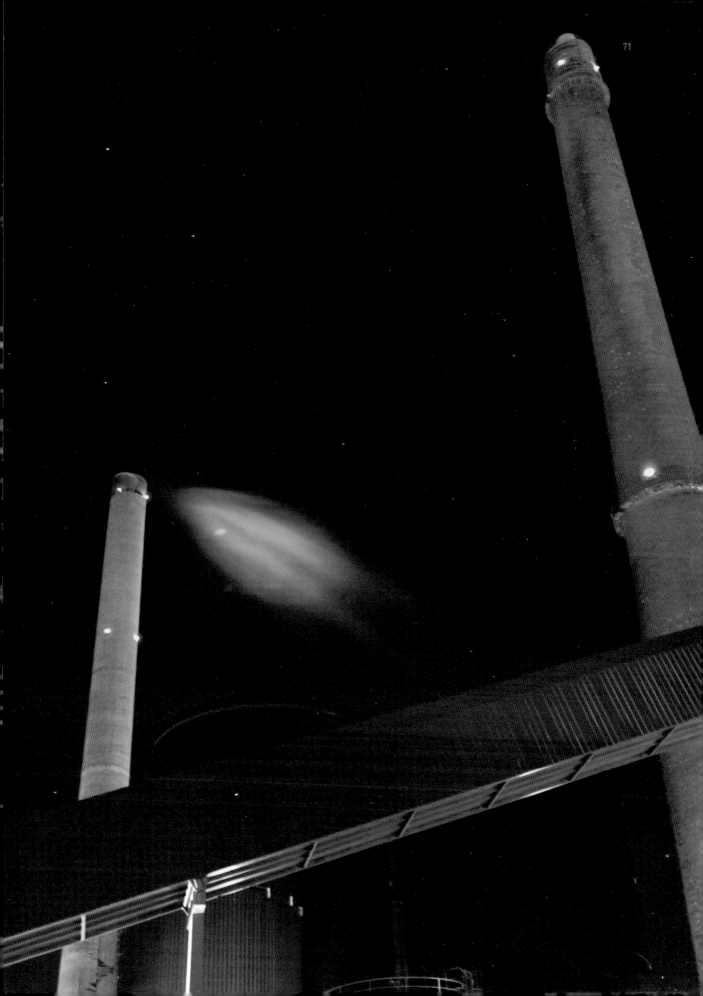

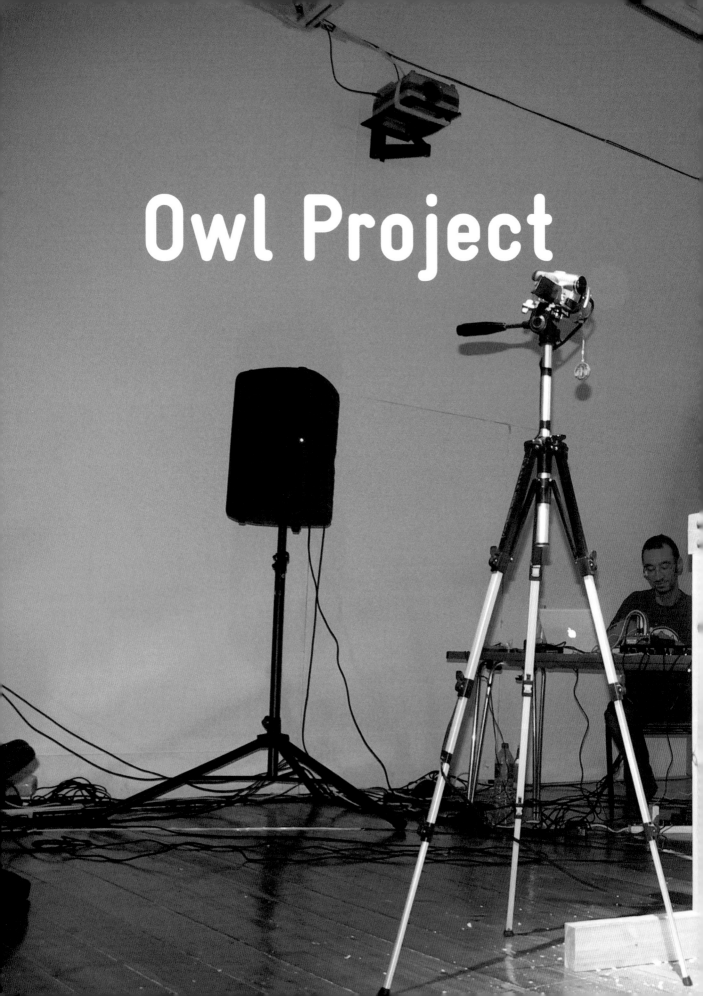

Owl Project

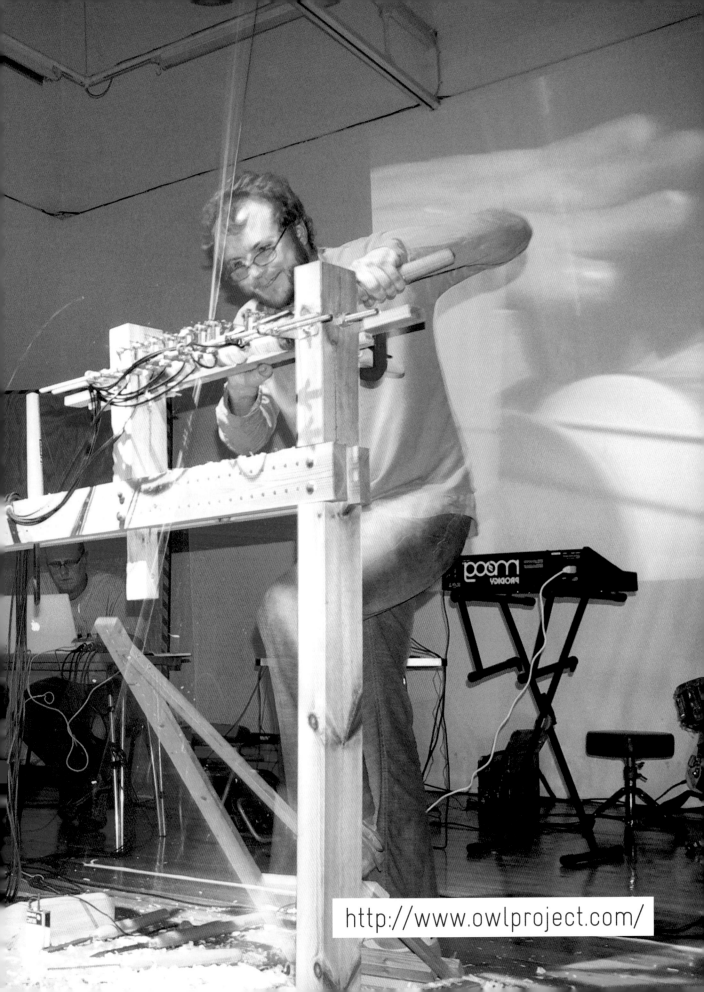

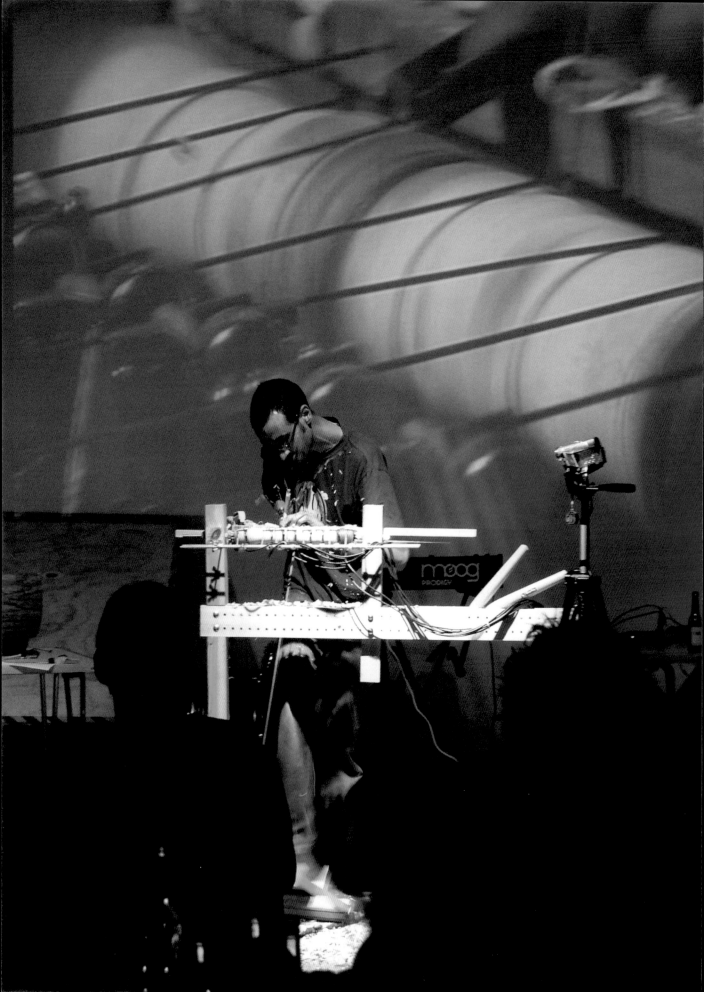

Owl Project

"Owl Project exists in this kind of strange zone where we make technology that's desirable, but then there's not very much of it because it's really hard to make and no-one can really buy it."

Simon Blackmore

Hello. I can't believe I'm stood here in front of a log after such amazing talks. I've not been to a conference with quite so many extraordinary works and ideas. My name is Simon and I'm from Owl Project and there are three of us, Steve, Antony and myself. We all come from slightly different backgrounds: mine is quite similar to Steve's, I graduated from a fine art degree back 1999, and then I did a computing MA. Antony who is not here today, took a similar route.

I'm going to just start with the Logık which is quite a few years old now. I had just done an MA in Creative Technology and had studied lots of different interactive software. I had got really excited about learning computing and then I came out of the MA and I just kind of... I don't know, I have a really funny relationship with technology where sometimes I love it and then I just look at it all think, "oh God if I see another thing just interacting with something else, it will drive me mad". No disrespect to anyone's work because that's what I do, it's just what is this technology that we're dealing with and why do we need it? So Owl Project exists in this kind of strange zone where we make technology that's desirable, but then there's not very much

of it because it's really hard to make and no-one can really buy it.

The Logık in particular came out around 2001 when there were a lot of laptop performers and you would always see them standing, ironically in front of a laptop just like mine, just doing their stuff. We had a love for the music and excitement about it, but also a strange repulsion of thinking I'm going to have to buy an Apple computer to be creative. There is a culture of technology being sold as something that will make you somehow imbued with creativity and so from that point we started making these limited systems that we tried to be expressive with. I'm going to show you a video of the first Logık performance. This was back in 2001. You will notice that we are nodding our heads out of time, this is because we had two laptops, or two log laptops and we didn't manage to get them synchronised so they were playing cross rhythms.

A key feature? Well ironically we managed to sort it out through more technology later with stepper motors and I think that the Logık music went a bit downhill after that. Many of the sounds generated by the Logık were from the hum of the lights that lit up the display.

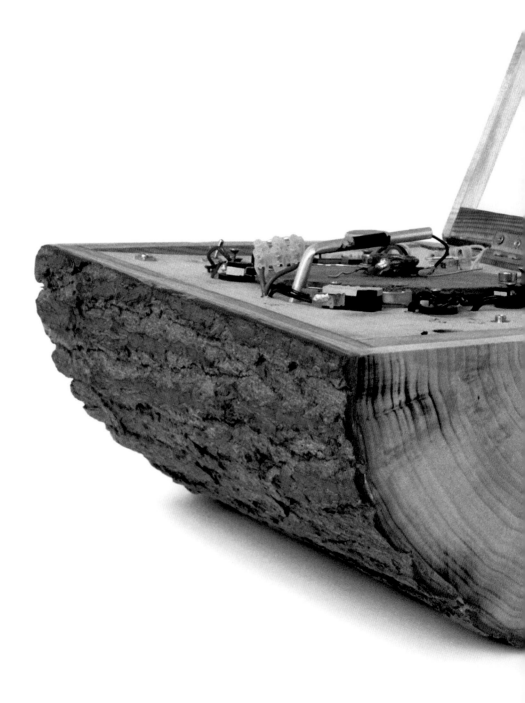

Actually 240 volt lights that put this huge hum through the PA. Actually when we made these we didn't know anything about electronics. We would do things like connect the jack to a switch with just a battery and when it's switched, it sent a voltage straight to the PA. At one point we did a performance in a working man's club and managed to set the speakers on fire. I don't know what we did, but I think the logs kind of moved the speakers too much.

"I guess we've really worked on the margins because obviously this music is not going to get us into the charts"

Basically we had this kind of perverse musical direction, while everyone else seemed to be learning how to use Max MSP to create generative music software, we were trying to make the music they were making just on our logs. The inside of one of our logs looks like a Max patch or something. I guess we have really worked on the margins because obviously this music is not going to get us into the charts, but interestingly we also work on the margins of woodworking as well. I think I might stop it here and move on to Steve. If you imagine this as a kind of "out there" electronic music, Steve is going to talk about working in the "out there" regions of woodworking.

Steve Symons
I joined Owl Project four years ago. I started with the Sound Lathe Project, which is an exploration of the way craft changes and the way industrial processes have changed. The Sound Lathe is a traditional pole lathe. Originally people used pole lathes to produce wooden bowls and they were always happy with their wooden bowls, and wooden bowls would be made close to the village where they were used, so there was a very decentralised industry of

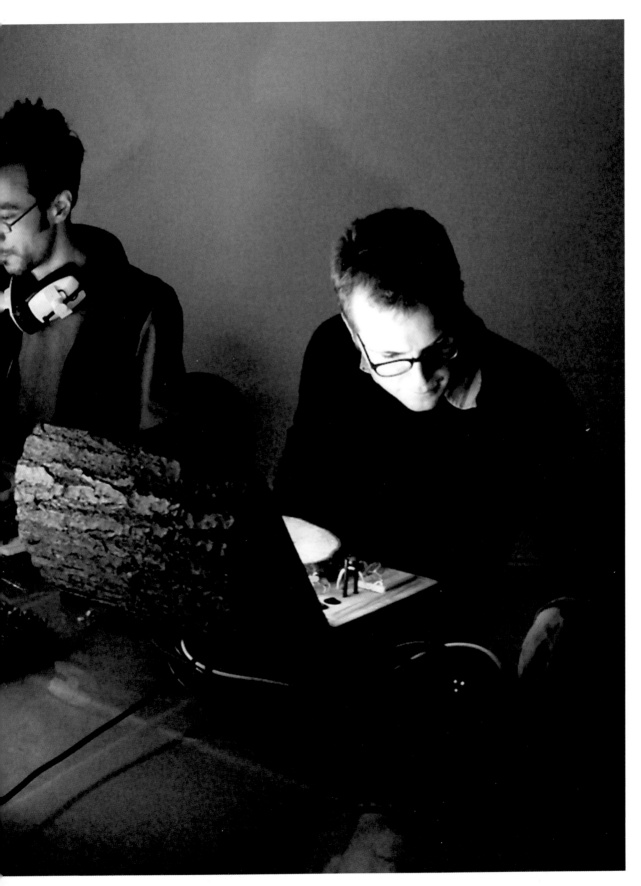

IMAGE: Owl Project, Logik, Hull Time Based Arts, 2002

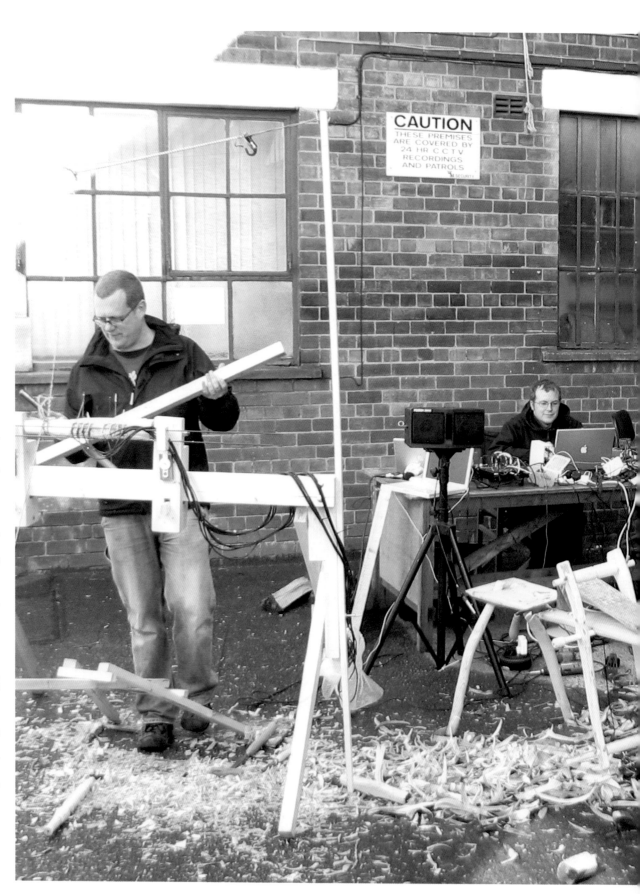

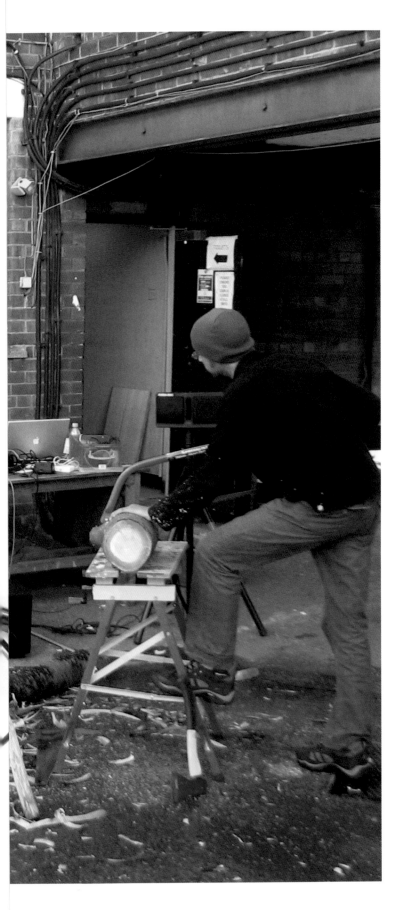

people up and down the country, using a lathe to make wooden bowls, trading them and using them locally.

At the same time you could buy porcelain pottery, but it was very expensive, because at the time the kiln furniture was simple, well to make some porcelain you had to fire your plates on the floor and you couldn't stack them up, so there was no mass production. Then someone had the clever idea of putting little bits of wood in between the plates, so they could stack up lots of plates, whereas before they could just make one set of plates from each firing, they could suddenly make hundreds and the price of porcelain just collapsed and everyone could buy this product which people had wanted for a long time, but hadn't been able to afford. So the wooden-bowl-making industry, which had been employing people for centuries, just over a few years, completely disappeared... so what happened to the bowl turners, they became Northern European spindle turners or handle makers for axes and knives, or spindles for the backs of chairs.

The Sound Lathe is a traditional pole lathe which is driven by an up and down cord and a foot treadle. We collaborated with Mike Abbott, one of the UK leading pole lathers actually, who has written a couple of books and is responsible for re-emergence of pole lathing in the country.

Simon
Mike is probably like the Brian Eno of the pole lathe.

Steve
So first of all you have to get your wood ready before you can turn it. This is Mike Abbott's workshop where you can do wood working courses in poling. We worked with Mike at Edale in the Peak District not last summer, the summer before.

Simon

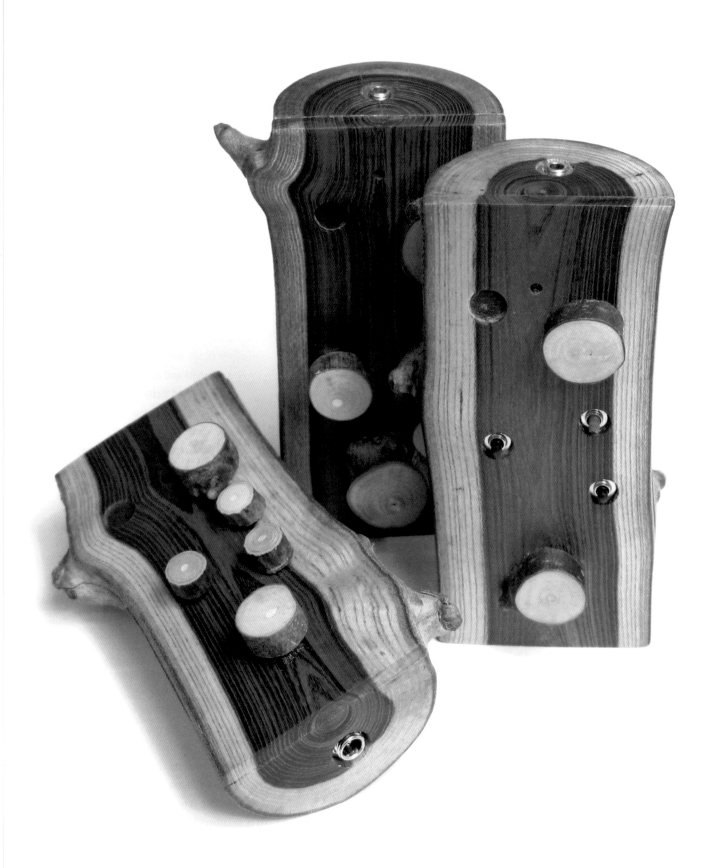

were doing with this tradition, this centuries-old tradition and of course we had to get him on the lathe, actually we had to slow him down, he was itching to have a go and make some noise. It was a very nice way to finish a week of hard work, meeting Marco there.

Steve

Now we are going to talk about the iLogs. We are interested in mobile phones. They are desirable, the way you interact with them in particular, but it's soulless in some ways, so we like this idea of housing our stuff in wood. We have built sound systems which make different sounds, for example a "rustle" sound.

Simon

The iLog is our competitor to the iPod. The iLog stores twenty seconds of audio, you can take the power away and plug it back in and it's still there. The buttons... well we've improved them a bit now, as no-one could really tell the difference between the one you turn and one you push, so they get pulled off occasionally so now only turning ones are wood. The functions it has are better than the iPod, we think, for live performances you can grab a sample really quickly and then you can slow it down. The "rustle" has a really nice feature where you can go back into the recording and get old samples out, by taking the voltage away from the recorder.

Steve

Another option of the iLog is the desk top version... the stump, that is based on the idea of sawing, so you create the power which allows you to make noise. The final iLog that we will talk about today is the one that turns light into sound, it picks up on frequencies. This is reproduced in real time with a small PIC. The symposium environment here today with the talks from designers is a bit strange, we are usually working towards some form of performance.

We all make instruments in our own particular way, generally there is a sound we are aiming for and in Antony's case, a process that he is interested in. I'm more interested in the actual act of interaction and the action you're doing and what that means sonically so hence the sawing. We also have another series which is a thing called an mLog which is a USB version which you can plug into audio-making software.

IMAGE: Owl Project, iLog Rustles, 2006

Q&A

Q Two questions, if you have a period in terms of furniture or performance what would create your favourite sounds, so would it be rock or would it be in terms of the wave forms and secondly, what's your favourite wood to use?

Simon The carving of the shapes is quite an interesting one. When we worked with Mike Abbott, we were really excited to work with a guy who can do loads of really nice curves and stuff but he says that he doesn't really do curves.

Steve Got to be straight like this.

Simon Yes he's like coming across saying "I'm not really into that decoration type of thing".

Steve A real battle to get him to build up and then do the full dimple. But in terms of our own carving skills we just do interesting shapes and as for wood, laburnum, apart from the fact that we have to be masked up to work with it as it's poisonous, or cherry.

Q When's your first album coming out?

Steve We're still working on the way to etch it into the wood. Bit problematic at the moment.

Q Have you got an Edinburgh printing shield?

Steve No I'm afraid not no, but perhaps we should.

Q I would probably buy one of your iLogs if you got it up to maybe forty seconds just twenty seconds isn't enough.

Steve We do have an iLog Pro under production.

Simon I want to know what you would do with the extra twenty seconds?

Steve Or you could just slow down half, there's your forty seconds…

Simon Any other questions?

Q How often when you're producing an instrument and you've obviously got a process in mind at the start of that, how often do you get to the end of that process and go, oh I don't like how that sounds, I'm going to do it differently?

Simon Our design approach has an evolution, I think the concept of making music with a lathe is almost flawed from the beginning. We had this idea that it could be amazing and it always is a bit, just weird, and I think that is interesting, so it's exciting. You have the liveness of the beat and it's like, oh well this is really good and then you listen back to it and the beats are all over the place.

Steve It's improvised anyway, but yes, it is a cyclic process. First you make your instrument and then you have got to learn to play it, then you perform with it, and then you develop it. For example this is a log I can feed audio into and audio comes out and acts as a resonance chamber, it's got some contact microphones inside. This was an idea about trying to make something more organic. I drop things on here and actually cutting and sawing this as well and it will eventually get cut in half. It's an ongoing sound instrument and that dialogue is just an ongoing process.

Q I noticed in the fist clip you showed you were wearing balaclavas – is that significant in any way?

Simon That goes back to art school. The whole Owl Project thing came out of when we were at college in Cardiff and we used to go out and light fires all the time, as you do. Not in public spaces but in Cardiff you could go out into hills quite easily, which I have to say I'm a bit more nervous about doing in Manchester somehow. One night we were just by a fire and we had a little sampler with us and we sat recording the sound of owls and then we got surrounded by them, just amazing just playing the twit twoo sound back to them and one of them just flew over us. I don't know, the balaclavas, that's an interesting one: I think it was because of poaching, we were kind of into the idea of guys poaching owls, I don't know.

Steve We stopped wearing the balaclavas but the costume debate does go on occasionally.

Simon We've got very nice t-shirts with OP on the back.

Steve Yes but we should probably get back to balaclavas.

Jason Bruges Studio

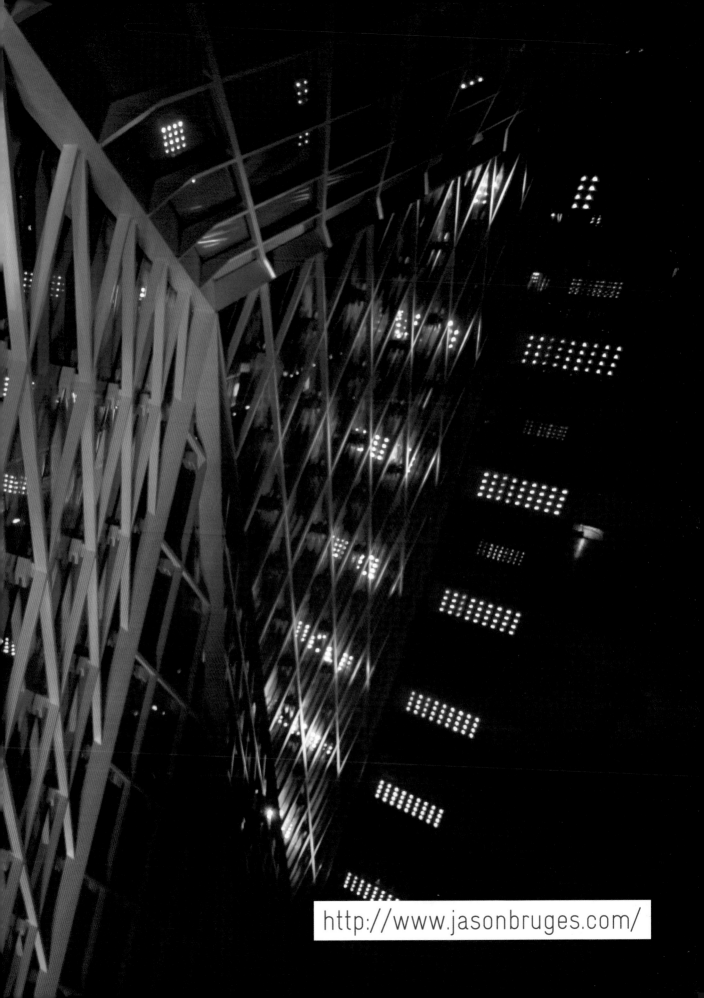

Jason Bruges Studio

"We are very much hands on - it's all very much about building things"

My name is Jason Bruges and I am going to talk about the current practice of the studio which I officially set up in 2002. I am going to discuss a question that has been touched on by a number of speakers at the symposium, specifically what do people working in this field call themselves? Should this be something that takes time out of your day to really think about and if we don't will we continually get pigeonholed? Personally, I don't know which category I am in. I trained as an architect, I worked as an architect, based in Hong Kong and London, also as an interaction designer at an agency, working on interaction environments, spatial experience with environments and I have always been interested in architecture, ephemeral architecture that can change opportunities, but really when starting the studio the question was what to call yourself, in order to get that work and how to get those commissions. To me the work is the same, it is the same process, for me the same outcome, whether it's a stand alone artwork in the gallery, right through to an intervention in a public space, or a collaboration with an architect, or a limited edition piece, or even a piece of consultation. Each kind of work can be represented in many different guises.

The practice is based in London, currently with a team of sixteen people. I bring in work and creatively direct, but it's very much a team effort and there is a mixture of architects, industrial designers, interaction designers, lighting designers, mechanical engineers, so a real mixture of people. We are very much hands on – it's all very much about building things, testing things and prototyping and certainly a lot of work is ephemeral, so it is about testing things and people, seeing them in reality, not just talking about them but actually showing clients them.

An example of our work is a cold cathode matrix we are proposing for a museum in New York, which reacts to traffic and pedestrian flow; another is a grid of air-controlled devices that we've just installed in Guangzhou, China. The work has been really varied: Litmus was one of the first pieces that we actually built, it took about three years to get to the point where we actually built something and that's the problem with working in the built world, things take a long time. The piece was a commission from Havering Borough Council, in the very east of London, it was for a series of wayfinding devices, land marks, artworks, very hybrid, a series of totems that responded to the

environment in different ways. One showed the changing light levels, another looked at tidal levels and a third counted cars. For example, there is one that actually picks up the Ecotricity wind turbine in Dagenham dock and displays kilowatt hours as a read out. They are all abstract although scientifically very accurate, but it's about making people engage with their environment and explore it, talk about it. People will go past wondering whether this is some kind of elaborate speed camera.

The work that I have described so far is very much stand alone. It's been work that's come through the public realm and under the guise of public art, but I see it as being more wide ranging. Then we have also had the opportunities to work with quite a few different architects, for example we have worked with Kathryn Findlay on a piece called Memory Wall

for the interior of a hotel. It was an interesting project as different architects designed each floor. The idea was to create spaces that continually change, a textural dynamic. In a similar way to the work of Moritz Waldemeyer, this space responds to the colour of clothes that people are wearing. It was something that was embedded, built into the wall, but we delivered as an artwork shipped whole to Spain in numerous crates.

The projects that are undertaken within the studio range from the very small to the very large. On a current project we are working with the University of Southampton, which is quite interesting, people go where is it, what size is it? This is a product we can't even see, we have to put it under our special laser microscope to actually be able to even see it. It's in the foyer of the new Nano Technology Department at

Southampton University. We are creating a whole series of silicon wafers that create light patterns. An interactive nano surface, which will interact with people in the lobby and then enlarging and magnifying the output from the microscope up on to a wall in the atrium. It resolves itself as wonderful fraction patterns.

At a much larger scale there is a project that is looking at lift activity and building activity and playing that back out through the external facades. This is a study for a tower in Moscow and taking on board the building activity, being a contributor to the aesthetic and the style of architecture. These pieces have different life spans, in another case we created a series of imaginary environments for the BBC, a series of light environments where they imagine where the DJs play from, rather than the basements of the BBC. These lasted for three minutes before

we had to take them down, it's filmed in one shoot, so it's very, very, ephemeral.

Occasionally we get ridiculous briefs from clients asking us for projects that last a longer period of time, for example we finished one this summer in Leicester, which is quite an interesting project. The brief was about disguising a surface, a great big concrete billboard which was essentially a left over part of a multi-story car park – a new shopping centre is adjacent to the car park and it has left a large surface exposed. The city council doesn't know what to do with it, so we started looking at mirages and how they blur horizontal edges, it's very much about blending colours and geometry across the leading horizontal edge and in this project we are using thermal mapping of the shoppers below and mirroring it onto the surface above which is constructed

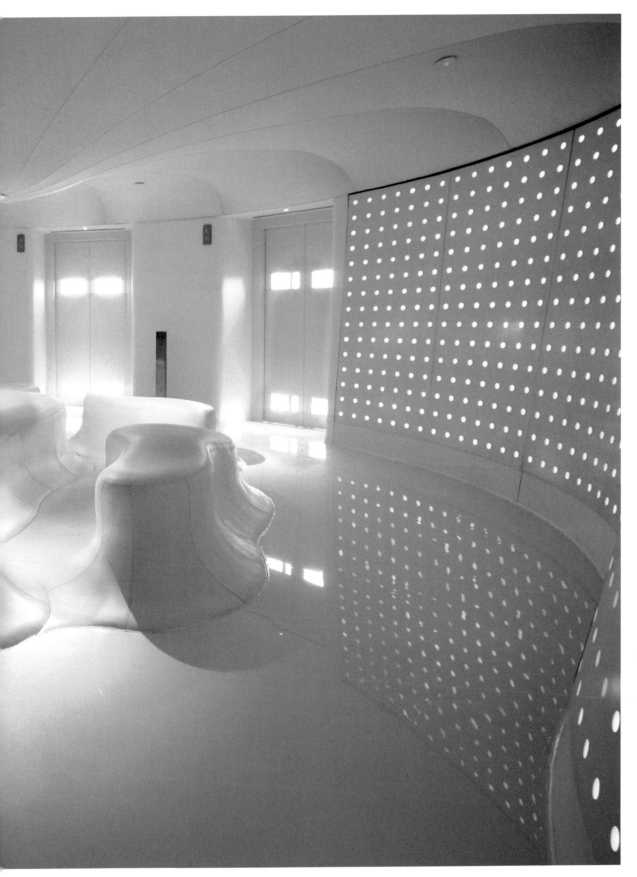

IMAGE: Memory Wall, Hotel Puerta America, Madrid, Spain, 2005 © Jason Bruges Studio

from diachroic discs. The discs rotate in order to change colour, like "glazed pixels". The colours are determined by the manufacturing process and the whole composition is determined by each observer's location. They are driven by a pulsed stepper motor at the back that runs through the concrete wall so each disc is easy to access. The client wants this to last for 50 years, so we are making sure it is all very, very serviceable. Obviously there are millions of shoppers a year going under this piece and there is nothing between them and the piece. Public liability is not enough to allow one of these to drop off, so we have had to get all sorts of safety accreditation. We have had tests ranging from shotgun tests to full cans of coke being thrown at them across the studio, good fun, but very important.

Also in Leicester we have been working on some traffic interactives, a series entitled Leicester Lights that consists of lamp posts that are sited through the centre of Leicester and that respond to the traffic flow. This project started with a brief from the council looking at processions through Leicester. Then I found out there were only two processions a year. So we started to look at the everyday, how cars and people move within streetscape. The lights are bolted on like parasites and the larger ones, which are like gateways, have a colour sensor. There are two types of colour sensors: one for day, one for night; one reads daylight reading actual daylight colour, the other one is balanced against the characteristics of the lamp gear, so you get the right colours.

The next project that I want to talk about is entitled Pixel Cloud and is sited in the north atrium of a building in Spitalfields and you do get these curious spaces, where you are asked to hang something, the final piece is a curious sight against all the lawyers working in the space. We work in the public realm quite a lot, so to have something that is very new, that lots of people want to go and see, is very interesting.

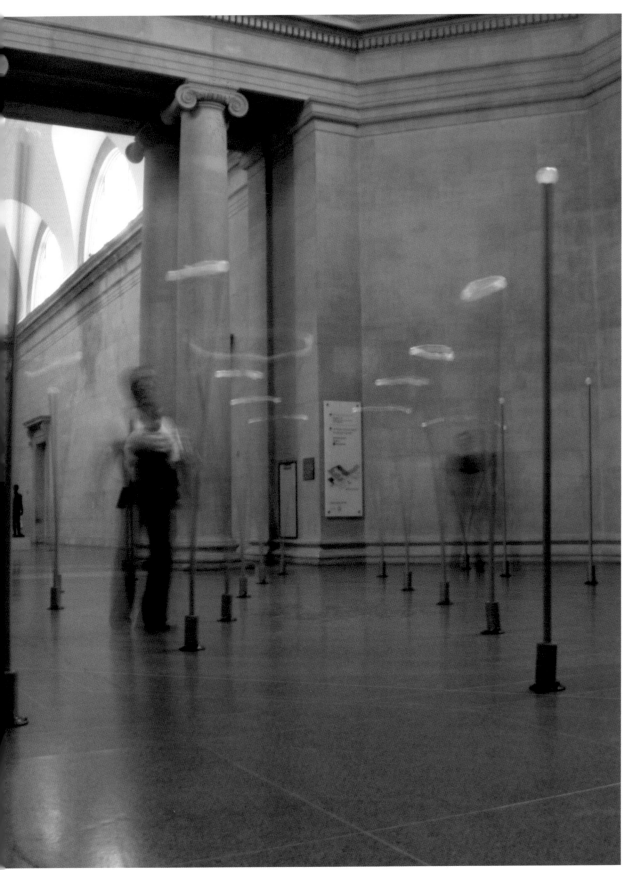

This piece is based on the idea of an atrium which bounces light down to all the floors within the building and this is amplifying that process, so if you have clouds moving across the sky, different colour skies and the sun moving around the sky, it's basically taking these characteristics and playing them back through a 3D matrix.

Obviously different people are developing similar projects at the moment each at different scales, different longevities, but what is unique for us is really actually making it work in a physical permanent architectural space. Actually creating something that's live, that's got to sit there for a long period of time, alongside people who were using the space as a working environment. Pixel Cloud hangs from the top like a traditional chandelier, power and data runs down through the piece, but it is responding to the sky, also internal occupancy of the building. London isn't always going to have beautiful skies, so we have software that looks around the net for other skies as well. The light engines were designed in the studio with the help of a subsidiary of Zumtobel who produced little origami LEDs that were located within the space.

The idea of looking into the sky, has been taken forward into a project we're doing in Dublin at the moment, which is an extension to the Clarence Hotel, which is owned by U2. The aim of this project is to catch daylight and bounce it through the hotel's atrium. This is a Norman Foster project and we're basically creating the digital landscapes at night in the building, so we are starting to look at a variety of low-resolution wallpaper to coat the atrium. The idea is that the wallpaper will change with the seasons and the different skylines of Dublin. Obviously there is opportunity to pipe different ambient environments from concerts and things into the environment as the owners go on tour.

One project started with a phone call from a production company representing George Michael, who was preparing to tour. Normally we don't work on tours, we have got friends that do a lot, so we were a little bit hesitant about designing a stage set. However, Willie Williams is the Creative Director and the Lighting Designer with U2 and we were asked to look at the interaction; people on the stage, with the stage environment, both the movement and sound reaction we were outputting was sampled from every member of the orchestra – there was a three-storey bank either side of the stage and sampling them and playing acoustic signatures and the build up of the narrative through the stage.

Willie Williams created LED backdrops which he wraps around, so you can actually walk and dance on it as well, and together we developed an evolving narrative in light that came through the LED matrix of the stage and it has actually changed the way George performs, which is interesting: he started standing backwards performing to the stage, because he could see himself have an effect on the stage. We have also been exploring thermographic mapping, as obviously any optical tracking system struggles a little bit looking at a few million LEDs laid out on the grid beneath it, so we concentrated on the thermal map. This had all worked really well until the first time that George actually came on the stage, they turned the air conditioning on. It's not like it's on a building when you know what order things are going to go in, it seems to be more haphazard than that and suddenly a nice image of the stage and how it was changing disappeared... something that was all very, very cold, so we had to work with the calibration of the cameras live during the rehearsal.

In another project entitled Recall, which was sited in Broadwick House in Soho which is a Richard Rogers building, we have been looking at lift activity. It was a kind of curious

IMAGE: Pixel Cloud, Bishops Square, London, 2007 © Jason Bruges Studio

The one question that recurs, each time we look at these types of projects, is obviously the power and energy being used and this is something that we have been mindful of and it is something I've been working on for some time. In the Wind to Light project we worked on in the South Bank Centre the idea was to create a piece that visualised some of the movements of energy around the building and in this case looked at the wind movement. It is sited in the Queen Elizabeth Centre in London and looked at a whole series of nodes, wind powered, visualising the wind movement around the building. In order to test the concept I commandeered all the desk fans in the studio to create a temporary wind tunnel. When the piece was finally realised it was wonderful to see something quite ephemeral being visualised and also it was looking at renewable hardware as an aesthetic.

One of the final projects that I am going to talk about is a temporary piece, called Dotty Duveen and created for Tate Britain. It was a series of what could be best described as wobbly wands that visitors were encouraged to touch, unlike all the other artworks in the gallery. As you touched the wands the luminaires at the top lit up and there was quite a lot of sustained heavy interaction! We built up an activity map of the space, in terms of which bits of the gallery were hot and cold and where people were, a lot of fun.

I'm going to leave you with one project which actually you may have seen in Edinburgh. This was a digital cyclorama which has been travelling around the country as part of the O2 Memory Project. This is an interactive installation piece conceived to prompt thought and discussion around the temporary nature of our digital memories. The piece consists of eleven cameras, facing outwards from a drum, each camera takes a shot in sequence, so the first camera will take a photograph and after five seconds the second camera will take

IMAGE: Pixel Cloud, Bishops Square, London, 2007 © Jason Bruges Studio

project and again this is how we get involved
in projects, we were approached by a finance
company that was buying the building for
a client, they were the third owner and they
found the public artwork condition that had
never been discharged by the original planning
commission, and Westminster Council
suggested they come to us to look at what we
might do with the building. So we looked at the
building activity and actually representing that
on the outside of the building and playing it
back, so essentially creating a kind of daytime
map of the lift movement and recreating it as
performance in the day in the scenic lift shaft.

Another piece called North-South over East-
West was sited on London Bridge, which was
created as part of a lighting festival exploring
pedestrian activity. Specifically it adopted a
playful approach to the idea of commuting in
and out and movement around the city. We
had the idea that people have a steady gait
and there are opportunities to interfere with
it, for example the speed that people walk.
What I especially like is, when you create these
interventions, how they work with people
in their everyday movements and how this
interacts with them. People being very confused,
where the light's coming from? Confusing
tourists but also it is something that people
started playing with as well.

This is something we've been looking at, it is
taking ambient movement that is happening
within the environment and actually playing
with it. Mapping Bluetooth activity and using
that within all sorts of interventions. For
example, a piece in Poole that is an interactive
bench responds to mobile phones in the vicinity
and creates unique colours based on Bluetooth
IDs. Another piece we were testing in the studio
for the Queens Museum of Art, a freeway runs
alongside this and we're mapping the traffic and
the pedestrians on to it.

IMAGE: O2 Memory Project, London, 2008 © Jason Bruges Studio

The one question that recurs, each time we
look at these types of projects, is obviously
the power and energy being used and this
is something that we have been mindful of
and it is something I've been working on for
some time. In the Wind to Light project we
worked on in the South Bank Centre the idea
was to create a piece that visualised some of
the movements of energy around the building
and in this case looked at the wind movement.
It is sited in the Queen Elizabeth Centre in
London and looked at a whole series of nodes,
wind powered, visualising the wind movement
around the building. In order to test the concept
I commandeered all the desk fans in the studio
to create a temporary wind tunnel. When the
piece was finally realised it was wonderful to
see something quite ephemeral being visualised
and also it was looking at renewable hardware
as an aesthetic.

One of the final projects that I am going to talk
about is a temporary piece, called Dotty Duveen
and created for Tate Britain. It was a series of
what could be best described as wobbly wands
that visitors were encouraged to touch, unlike
all the other artworks in the gallery. As you
touched the wands the luminaires at the top lit
up and there was quite a lot of sustained heavy
interaction! We built up an activity map of the
space, in terms of which bits of the gallery were
hot and cold and where people were, a lot of
fun.

I'm going to leave you with one project which
actually you may have seen in Edinburgh.
This was a digital cyclorama which has been
travelling around the country as part of the
O2 Memory Project. This is an interactive
installation piece conceived to prompt thought
and discussion around the temporary nature
of our digital memories. The piece consists
of eleven cameras, facing outwards from a
drum, each camera takes a shot in sequence,
so the first camera will take a photograph and
after five seconds the second camera will take

IMAGE: North-South over East-West, London Bridge, Switch on London 2008

a photograph and after ten seconds, the third
camera will take a photograph and so on and so
on, until all the cameras around the drum have
taken a picture and in which case a minute's
worth of footage will have been captured. Just
going around the front, entering the cyclorama
there is still quite a bit of work going on in
here and you can start to see the images on the
screen starting to bring the cyclorama to life.
Inside the cyclorama there is a series of four
thermographic cameras in the ceiling that can
monitor movement inside the piece. So as I step
nearer the screen, I can move the film back and
in time and then I can move it forward again.
Which effectively means that I can have control
over one of the screens, but I can also take a
position in the cyclorama and walk all the way
around the cyclorama revealing a particular
time of day, say two o'clock in the afternoon,
the day before.

Q&A

Q I'm confused about your client base because I expect there are people you work with, they require quite a leap of faith to employ you to do something, the point of concept to the point of reality must be very different, because there is a lot of effort and build goes into creating a lot of the work. What's the nature of the clients that you work with and how do you get those clients?

A This last project it's very unusual, because we didn't usually work with agencies and this was an agency for O2 and they happened to have a bit of technology they wanted to celebrate, which was this back up system for the mobile phones and this was about creating memories as well. They knew we were doing this work, so the two projects aligned, but the timing was horrible and start to finish was three months, so obviously there were problems with that. Then there are other projects like the one in Poole with the wands which vibrate, that is our first project and it is still ongoing, with a very small amount of money from the Arts Council and a few other stakeholders, but it really does spread across lots of different sectors, private, public individuals, complicated projects from many stakeholders, so each project is different, but that's what I quite like about it, but it does also make it complicated at the same time.

Q Do you actually go out and seek clients or do you find a lot of your past companies to work with?

A We don't really go out and seek clients, no. We do get invited again to be short listed for things but we are considering, we might get even more ideal projects if we actually target people rather than them coming to us. At the moment we are reacting to situations more than actually thinking ahead but we're getting a nice mixture of work and we're kind of happy that it's been organic, but I suspect that will not always be the case.

Q You mentioned at the beginning of the presentation the broad-based effect of the teams in the studio. Do you find that the academic disciplines within UK universities meet your needs in terms of specific expertise, or do you feel that you need something else?

A It's very eclectic, people who work in the studio and it is more quite often about personality and a mixture of skills, rather than any particular course. There have been times when I didn't think we were going to need any mechanical engineers, but this person came along with a very nice mix of skills and it was just a coincidence here we had something that was mechanical and moving that required it and he had a lot of interests, so it made him useful for more than one project. If you are going to get someone in and train them and make them useful they have got to be wide ranging enough to be useful on a few projects at the same time – it is about people actually having quite a few different interests, so quite a lot of us programme, quite a lot of us render, quite a lot of us sketch, we do all of those things and again going back to the first line, it's really not about pigeonholing people as well, as much as the work we do, I think is important, but I quite like unusual hybrids and unusual mixes of things. Like a colleague in the studio who works on the cyclorama projects, I mean he is an architect and he's interested in interaction design and he's a set designer, so you get all of these interesting hybrids I think, which are kind of important to pull out really rich veins in the work really.

Q Do you find that your background in architecture helps you a lot?

A I think in terms of how my work progressed, I had to loosen up a bit actually. I worked for Norman Foster for quite a few years and it's all quite rigorous and it's quite a good process, whatever you think of the architecture, but actually just loosening up and doing things a lot more ephemeral, doing things quickly and thinking quickly, how you present, I've worked in agencies and worked like an artist, but the architectural, a lot of the work is site-specific, so the approach is quite architectural, but also how you communicate and the kind of rigour which goes into how things are assembled and go together in the process. I think it's sometimes for the clients, it gives them reassurance essentially what you are communicating, even if it looks risky, they've got some belief in you, in terms of being able to realise it.

Q Do you find that your clients allow you a lot of creativity in your projects or do they have a preconceived idea of what they have in mind?

A Each project is different – sometimes there is an idea, it might be about scope, where the opportunity lies, so it's not a blank canvas, so you have an area facade here where we would like a feature, or there's an opportunity to do something. It might be they have quite a defined idea, we let them run with it but we actually kind of expand what it could be. Certainly a lot of these projects are multidisciplinary in terms of working with big design teams, architects, landscape architects, whole teams, all sorts of people quite often plugging into that but trying to make it flexible enough, so it's interesting and there is a balance between getting something that's really defined and we do kind of periodically turn things away, because they defined it and narrowed it down too much where we're thinking, you can't really have any kind of innovative thinking here. So it works both ways.

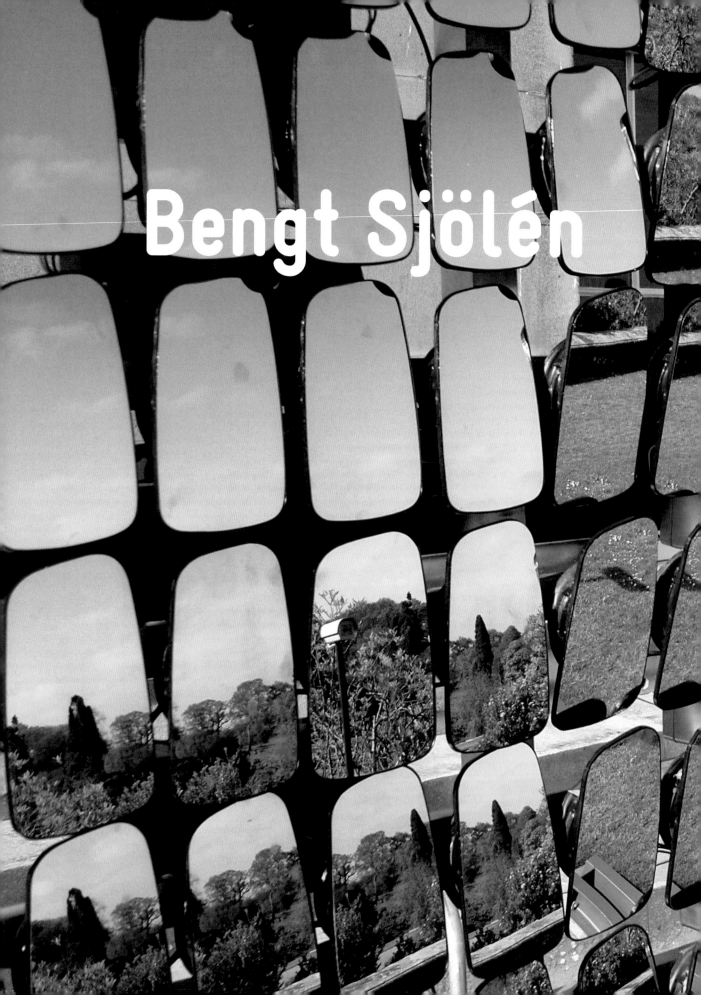

Bengt Sjölén

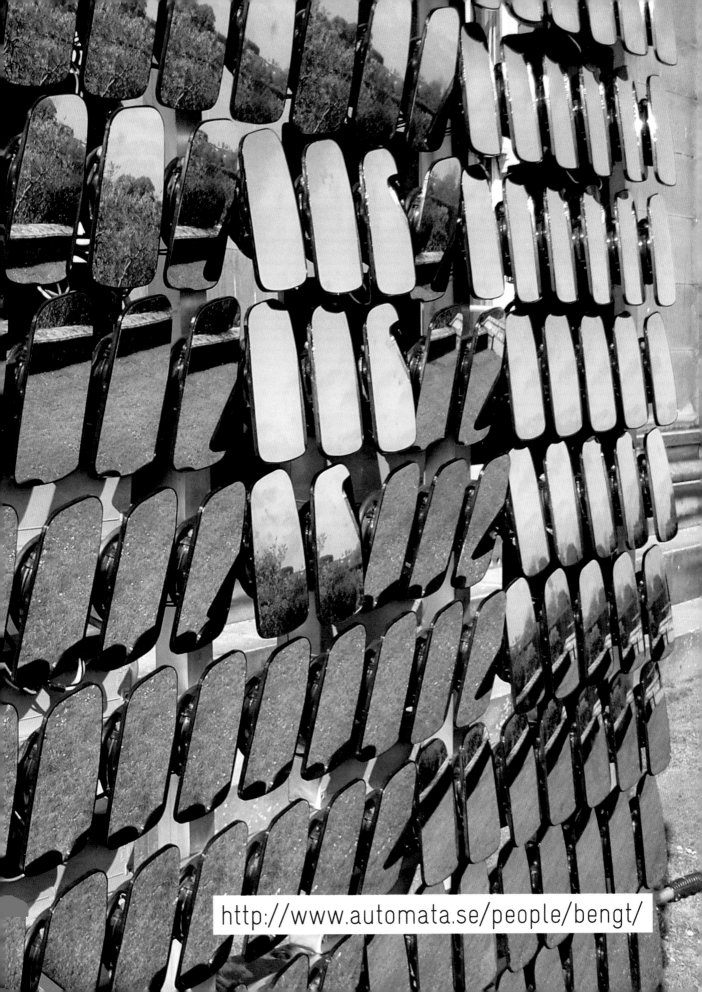

http://www.automata.se/people/bengt/

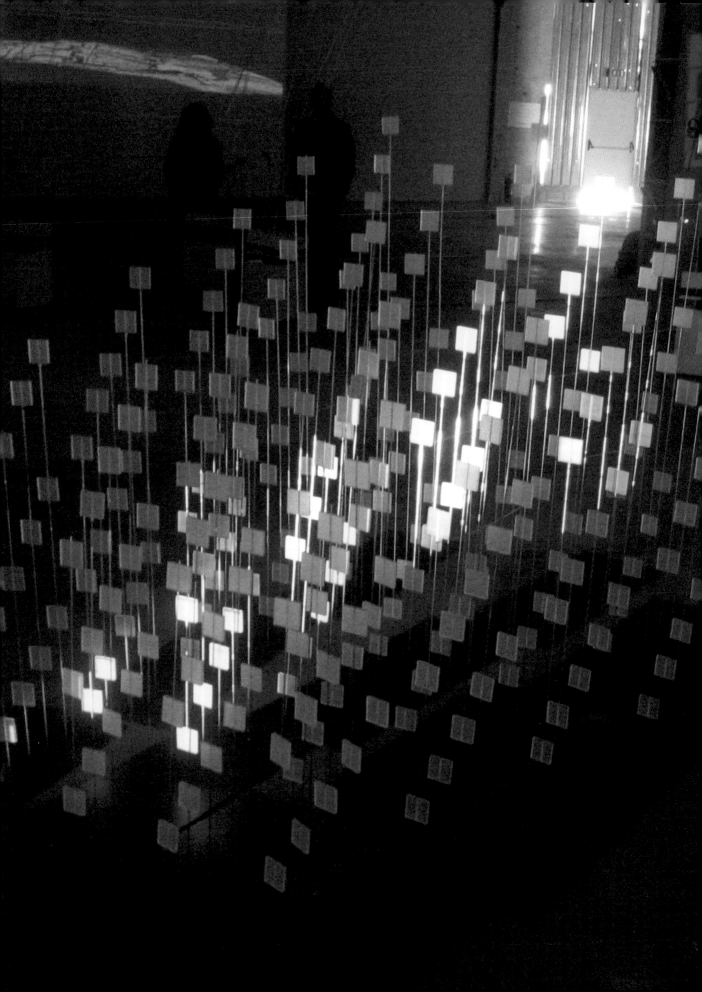

Bengt Sjölén

"I often just call myself hacker"

My name is Bengt Sjölén and I never know how to present myself in one word because I'm not really an artist, I'm not really a scientist, I'm not really a researcher and I'm not really an engineer, but I function as all of those, so I often just call myself a hacker because it adequately describes most of the things I do. I'm going to start by just talking about a few projects and about the way these projects come about and the networks in which they come about. The first one is a project called Distributed Projection Structure. It's part of a series called Induction House started by Aether Architecture. It's a three-dimensional, very low-resolution screen. If you put your eye where the projector is you would see a seemingly flat surface but as you move around in the space you see that the surface is spread out in the space. With the projector you can light each pixel individually. Here are some examples showing some rotating planes in that space. Of course it's a very low-resolution display so it's very bad as a display, but more about the concept of doing distributed projection in space.

Another project, together with Adam Somlai-Fischer and Danil Lundbäck, is the Brain Mirror, which was commissioned by the Swedish Research Council and the Swedish Travelling Exhibitions for a science communication exhibition about brain research. They wanted to inform the public about the current state of brain research and they had this huge exhibition with lots of scientific information but they wanted to have something that was more playful and fun. We proposed to make an augmented reality mirror where you put a helmet on your head and it tracks your head movement and displays a volumetric magnetic resonance camera image on top of your mirror image. As you move closer to the mirror it will slice the volume so you can look inside what visitors believe is their brain. It's in fact always my brain they see but brains look alike. This piece has been touring with the science communication exhibition for about two and a half years in Sweden but it has also been exhibited in art contexts at Ludwig Museum in Budapest and at Forum 2007 in Monterrey, Mexico and many more.

Another project with Adam Somlai-Fischer and Usman Haque is the Wi-Fi Camera, which is a very simple lo-fi camera that actually takes pictures of Wi-Fi space. The idea of this came about after travelling to different places all the time, always looking for wireless networks, because when you work with people all over the

Bengt Sjölén

"I often just call myself hacker"

My name is Bengt Sjölén and I never know how to present myself in one word because I'm not really an artist, I'm not really a scientist, I'm not really a researcher and I'm not really an engineer, but I function as all of those, so I often just call myself a hacker because it adequately describes most of the things I do. I'm going to start by just talking about a few projects and about the way these projects come about and the networks in which they come about. The first one is a project called Distributed Projection Structure. It's part of a series called Induction House started by Aether Architecture. It's a three-dimensional, very low-resolution screen. If you put your eye where the projector is you would see a seemingly flat surface but as you move around in the space you see that the surface is spread out in the space. With the projector you can light each pixel individually. Here are some examples showing some rotating planes in that space. Of course it's a very low-resolution display so it's very bad as a display, but more about the concept of doing distributed projection in space.

Another project, together with Adam Somlai-Fischer and Danil Lundbäck, is the Brain Mirror, which was commissioned by the Swedish Research Council and the Swedish Travelling Exhibitions for a science communication exhibition about brain research. They wanted to inform the public about the current state of brain research and they had this huge exhibition with lots of scientific information but they wanted to have something that was more playful and fun. We proposed to make an augmented reality mirror where you put a helmet on your head and it tracks your head movement and displays a volumetric magnetic resonance camera image on top of your mirror image. As you move closer to the mirror it will slice the volume so you can look inside what visitors believe is their brain. It's in fact always my brain they see but brains look alike. This piece has been touring with the science communication exhibition for about two and a half years in Sweden but it has also been exhibited in art contexts at Ludwig Museum in Budapest and at Forum 2007 in Monterrey, Mexico and many more.

Another project with Adam Somlai-Fischer and Usman Haque is the Wi-Fi Camera, which is a very simple lo-fi camera that actually takes pictures of Wi-Fi space. The idea of this came about after travelling to different places all the time, always looking for wireless networks, because when you work with people all over the

world and you're away from home, then you're alone when you're not online but when you are online you are in this virtual space where you have everybody close to you and you soon get very aware of the spatial qualities of Wi-Fi – moving a metre could make the difference between good reception or bad reception, between a warm, welcoming place or a cold, barren place. The original idea was making a pinhole camera that would consist of a Faraday cage, a box that would shut out all radio waves, and then a hole in that, like the hole in a pinhole camera, and a grid of radio sensors on the back wall. It would be expensive and complicated to do, so instead we built a little device that is actually a single pixel camera but it moves this pixel. If you know how a pinhole camera works, and it would be possible to do this with light as well of course, it would just be a light sensor in the hole of the pinhole camera, looking in one direction at a time building up the image pixel by pixel. If you take an image in the exact same location, you get exactly the same image. The images where you have this smooth pattern, they are interference patterns from a transmitter that is actually inside the room so the waves cancel out each other when they bounce back and forth. Radio waves behave very much like light at these frequencies as they bounce off everything, just like when we look at the colour on the wall, what we see is actually light from a light source reflected and bounced into our eyes, and the radio waves do the same thing. Each of these different colours are different networks. We also tried to do this lenticular printing photography where you can see different pictures from different angles, overlaid on the photographic images, so we can see how the networks distribute in the room.

Ping Genius Loci is a project with Aether Architecture. It is a platform for experimentation with sensor and actuator spaces. Each of these physical pixels can rotate its top and thereby show different colours to the viewer. Each is solar powered, and they all

IMAGE: Brainmirror: Danil Lundbäck, Bengt Sjölén and Adam Somlai-Fischer, 2005

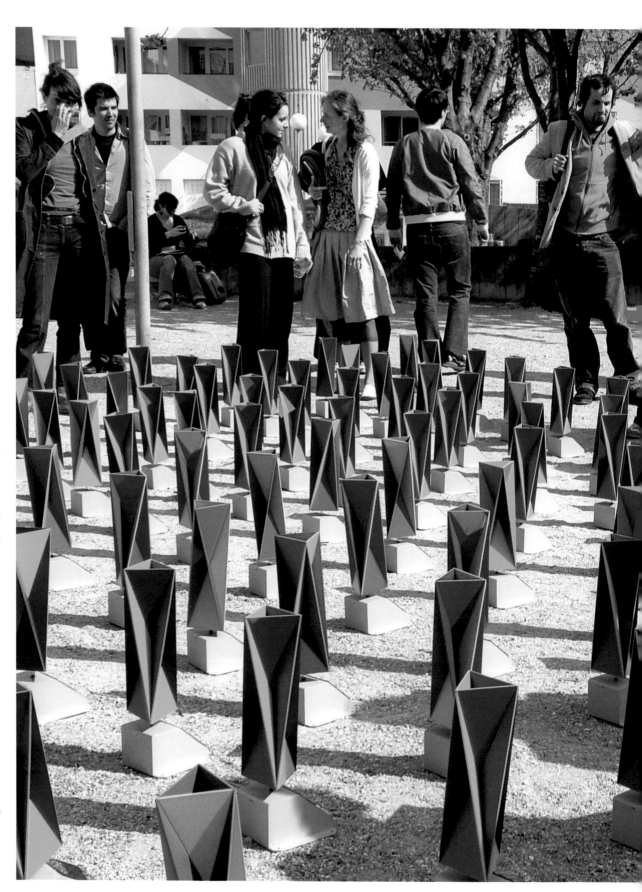

IMAGE: Ping Genius Loci: Aether Architecture and Bengt Sjölén, 2005

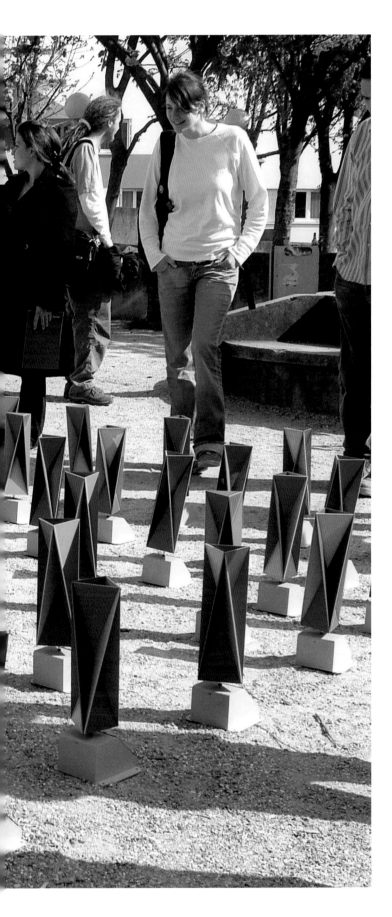

form a radio network, communicating with each other. We did some experimentation with making games and other interaction scenarios, like playing Pong by walking along one edge, making sounds to catch a bouncing ball. It's also quite dysfunctional as a display. These are some tests of synchronised movement between them. Also this is just a hundred of them so one quarter of the whole setup of 400 pixels.

Aleph Reorganizing Vision, with Adam Somlai-Fischer, is a kinetic reflection display. It consists of 200 powered car mirrors and the idea is that it looks at itself through a camera and it can move the mirrors and use the environment as a palette. It would pick colours from the environment by pointing the mirrors in different directions. So far, we have only shown this on one occasion, which was at Belsay Hall outside of Newcastle. It was outside for five months there and what we didn't think of is that it's very bright outside and the ground and everything else is quite dark so even though they have these very colourful gardens, that we thought it would be nice to pick colours from, we basically found that it was a binary display. You could only show bright or dark so we had to deal with that but next time we hope to do something with more colours.

I have undertaken a number of projects that merge the worlds of commerce and research. With Teenage Engineering we made an event marketing campaign for Sony Ericsson with 280 of these small Wi-Fi boxes, that are really tiny Linux computers, pushing content to new Sony Ericsson phones. The same technology was used for a research project in Budapest, Bluespot, which is a messaging network for places where you actually send a message to a bar or a café or some place like that where one of these devices is installed – so people can communicate not person-to-person but location-to-location.

IMAGE: PCB Prototyping and machine self-modification with CNC: Bengt Sjölén,

IMAGE:Reconfigurable House 2.0: Adam Somlai-Fischer, Ai Hasegawa, Barbara Jasinowicz, Bengt Sjölén, Gabor Papp, Tamás Szakál and Usman Haque, Z33, Hasselt, 2008

"These projects also blend with various toy hacking projects in teaching"

Reconfigurable House and Reorient are both very much networked productions. Reorient started with Hungarian architects organised by Adam Somlai-Fischer doing the Hungarian Pavilion at the Venice Biennale of Architecture 2006. They brought 20,000 different toys and wired them up, controlling them and thereby mediating the space. I was the technical advisor for this project in its first incarnation at the Biennale and then I've been making software and designing content and hardware when it has been shown later. These projects also blend with various toy hacking projects in teaching, and actually have their roots in the toy hacking manual, Low Tech Sensors and Actuators by Usman Haque and Adam Somlai-Fischer, and having workshops for teaching design and architecture students to build interactive electronics by using toys as components. Toys often have sensors and actuators like, for example, small cats that have eyes that light up when you touch them and you can use the power to the eyes to control a motor, for example, or trigger something else and then build complex systems with many of these devices.

Another project in between art and the commercial world is a marketing campaign for Absolut, the Swedish liquor brand. They don't do commercial campaigns like normal people do, instead they commission artists to do some work and then they normally make prints from this. But this time they wanted to make something interactive and online so they asked us whether we would like to do a proposal for making a creative machine and we proposed making a choir that would sing with speech synthesiser voices. They chose our machine and another project that is a robotic quartet with a

50-key marimba catapulting rubber balls at its keys. That was in New York and was made by Jeff Liebermann and Dan Paluska. The choir is a project with Teenage Engineering, which is my studio in Stockholm. Each of the choir members contains a small Linux computer and some of them have motors and LEDs so they could have other actuators than the voice as well. The idea was that you interact with the choir online by writing lyrics on the web page and those lyrics are used both as seed for generating the composition and woven into the lyrics that the choir sings.

The Phone for Elephants is another research project, which uses partly the same technology as the choir for sound. This is a phone for elephants so that the elephants at the zoo in Kolmården in Sweden can talk to the elephants at the Cologne Zoo in Germany. The reason for this is to measure an elephant's value in life. They do a number of sequences of trials where elephants would have to pay by lifting an increasing weight every day for their breakfast, for showers, for having their teeth cleaned and stuff like that. The final phase of this is to see if they are willing to pay for social contact, well, audio contact. They are still doing these sessions but there has been a lot of trouble between the elephants in Cologne because they always get into trouble with each other so they have had to abort the tests and have not been able to run for two weeks continuously yet but we hope to continue after the summer.

Now just a few words about myself, just to put me in context. I don't have any formal education, I was educated in the home computer demo scene. In this scene we were competing about making the best possible things with the computers that were very limited at the time, the Atari ST and the Amiga, and we were always pushing the limits of that hardware. In one sense perhaps it would have been normal for someone like me to study computer science or something like that but I

IMAGE: Absolut Choir: Teenage Engineering, 2008

thought that I would always be able to learn the
stuff I needed and was interested in on my own,
so I studied other things that I found interesting
like film theory, biochemistry and philosophy. I
still do from time to time. University in Sweden
is free so it's possible to take a course every now
and then.

Programming is my main tool, and even when
I do designs or hardware, I normally do it
programmatically like writing software for
generating schematics for circuits or generating
the layout for the circuit boards themselves or
designs for mechanical parts and things like
this. I don't live from art projects and I don't live
from research projects and I'm quite happy not
doing that. I work a few months a year doing
commercial projects, for example building
technology for advertising agencies and things
like this. Then I can spend the rest of the year
doing the things I enjoy doing and take an
interest in without having to feel the need that
they should be profitable. Time is not money,
money is time – the money I make working
commercially only buys me time to do the
things I enjoy doing. So some of the networks
I am part of include Automata. Automata is
my company where all the economy of my
commercial work goes through. But Automata
is also a collaboration with two friends from
the original demo scene, Lars Rustemeier and
Stefan Guath. We started this because we have a
huge amount of mutual respect for one another
but we're not doing anything together currently
but Automata is sort of a letter of intent that we
will do great things together some day in the
future.

Teenage Engineering is my studio in Stockholm
and with whom I did the Absolut Choir
project for example. Teenage Engineering is
me, David Eriksson, Jens Rudberg and Jesper
Kouthoofd, all quite diverse in profession.
Jesper is a film director and industrial designer,
David does amongst other things product
design, DJ-ing, music and software, Jens does

IMAGE: Teenage Engineering Studio, Stockholm, 2008

IMAGE: Panoramic Wifi Camera I: Bengt Sjölén and Adam Somlai-Fischer with Usman Haque

software, games and music-related stuff for example. Some examples of the things we do together includes VJ software, music and sound technology, building hardware, product design, event marketing campaigns. All this work takes place in our studio, which is filled with machines that we love including Milling machines, laser cutters and lots of other tools like this. All of these projects are made by different constellations of people, so in this constellation as well, it is not a one hundred per cent commitment, we share the space, we crossbreed ideas, some do projects together, but everybody works on their own projects as well. These are some pictures from our studio and one of Jesper's design projects, the MonoMachine, a Swedish synthesiser by Elektron. This is an example of what we do with software as well. This is a milling machine routing circuit boards with a Python program running my schematics and layout programs milling away copper from the glass fibreboard with copper on it and then drilling it. We have also built extensions for the milling machine, by using the milling machine. That's a beautiful thing that you can actually build machine parts with a machine to extend that same machine. For example, for dispensing solder paste on circuit boards, which means that you just need to place the component in the solder paste. We also built a pick-and-place extension for the milling machine so it can pick components from these trays, turn them in the right direction and put them in place on the circuit board. Then you just need to bake them for a couple of minutes at about 270 degrees and then you have a ready circuit board.

Some of these networks are not quite as fixed as Teenage Engineering, which is four people and Automata that is three people. Many of the other projects are in what we call peer production networks, where different people join for different projects and for different incarnations of projects the people might change all the time. The idea is that when you

make something, when you make a project together, there is no-one who is the author, or the creator, or the artist, but the network itself is the artist or the creator so you have to give up the idea of being the individual creator. The project does not belong to any single author or specific artist's identity.

Adam Somlai-Fischer and I are involved in almost all of our projects together. In our projects there is typically a huge web of networks and different constellations of different people doing different things in our projects and this, I must say, is my preferred way of working. Always being able to take in new people, not only for sharing the workload but for getting inspiration and getting input from other disciplines and from other people's experiences – in the way it always generates new ideas and new projects as well – is a fantastic way to work.

Q&A

Q I would like to ask just now a quick question on just the last thing you were saying of you sharing work, how does it work with copyright for industries?

A Yes, actually many of these projects are done with a creative commons licence, which is basically like open source for things that are not software. So the idea is that anyone, with proper crediting, should be able to use what you do. Often the making of the projects are made public as well and software made open source as well as designs made available for download so that people can actually continue working with and evolving the same project. I must add that I would be honoured by someone copying my work.

Q Can I ask why you find it essential to write your own software tools, the things like the schematic layout, the PCB layout? To me it seems... is it not adding to your workload?

A It is. It can be a huge amount of work but the thing is that if you, for example, take generic software for making circuit boards then you can do a circuit board schematic. If I do a PCB for running twenty different motors, for example, and want to change parameters for the schematics I can make an algorithm that generates the schematics parametrically so that when I change properties that make the entire board with all the parts and how they interact differently and I cannot control that with parameters in a normal layout program because that is just a layout program where you can just draw things. Then I would have to throw it away and redraw it. But also it is a way of avoiding human error because it takes a long time if you make mistakes to find them and anything you do programmatically the program would redo every time and do it right.

Q What do you think are the obstacles with not working in a single discipline?

A Oh, I don't know. I mean it's not like I have chosen not to. I see it rather like that I do the things I do because I want to do it and I cannot not do it, and then I find collaborators and forums in different disciplines that actually take an interest in these things. It's like the media art scene which from my perspective just happens to take an interest in the same things that I like to do – I don't really see this as taking part in any particular discipline but I have a hard time comparing, too, because I'm only doing the things I do and they seem to fall into different categories because someone else made those categories.

Q Would you talk about your choice of programming language, what you like and what you don't like using?

A Yes well ideally I would prefer to work with Scheme or Lisp but Python I think is a beautiful compromise between functional and object-oriented programming and it is very expressive as a programming language. I do not like languages that try to cripple programming in the sense that I feel that Java does, for example. To me, the idea with Java seems to be to make all programmers replaceable which makes sense in a big corporation, but I am not interested in making myself replaceable in that sense. I want to have the most powerful tools at my fingertips and I want to be able to express things I need to express with as little code as possible, and Python really makes that possible for me now.

IMAGE RIGHT: Reorient: The Grand Baldachin, Institut Hongrois, Paris, 2007 Adam Somlai-Fischer, András Kangyal, Anita Pozna, Anna Baróthy, Attila Bujdosó, Attila Nemes, Barbara Sterk, Bengt Sjölén, Gergely Kovács, Ida Kiss, Krisztián Kelner, Melinda Matúz, Melinda Sipos, Pierre Foldes, Szonja Kangyal, Tamas Szakal

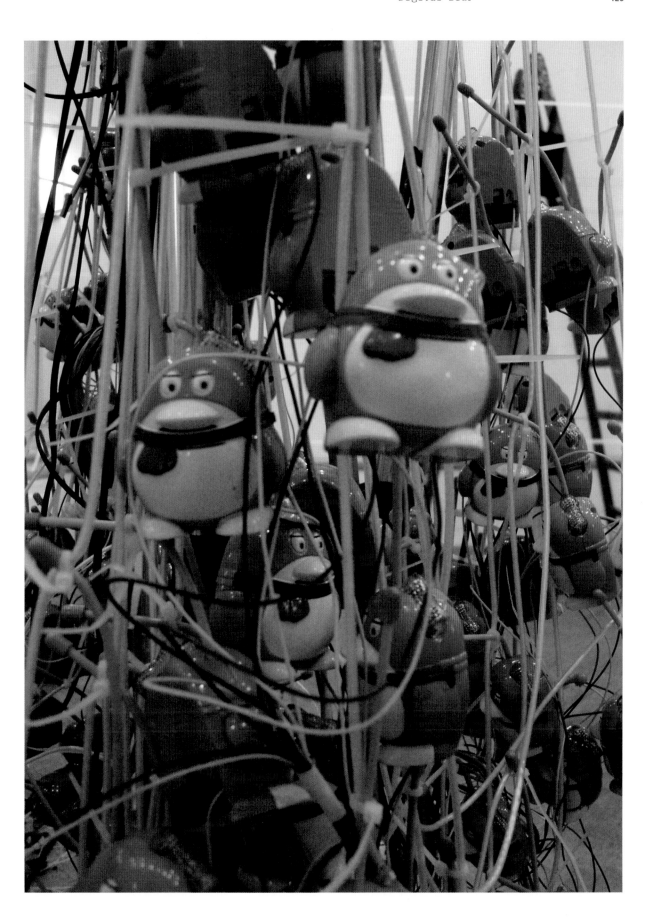

Moritz
Waldemeyer

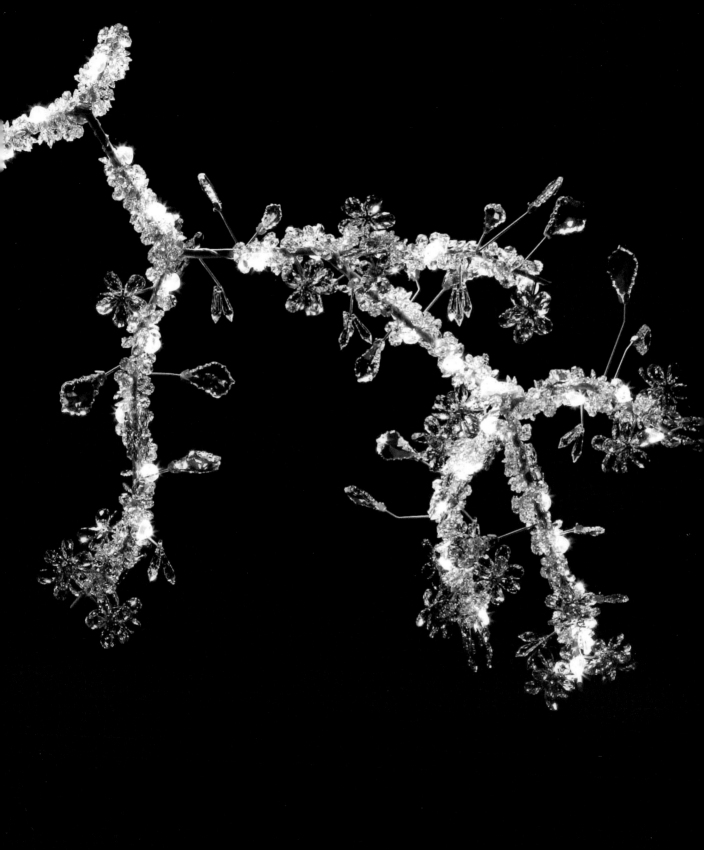

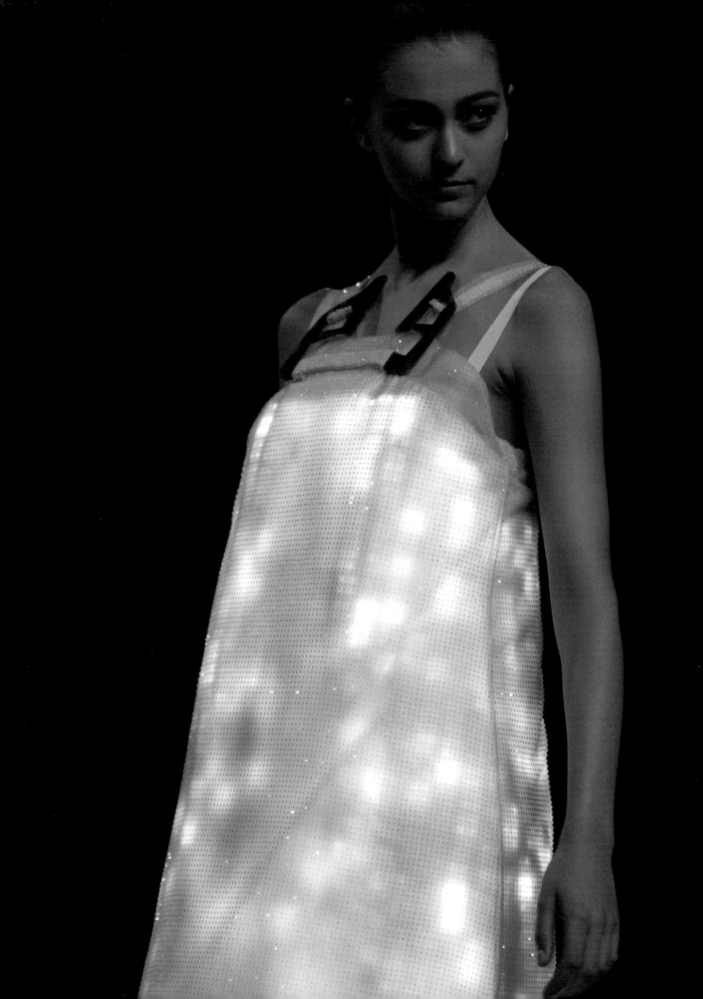

Moritz Waldemeyer

"now back to some entertainment"

I started the career that I am in now about four years ago. My background is in engineering. I studied at Kings College, London where I did an engineering degree and then I worked for Philips for a while in a quite normal engineering career doing research and development and at one point in time I just wanted to try something new and I got in touch with a designer called Ron Arad. He is very well known in the design world and I just went to his studio and showed him the stuff that I had been doing at Philips. At Philips I had been playing with embedded systems and coming up with ideas for consumer electronics and making prototypes and then making stuff work and Arad kind of liked that and before I knew it I was involved in a project for Swarovski, which was a crystal chandelier, and immediately the pressure was on. Arad had the idea to have a text message chandelier and there were only four weeks to the show in Milan and from here we went onwards. This was my first project in the world of design and it was a big success. In that year, everybody knew about it, it was published all over the place and all of a sudden I was like right in the middle of this design world and projects kept coming in. I have done a lot of work for Swarovski, particularly chandeliers.

One is a design by Yves Behar, it's huge, four metres long, it's like the size of a car and just as heavy as well and here we just had some waves of light going through with 2,000 LEDs.

Another is a little design I came up with using crystals making them rotate in space using two strings per crystal. When you pull on the strings you can position them anywhere in two dimensions and altogether they make a moving spiral. Another was a Ron Arad design, a follow up on the text-messaging chandelier. This time he wanted to draw in crystals and so you see the crystals are almost like a screen, like a flying carpet. And you can draw on the palm computer, there is a Bluetooth link which works in real time so as you doodle on the palm computer you see your drawing appear in the chandelier.

I have also collaborated with Troika on one of their projects where I helped a little with the prototyping. Troika came up with this idea to have a box that's been mounted on a post, somewhere in the public space and what you do, you send a text message to it and it shouts it out with a speech synthesiser built into the box and well you can send anything you like. I think the idea came from a change in the UK laws that

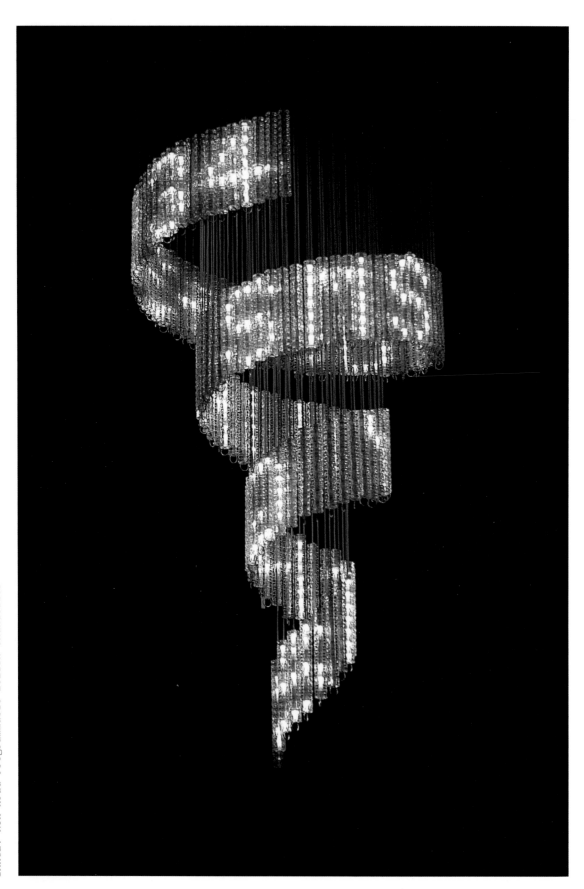

IMAGE: PANDORA Chandelier with FredriksonStallard for Swarovski

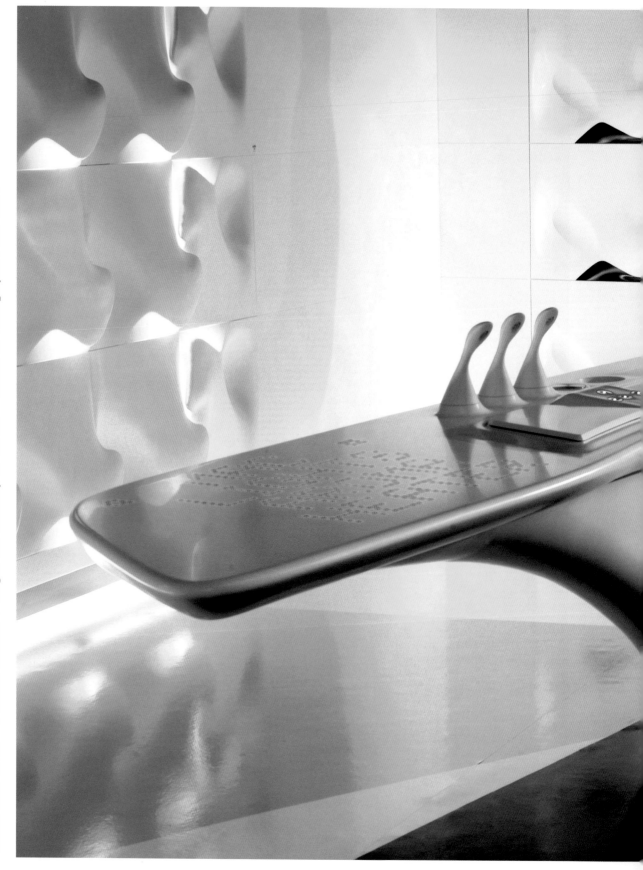

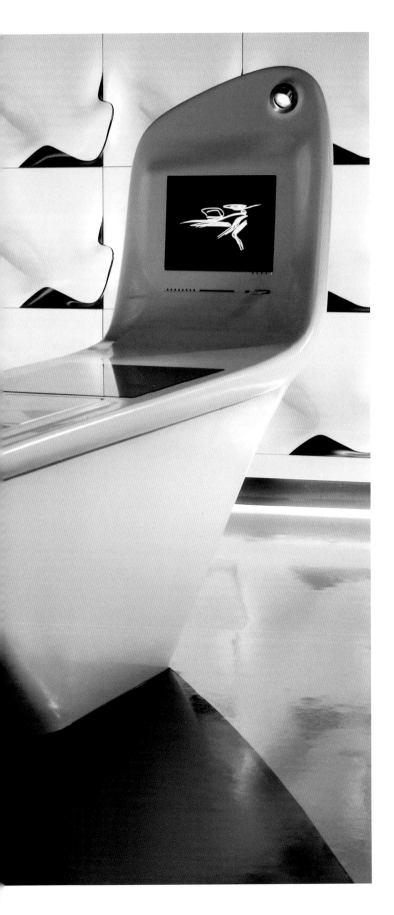

you couldn't protest in front of the Houses of Parliament any more so they wanted to make it possible for people from the comfort of their own home to protest and voice their opinion. It was then used for an MTV campaign where they installed it in Copenhagen in the main square and people used it for about a week or two and they had a lot of fun with that.

Another piece of work is a chandelier designed with Tord Boontje. It is quite a well-known light and in this project I also tried to come up with a system for making the LEDs as small as possible with intelligence inside the LED and to give the light this kind of twinkly effect. After that I got to know a gentleman who works for DuPont Corian and they were about to start a project with the architect Zaha Hadid. They commissioned Hadid to design a kitchen and this image shows what Hadid thinks a kitchen should look like. They wanted it to be like super futuristic and full of technology and they asked me to come up with some technology to go with Hadid's design. You can see that on the surface of the worktop it's got an LED display but what's nice about the Corian is that you can actually put all the technology underneath so you don't see anything on top until the moment when it lights up and it shines through the Corian like through milk, let's say. The light comes out a little bit diffused and it looks rather nice and so the kitchen has these menu-driven functions. It's got a touch pad on the side, this blue illuminated thing, and you can go through the menus and select different functions of the kitchen none of which are really conventional to a kitchen. For example, it has a computer built in and you can see the screen on that vertical bit there. The kitchen unit had an Apple Mac built in and it had the software that allows you to get to all the multimedia functions called Front Row. So over the kitchen counter you could select music and you could go through photos or get to the Internet or watch a video or also get through recipes, for example, which sounds a bit geeky but it's actually quite practical because

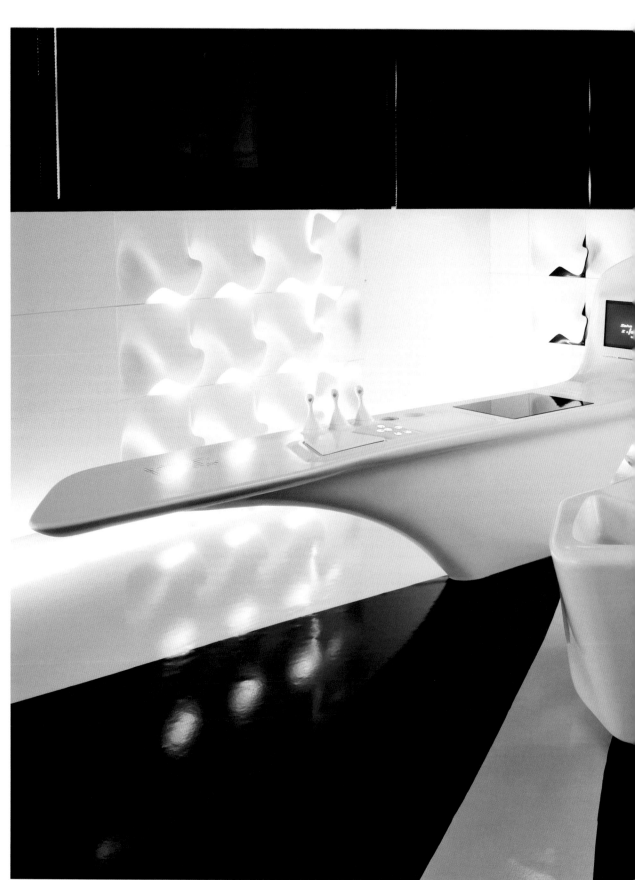

IMAGE: Zaha Hadid - Z ISLAND Kitchen / Images are courtesy of DuPont ™ Corian ®. Photographer: Leo Torri

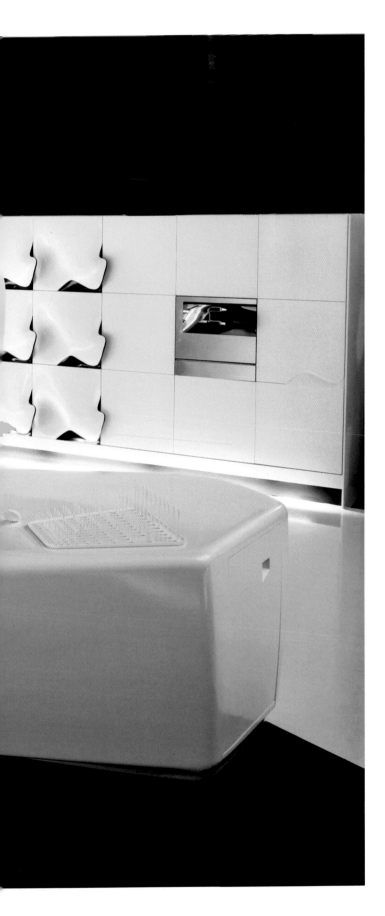

when you're cooking and you've got your hands dirty you don't want to fumble around with a computer, and since it was all integrated on the Corian you could get it dirty and keep going. So you know, it is a practical material too and it's used in the medical industry for that reason, and here in the kitchen it lent itself very much to that. The lights could also be controlled, they were in the background where they were retro-illuminated with full-colour LEDs and we could change the atmosphere of this space by changing the colour. There was aromatherapy built in too, interestingly, because you could create smells without actually cooking. The three knobs that come out there had these smelly jets built in and that all worked and it could be controlled as well from the kitchen system. Last but not least, there is a heater within the system and that was an innovation for Corian because they managed to sandwich a heating fabric between the Corian and they got that element from a space technology company in Israel. This was a relatively big innovation for them because they can use it as a radiator or in the kitchen users can put the plates on there and they warm up.

A result that came out of that project working with Corian was that I wanted to do something a bit more playful and I proposed to them to make some sort of gaming tables using those interfaces. So I made two tables, one of them is a roulette table, and one is a ping-pong table. They also used this idea of having the LEDs coming through the Corian. They have touch control and you can play games, ping-pong and roulette, which I thought was kind of cool because when you switch it off you don't see anything so it's a bit like you could have a secret gaming parlour in your kitchen you know and sit there around and have like cookies and then the police comes in and it's, "Right oh yeah we're just eating cookies," and switch it off. There were LEDs built into the lampshade on top of the roulette table which go in a circle to signify the rotation of the roulette game. There

was also a Corian mirror, sort of the same idea, there's a little camera, low-resolution LED display to change the optical properties of the material in a kind of intriguing way. That was the third piece of that exhibition.

"I wanted to do something a bit more playful"

Right, the next project is a bit of a jump. A totally different project and at one point in time I got this phone call from a company and they were working on these new ideas of Hussein Chalayan. He is a fashion designer who's very well known for being very experimental in his work and they were already busy making these dresses that could change fashion history. So one dress would morph from one period into the other and they needed somebody to programme them so I got the job, made some circuits and programmed Chalayan's dresses. The most complex of these dresses starts out in the 1940s in this shape with the hat, long skirt and it morphs into the 1950s petticoat. It goes shorter as well, all automatically, and then it goes into 1960s and so does the hat. This is a Paco Rabanne dress and so all of a sudden I found myself in the fashion industry without even trying and it was absolutely exhilarating finding myself backstage. It's crazy the energy that's going on there and you can't even imagine if you haven't been. It's like 200 people rushing around, getting the make up done, hair, getting the girls dressed, press all over the place. It is absolute mayhem and what's most interesting is that they do the show, it goes on for 15 minutes, and maybe 20 minutes after the show you're standing in an empty room and there is nobody there any more. Can you believe it? They don't even have a party. It's like show and off you go and that part was a bit of an anticlimax, but working on the dresses was actually fantastic and also seeing the way that Hussein is working I don't know where he gets the energy from coming up with all these

IMAGE: ELECTRIC KID Interactive Ping-Pong Table, Roulette Table and Mirror Gallery Exhibit at the Rabih Hage Gallery, September 2006

IMAGES: Hussein Chalayan - ONE HUNDRED AND ELEVEN Robotic Dresses 2009

new ideas every half a year and making them real. The final dress is probably everybody's favourite. The model went out in a really tiny dress and the hat, and the hat was illuminated as well and she stood on the stage and then the dress disappeared as if by magic, remote controlled, fully automatic. So, well, probably the best project of all of them.

So as I say every half a year Chalayan has to come up with a new idea and the half a year after this he came up with the idea of having video dresses. So he wanted to have two dresses with the surface totally covered in a video image and he had four weeks to do it in. So that was probably the most challenging project of all and here you can see a bit of the realisation of it. Of course, in four weeks you cannot use any fancy materials or fancy techniques so everything has to be off the shelf and what you can grab from distributors, what they have in stock, and so everything had to be done with conventional electronics. You see all these little circuit boards, each of them has four LED pixels on them and they are all autonomous video players. They were stuck on the dress, only taking power lines and when you switched on the power they would all start playing their own little bit of video. It got very serious during that project. We were not sleeping at all for about an entire week and well here we have all of Chalayan's computers, every computer from his studio all on one table programming the dresses and testing. All the LEDs were so bright that we needed a whole bunch of massive batteries to run them. They were very well concealed around the hip of the girls but they were like serious battery packs and they lasted about two minutes but the dresses were so bright it would illuminate a whole room. So one dress displayed a rose blossom and the other one a big tuna swimming in the sea. It used a low-resolution screen so it looked a little bit fuzzy and also it had to be diffused through the fabric but you do get the outlines of objects and it worked all the way around. The dress is plugged into the wall

because I had it for testing but the girls actually walked without any trailing cables, it was all self-contained for the show. Now this dress was also shown in that same show and the feature was that the hood was opening and closing automatically. There were another two or three animatronic dresses in this show. The company that made the dresses is called 2D 3D; they have a big workshop in London and a lot of artists use them to realise ideas.

So in this project, the designers are Frederikson Stallard and they came up with an idea to make a chandelier for Swarovski that can explode slowly and then slowly reform. They wanted to have thousands of crystals in the traditional shape of a chandelier and then that would slowly pull apart into chaos and come back together. All they did was make a nice animation on a computer and that's very easy, right? And then all of a sudden you're there and you have to translate that into real life. So you need to create a mechanical structure to hold it, and crystal is very heavy so we're talking about serious weights here. So there's a big plate to hang on the ceiling. We put these big winches on top. Now the difficulty was in the computer animation every crystal was moving individually and very randomly but having every string of the crystal with its own motor would be crazily expensive and would take a long time, and so I came up with this idea of only using four motors and each motor has these pulleys with different diameters, so the crystals would move at different speeds for each rotation and you get this idea as if it was totally random and here we've got the final set up of the chandelier.

Now let me jump to this next project. This is one of my own projects. Again I wanted to use Corian and lights but I thought it would be interesting to approach it from the other way around, because thus far we've always used light to shine through the Corian and use the white Corian as a diffuser. This time I thought it would be interesting to work with black Corian,

IMAGES: Hussein Chalayan development of AIRBORNE LED Video Dresses

which is as black as coal so no light would ever shine through it and so I thought I would play with the structure and I created a graphic element that's been cut into the Corian. Now the idea with these chairs is that they are being retro-illuminated. So there are LEDs built into the back of them that shine against a wall and what happens is you sit in a chair, there is a little sensor built in and if you wear bright clothes then the sensor will pick up on the colour and it creates a halo around you with your own colour. It is a bit of a mix between the fashion and design and I wanted the fashion to have an influence on the design and on the surrounding of the wearer. The design is influenced by images of kings and queens. I wanted to create a throne so that's why the chairs have a really high back and I wanted the person to be the most important person in the room when they sit down.

I have a few more projects I would like to describe here. I will return to Hussein Chalayan again. Approximately half a year later, Chalayan came up with a new idea and this time it involved lasers. I created a number of little mechanisms for him to mount lasers onto clothes. The lasers had to be moving as well. It was not quite enough to just shoot lasers out but he wanted them to move up and down so I had to come up with these little hinge mechanisms that would be mounted on jackets and dresses. So little server motors at the bottom, power cables for the lasers, some control electronics to switch it on and off and do fancy effects and then covering it all in Swarovski crystal because somebody had to pay for it all and here is the result. There were three dresses all shooting lasers out. The lasers moving up and down as well between shining directly into the crystal and out into the room. It was a very beautiful photo shoot this because the girls were standing on a rotating turntable so if you imagine like all of this in 3D and scanning past you like this it was visually absolutely extraordinary.

Finally, now, these gentlemen have become very famous on the Internet recently because they had the brilliant idea to dance on treadmills. They are called OK Go and they're from Los Angeles and they got in touch with me at one point in time to do something for them for their stage show. So I took these jackets that they usually wear and I put LEDs in the back.

Finally I will describe a very recent project that was commissioned by Microsoft. They have an art gallery in Los Angeles where they are promoting the Zune brand, which you might not know because it is an MP3 player but it's not available here in the UK. It is basically an Apple iPod competitor. What Microsoft are doing is they're using artists, they're commissioning art pieces to promote the brand which I think is fantastic because they've put together an amazing mix of young artists, beautiful video work and graphic design and if you go to their website you can have a look at the work. Now they asked me to do a lighting installation in the entrance to the art gallery and it was kind of a strange space, it's only about four metres by four metres but quite high. So I thought I'd fill the entire space with fabric. I'm using the same fabric that Hussein uses in his fashion because I think it's absolutely beautiful the way that it catches the light. It's organza and when you put light behind organza you get these amazing kind of cross effects of light. So I basically filled this entire space with these big sheets of organza and then I put just a single line of LEDs on each sheet but altogether they create a three dimensional shape of a lampshade so it's almost like a CAD drawing in real life, you know, it's just these illuminated lines but they have a quite nice quality to them almost like underwater because it's all this blue fabric and it sort of disappears in the back. Now what's interesting about the Zune player is that you can send a track from one player to the other. So you can send a track to this installation and then the installation will pulsate with your track. So people who come and visit can have fun with their own music.

IMAGES: Hussein Chalayan – READINGS Laser Dresses development

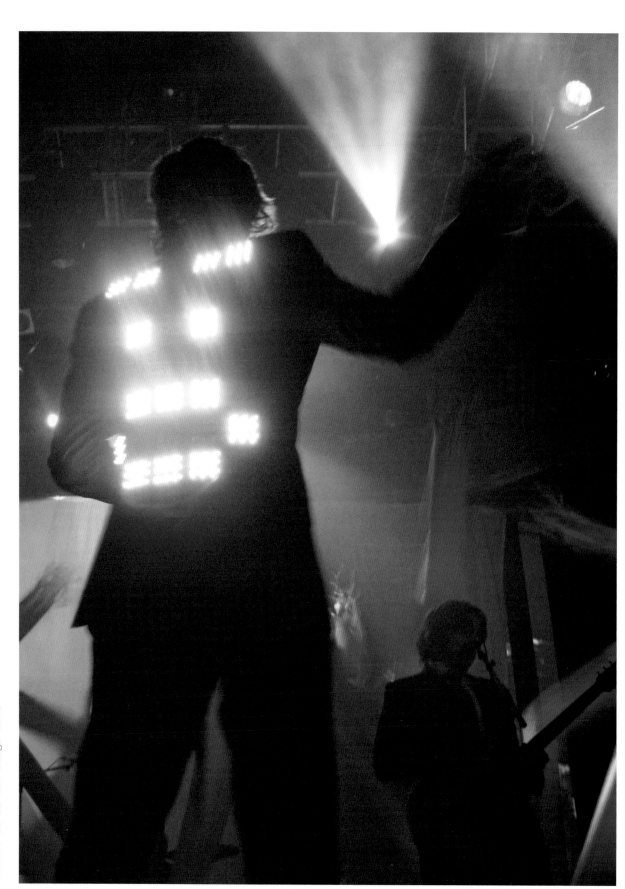

Q&A

Q Were all the OK Go jackets synchronised together?

A Yes, they were running independently but they had a synch button because they're musicians. I think that's what they can do, they're like one, two, three and then they're going... now!

Q Your projects look very handmade but do you have to organise that in the studio or do you just do it all by hand or do you have people helping with it?

A It depends, well the dresses are obviously handmade because you can't buy a dress and integrate electronics into it. I mean these are Hussein Chalayan's creations. This is proper haute couture, as you would find it in London, Paris, Milan or on the catwalk. So it's all made by hand. They are all made by a large team of fashion people as it's the only way of creating something like that.

Q How long did it take?

A It depends. The first set that I showed, the ones that are moving took probably about three months and there was a very large team doing that. We're talking probably 30 odd people working three months continuously to create those dresses and the other ones were not quite as involving where as I said for the video dress we had about four weeks and the laser dresses it was a little bit more than that, maybe two months, something like that.

Q I just wondered what you would describe yourself as being now. You said that you were an engineer in your early career, what are you now, what have you become?

A Well, it's moving more and more in the direction of design I think because design is reasonably broad that it covers various aspects. I don't know, how do you guys call yourselves? It is really difficult isn't it? You were saying it's impossible to say right? Well I guess that's why we're here in this book because none of us really know what we are. This is what this book is all about isn't it?

Q I have a question on the games table because you spoke about the LEDs, which are in it, but what kind of interactive software are you using?

A Well all of this stuff is written in C, running on microprocessors so they are all embedded systems. There is no operating system or any such thing. It is actually quite low-level electronics.

Q Are there any sensors in there?

A Yes, the games table has track pads, which are a bit like the ones on your laptop. You know the mouse pad, they've got that but it works through the Corian, which is nice so you don't see anything on the top.

Q I was just wondering what is your own role. Is there a concept or something that you're kind of experimenting with through your work?

A Well I guess you know during the work you always have like new ideas and some of the ideas are so intriguing that you just want to realise them and so you're looking for ways of doing that and so I guess the ultimate goal is to realise as many of my own ideas as I can until I retire and then not do anything else at all after that.

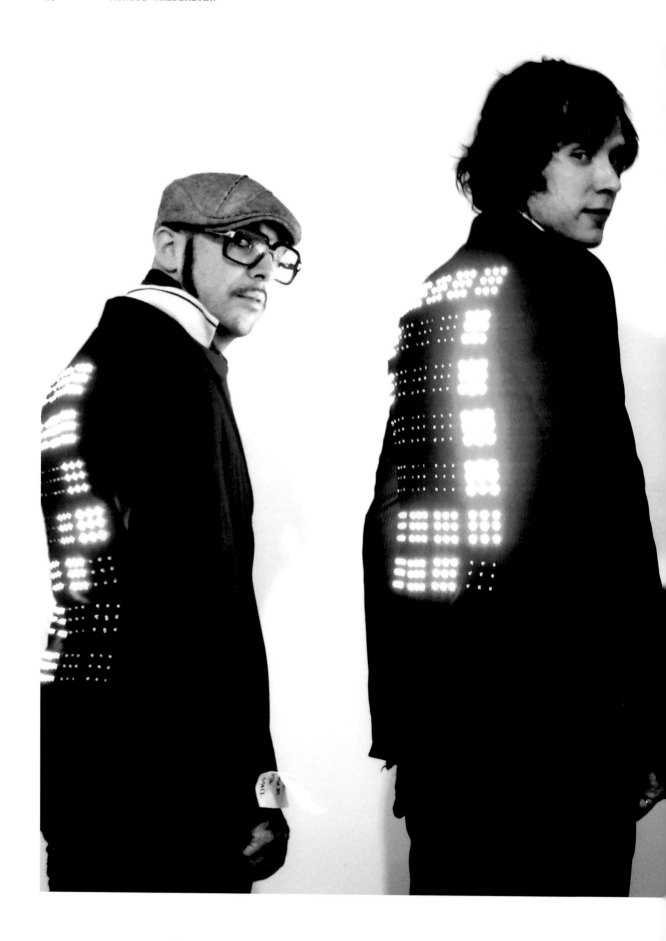

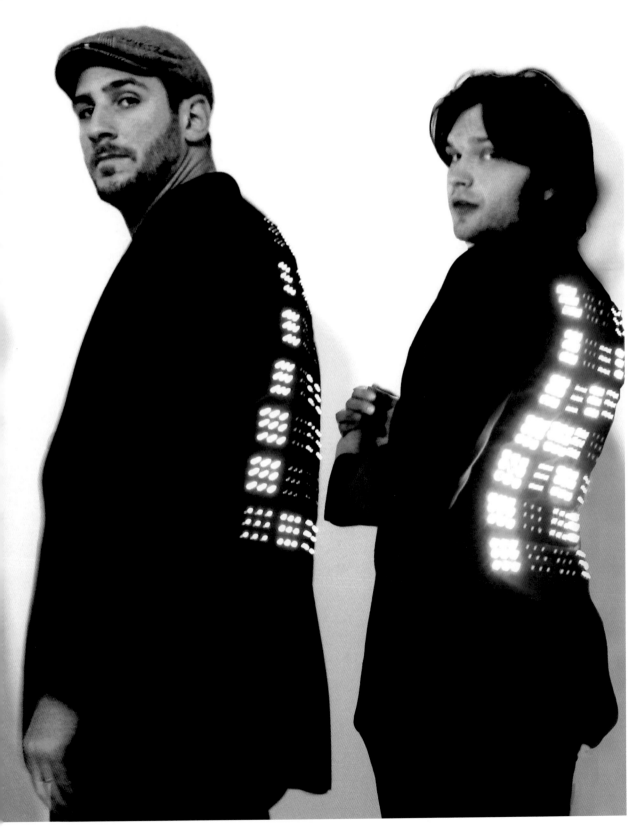

IMAGE: JOYRIDER Spinning LED for the ICA

BigDog
Interactive

http://www.bigdoginteractive.co.uk/

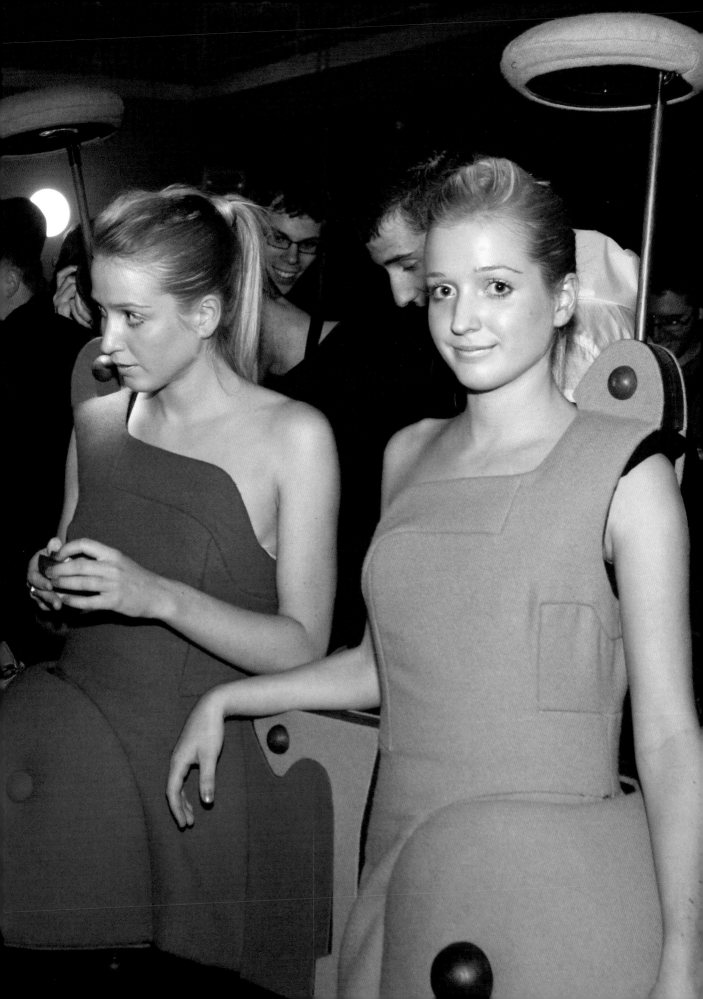

BigDog Interactive

"All the stuff we do is trying to get people away from sitting at a screen... It's trying to get people to communicate out in the real world and to interact with each other and create something collaboratively"

IMAGE PREVIOUS PAGE: Metamorphosis with Welfare State International. Photo credit: K. Woolford IMAGE LEFT: Sharewear by Di Mainstone & V2 Institute for the Unstable Media, Photo credit: Jacqui Bellamy, PixelWitch Pictures.

We were thePooch but we're now called BigDog Interactive and I'm going to tell you about how we transitioned from thePooch to BigDog Interactive, and tell you about some of the projects we've done in the past and some of the things we're working on now. So, thePooch was formed in 2001. Around this time, I was at Georgia Tech Research Institute and I was designing interfaces for Navy aircraft technicians before I moved to England and I was then asked to take up a PhD post in England and start working on some Human-Computer Interaction (HCI) interfaces and technologies. I met a group of people at Lancaster University when I took up the research position there, and we formed a collective called thePooch. A lot of the members of the collective had Arts backgrounds, some had Engineering backgrounds, and some computer science backgrounds – lots of different interests. We decided we wanted to push the envelope of what Human-Computer Interaction (HCI) was doing at the time and here are some of the projects that we've done in the past.

Our major goals are to look at interfacelessness and unanticipated performance spaces. So, we are interested in unexpected spaces, like Greyworld, and we like extreme prototyping. We are interested in developing things that are highly portable, can be put together and deployed in a space very, very quickly and can be built in a day, with a very small budget, and with very tight time constraints on the project. We have run a lot of extreme prototyping workshops, which allow artists and scientists from across the UK (and beyond) to come together and these workshops have grown into larger conference events, which I'll talk about later. We have run workshops, for example, Chindogu Challenge, which looked at the art of Chindogu, and asked people to make extremely unuselessness prototypes. That is, build a product based on Chindogu principles in one day.

First, I will tell you about some early projects – Andrine and the Kirlian Table, and Art-Cels (www.art-cels.com). Art-Cels was a three-day performance celebration with the performance artist Stelarc, which we held in Lancaster in 2002. We asked Stelarc to come and participate in some workshops and lectures and do the academic thing and then we held a performance party at the town hall in Lancaster on the final day. We asked people to come and do whatever they wanted to – do some guerrilla performance

with technology. Participation ranged from people simply showing up (we encouraged costuming, so some people showed up in robot outfits), to guerrilla networking. We developed quite a few art pieces that evening and one of them was Andrine. Andrine is an emotional interactive avatar, so you can send text messages to Andrine and she responds emotionally to your text message. She understands over 60,000 words and sentences. We ran Andrine at Art-Cels and it was quite popular and so we've run it quite a few times since then. Andrine was recently re-skinned with famous faces from people in Liverpool for the Capital City of Culture opening night gala event, where she was projected on a massive balloon.

Shortly after that we developed, again in a short period of time, the Kirlian Table that is based on the idea of Kirlian photography (so when you take a picture it shows your aura). The idea was that you would put an object on the table and your aura would be burned onto the table and when you took that object away, your aura would slowly disappear. The table was developed in one day and it's been used extensively since and kids love it, and it's very easy to set up. When we started doing these types of interactive installations, they were very cutting edge. Now you see them a lot more in museums and galleries and they're becoming commonplace. So it's been very exciting to see that transition from being at the margins to now being in a huge pool of people who are doing this kind of work.

In 2005 we decided to form a limited company based partially on pressure from a lot of people and partially because we thought, what is wrong with making some money out of something you love doing? So we've developed a lot of things since then and during that transition time. The first year of course, was filling out lots and lots of paperwork. One of the earliest installations we did during this transition time was called Metamorphosis. I was asked to be

IMAGE: (re)Skinning Andrine. Photo credit: BigDog Interactive.

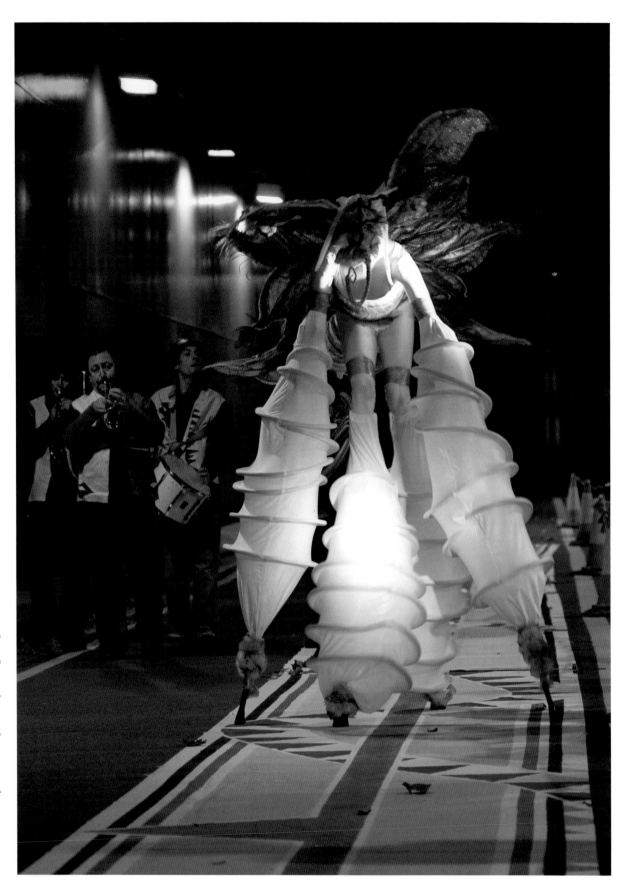

IMAGE: e-Campus Underpass Opening Night Gala. Photo credit: K. Woolford for BigDog Interactive.

the co-manager of the e-Campus Underpass project at Lancaster University. The e-Campus project looked to put a distributed network of large-screen displays across campus, and they were networked so you could show content on different displays. The Underpass project, which consisted of three projectors positioned above where people waited for the bus, was located in this horrible, awful, grey, dismal tunnel on the university campus. The clients wanted to brighten it up a little bit and to show people content about what was going on, on campus. It was also a place where visitors would wait for transportation. The main technical problem at the time was how do you create content that can run seamlessly across three screens so that the screens can run independently but also together? That was a huge problem at the time. It's not a problem now so much but it still takes some work.

So we created some content with Welfare State International, which was up at the Lanternhouse in Ulverston at the time. We developed some content which was a butterfly, a very, very simple butterfly, which was made first with paper and then digitised. The butterfly flew across the three screens. The idea was that when the buses went through the underpass and passed the butterfly, the butterfly would get frightened and fly back into its chrysalis. It was also meant to provoke questions about how our technology is affecting our environment. Not surprisingly, after the projectors were in the underpass for a very short time, they got gummed up with all the petrol that was being discharged from the buses' exhausts and I still don't know if anyone's run anything since then out of those projectors.

Our big thing is not just making installations but creating an event, some sort of event and performance around what we do. So we ran three workshops with students at the university to show them how they could use Max/MSP to create sound installations for the underpass and

to create visuals using Max/MSP. For the open evening event, we closed the underpass to divert bus traffic and gave people bikes so they could go through the underpass instead of having buses go back and forth. We invited kids from a youth housing programme in Morecambe to come and do the workshops as well. The idea being that we wanted the kids to see that there were opportunities at the university for them that weren't so scary. It's really important to encourage kids, particularly the ones that are afraid to ask questions or think that they don't have a place at university, that there is an opportunity for them there. And they had a really good time.

One of our more recent projects was working with an advertising agency. They are quite special people. Their problem was that they had 830 mobile phones, three different models, and you can imagine that the parts came from all over the place. They wanted to synchronise the phones. Each phone had a different video on it, which also had sound, and somebody had composed the score and they wanted these phones to run and show the video while the score was playing – a hugely complex problem. I don't know where the idea originated from: advertising people trawl the web looking for new ideas all the time. Ad agencies come up with various things by looking at YouTube and stuff. So you never know who's been inspired by your ideas. We don't necessarily come up with all these things on our own. We work with a lot of people who say, "I want to do something but I don't have the technical knowledge. How do I do it?" And so we provide that technical expertise. We have experts in eye-tracking, networking, wireless technology and embedded computing. I strongly believe that anything is possible. It's just a matter of how to do it. It's not about whether or not you should do it.

I want to talk a little bit about our research because I do come from an academic background somewhat, and I think it's really

IMAGE: Hoverflies. Photo credit: Jacqui Bellamy, PixelWitch Pictures.

important that we reflect on the things that we're creating, and maybe reflection is not done enough. Now that there's more people doing these kinds of things maybe that will change. With BigDog we look at Digital Live Art. Digital Live Art is the intersection of Live Art, Computing and Human-Computer Interaction (HCI). So as I said, in HCI we often look at how people use computers for task-based uses of technology, how to increase efficiency in the office or workplace. But we're looking at non-task-based uses of technology. Things like how you use computing in a club environment and stuff, although for a DJ that is work! So we look at what is called playful arenas. Playful arenas are things like clubs and festivals where spontaneous interaction and improvisation is encouraged. And we look at this notion of Paidia, or pure play, playing for pure pleasure rather than competitive games. We're looking at people messing around having a good time but in really harsh environments. Some people say, "isn't that a lot of fun!", but it actually takes a lot of work to design for these environments.

"it's really important that we reflect on the things that we're creating, and maybe (reflection) is not done enough"

One of the things that we look at is how we can encourage people – what we call witting transitions – to transition from watching something happening to participating in that and to even learning the skills, acquiring the skills, to be a performer within that performance. So how do you design technologies that allow people to transition wittingly? I've written extensively about this, particularly the Performance Triad Model and things like Tripartite Interaction. These models and theories are all very important, but I wanted to focus a little bit more on some of

the things that we've built here. So, Exertion Interfaces are something that I say is my area of expertise. Floyd Mueller Exertion Interfaces, which is work that's actually going on up in Scotland and Australia, are really physical interfaces – interfaces that require people to be super physical. So it's about getting away from pressing buttons and watching things on a screen to being really, really active, like using the WiiFit or the Wii Remote which make you move your arms around a lot more.

We built a system called iPoi – now uPoi. At clubs and festivals people do poi – poi is a ball on a string that you swing round your body as an alternative to dance. You can do lots of different moves, much like juggling. What we wanted to do was to allow people to create layered sound and visuals. So instead of just having one person controlling one sound and visual, multiple people could be playing poi and each poi ball could be controlling a different sound and visual. Initially we hooked up an accelerometer, stuck it on a ball, and wired it straight to a microcontroller, which was connected to a MIDI device that was connected to a computer and then to a projector. And we looked at this and it actually made some sound and visuals. And that was good of course, except if you're doing poi and swinging things around your body you can wrap the strings around your neck so it's not a great idea. So we had to make a wireless board and fit it inside a tennis ball. It's just an accelerometer and a tiny microcontroller that streams acceleration data so when you swing the poi, the acceleration data goes straight to the computer. That was good for just producing sound but we were only capturing data on a single channel so only one poi ball was transmitting acceleration data. So we started using Moteiv's Tmote Sky modules, which allowed us to send multiple streams of acceleration data to one computer or to multiple computers. So you could have someone swinging multiple poi balls or millions of people playing.

We were then asked to go to a little dance studio in Lancaster. We did a performance where we had lots of people just swinging the poi around – you might have guessed from the video that we were using triggered sound loops, so if you swung the poi it triggered pre-recorded sound loops. The next step was to create algorithmic sound – so we worked with some sound engineers, and we changed the visuals because by then we had taken the system to a lot of clubs and a lot of festivals. At the festivals, because of the environment, we had to redevelop our interface to allow us to change the colours, so depending on the colour of the tent or depending on the sound coming out of the tent, we could change all the variables and parameters. So, different coloured circles represented different sounds coming out, which evolved as it played and there were different colours for different people. We found that blocky images worked the best on tents, particularly at four in the morning at a festival.

I started becoming really obsessed with swings and swinging and pendulums. I came across a Harmonograph, which is a double pendulum that swings in opposition, and you can create Lissajous curves by getting it swinging at different times – that's how people originally made the graphics on bank notes. Whilst I was building this I had a call from Leeds University and their Emergent Objects Research cluster (PI Mick Wallis) and they asked me to become technical lead on a project that later became Hoverflies. We took the idea of the Harmonograph and we said what would it be like to turn that into giant swings for adults, so not for kids but oversize ones that made you feel like a kid, and project sound and visuals as you're swinging in opposition with someone, not quite hitting them but coming quite close to them? We worked with a lot of sound people to create various sounds. Martyn Ware, who runs the Future of Sound events, we worked with him – he's from Human League and Heaven 17. He's now very much into creating new sound

technologies and with Martyn we created the world's first outdoor real-time 3D interactive sound system. We set up the sound system in an outdoor park (on the university campus) and we set up the swings and we allowed people to come and just play on the swings. The system played really annoying sounds and different spacey sounds.

Currently, I'm working at the London Knowledge Lab, and I've built an interactive table surface using similar technology to the reacTable using Processing and reacTIVision to do the software side of it, and then building the table from scratch. In education, children are having a really hard time understanding basic physics concepts and basic science concepts, and so we are exploring if tangibles will allow children to better understand basic science concepts such as light reflection and refraction. You can use the table to show different science concepts. So we're creating a table first.

Next, I just wanted to mention the conference series that I'm founding director of called (re) Actor - which is about bringing people together who are experimenting with performance art and technology, for one day, to present their work, much like here. (www.digitalliveart.com)

One of the questions repeatedly asked is what do you think the future will be like? I'm more concerned with the question what would my ideal future look like? And most importantly, I think, having been involved in technology now for a long time, I am really disappointed that the number of women who are actually building stuff is dwindling – the numbers of women going into computer science is actually getting smaller, proportionately smaller. I think it really affects the types of things we see and the types of things that are built, and I'd like to see more women building things, not just men. I think the fashion world is fantastic because they've grasped technology and they hit a lot of people with their images, but I'd like to see more

women get out of those clothes, not necessarily in the way that Moritz Waldemeyer took them out of their clothes (!) and see them actually building things.

Moreover, I think because we have asked our computers to be smaller and cheaper and ubiquitous, we're starting to lose, well – we don't know what's controlling what any more. We don't know where our computers are. I was talking to someone recently who did a school talk and they said that they talked to the children and the children didn't know that you could build software for an iPhone or an iPod and that would be considered computer science. The schoolchildren didn't know or understand what computer science was or what the options were relevant to. So I think we need better exposure and awareness of what computing is, particularly as it's changing. I also think that those people who do build things realise the time and effort it takes to do this and I think sometimes people think that you can easily build something and there needs to be better awareness of how much effort it takes to build and that can only come from more people doing it, I think, and being hands on. And then of course, increased funding opportunities, because like I said, there's nothing wrong with enjoying what you're doing and making a living out of it, and that can only come from people taking risks and wanting to have a tail, like those developed by Greyworld, or something similar. So I guess my advice would just be first of all for people to get off their butt, and start building – more and more. More builders are needed.

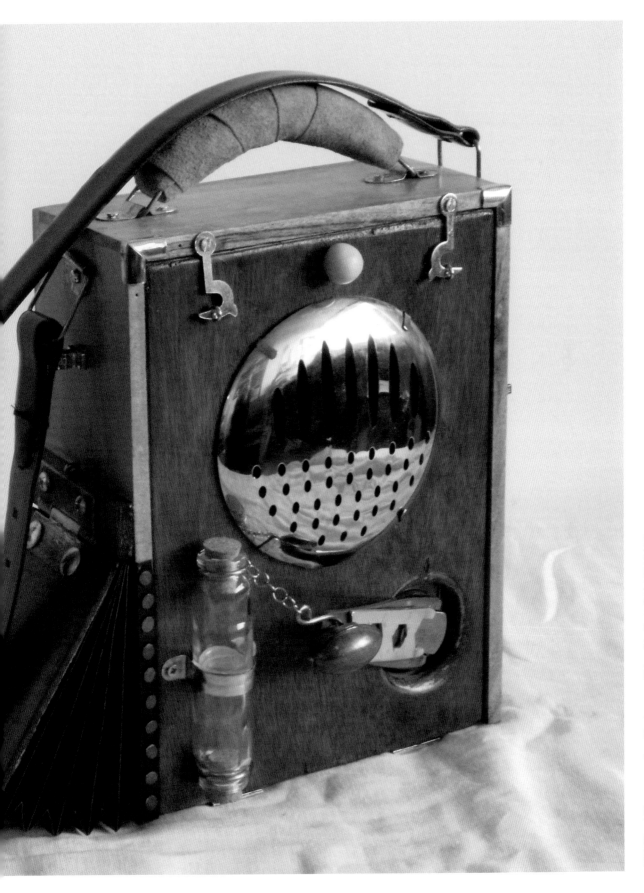

IMAGE: iPhonograph. Photo credit: BigDog Interactive.

Q&A

Q Your last point there about the increased funding, how do you feel about the commercialisation of some of these projects that are being used for now, does it bother you? Because I just wonder whether... a lot of the things you've got there, you have fantastic ideas and ways to do things, but no-one has asked you to do. It's a bit like the cart behind the horse, you find a way to do something and then you need somebody that needs or wants to do it. And a lot of the time the money or the buy in for it isn't there...

A Yes and they have crazy budgets these people, I mean just crazy. Sometimes I think their money is going into the wrong hands and our universities, let's not kid ourselves, they've become businesses and you see artistic practices becoming more and more like businesses, but maybe that's progress. I can be really argumentative sometimes and people talk about Open Source and having everything free and all this stuff, and that's great and it's brilliant. But we also have to kind of take a step back once in a while and say that's kind of like "open sores", as my friend calls it, where you have to rely on certain people to fix things. I think commercialising things and allowing yourself to make a living off it, what's wrong with that? That's what everybody does, and we are in a field that's growing. If it's not going to happen now it's going to happen in the future, and if people choose to be at home making something or in business making something, then that's their choice really. It just means that choice is there now. It wasn't a few years ago, and for some people it's not attainable particularly if you live in a very remote country, it's much harder to obtain commercial contracts and such.

Q I think it's interesting that a lot of people are extremely well educated and extremely intelligent and one of the things that you're probably not being trained to do is to publicise yourselves and try to sell yourself. I mean a lot of you are doing extremely well...

A Yes, well I mean some people think that's selling out and stuff, but it is difficult. I mean the hardest part of all this is how do you explain the importance of having a tail (like Greyworld's project)? I keep citing the tail as an example because I just think it's hilarious and it actually is exactly what we should be doing and thinking about, getting out of our comfort zone. Why go online and be crazy when you can do it in the real world. So, yes it is difficult because when you talk about some projects they sound totally insane, and most people look at you and say that's just stupid, why would you do that? But when you see the project in reality it can be absolutely beautiful. I can imagine Moritz Waldemeyer's dress and the room with the lasers in it and it's simply mind-blowing. It is absolutely beautiful and those projects are iconic images that last forever. Projects like Moritz's laser dress are the things that make us think about what we're doing and how things are changing. But I don't know about this publicity thing because if you do de-commercialise it, how do you sell yourself? We at BigDog don't know the answer. I think sometimes computing tends to attract people who are very introverted, meaning it's hard sometimes to get up and talk. You have to do a performance.

Q There is an organisation in France that campaigns for the advertising industry to be taxed 1 per cent and have that money to fund artists, which seems to be a very, very fair way of dealing with this problem of advertising constantly picking the ideas of artists.

A Yes, well that's brilliant, I didn't know that.

Q I wondered what the value is in actually physically making some of these things? So it looked like you actually dealt with that problem with the 800 or so phones, perhaps it could have been simulated. And it's something that somebody else I know, who's also worked in advertising funnily enough, said he always thought it was a complete waste of money not to simulate it until you've actually done it whereas I think it's great to have done it. I just wondered what you feel the value is?

A Well some of that was simulated because I mean obviously there's problems inherent in everything you do. But, I think I'm a sensual person, I'm human. I like to feel things and touch things and see things. And although I obviously see the value of virtual things and I'm really into the digital, I do like to experience things physically. The problem with a lot of the computing that we've all seen in the past is we've generally got one person on a computer at one time. All the stuff BigDog does is to try to get people away from sitting at a screen and looking at it and facing it. We attempt to get people to communicate out in the real world and to actually interact with each other and create something collaboratively, and to still be human. There are benefits of both virtual and digital but I think that's a really hard argument. But if you think it's cheaper to actually produce that digitally, you're wrong. You're very wrong. Simulation can be very, very expensive.

http://troika.uk.com/

Troika

"We like to combine and integrate our different skills – that often creates some unexpected results, and excites us."

IMAGE PREVIOUS PAGE: Troika / All the time in the world / 2008 / Photo © Alex Delfanne / Artwise Curators
IMAGE LEFT: Troika / Newton Virus / 2005 / Photo © Troika

We are Troika and I will go through a little bit of what we do and how we do it and show some examples of our work. We are a multidisciplinary art and design studio. What we mean by this is that we work in different disciplines and create different types of work. We work on one-off bigger interactive installations where we often use technology as a medium and we also work in graphic design. We create books as well as corporate identities that are perhaps the most commercial spin off of the company. The three founders of Troika – Conny Freyer, Eva Rucki and myself, Sebastien Noel – come from different backgrounds and mix a lot of different experiences and knowledge. For instance, both Conny and Eva have a background in graphic and communication design and I am a product designer with a background in engineering. Between the three of us, we have a very valuable set of skills that we like to combine and integrate because we think that bridging these different fields often brings out some unexpected results and this is what excites us.

We describe ourselves as an art and design studio and we don't really care too much about the distinction between the two. One aspect we find interesting is bridging art and design

and placing our concepts into the design context. With the "SMS Guerilla Projector' we created a product as a medium. We have many different fields of activity. We do a lot of exhibition work, and we do a lot of work with galleries such as the recent exhibition, "Design and the Elastic Mind" in New York. We also work for commercial clients like the BBC, the MTV Network, and we have worked with British Airways. Our work also includes applied work, like the exhibition designs we developed for the Arts Program of the Science Museum in London.

I would like to show you a few examples of recent work. We recently published a book called "Digital by Design", which includes the work of several designers and artists who are all using digital technology in a number of very unconventional ways. We think the book portrays something very new that departs from the tradition of media art, in a sense that for the first time the practitioners really develop digital technology or processes into material objects and are thinking about the correlation between the digital and the analogue world. In the book, you will find many examples such as Daniel Rozin's "Interactive Mirror", which is probably one of the most well-known interaction design

projects of its kind. In our work we are really interested in exploring how you can use design as a vehicle for meaning or experiences. For example, the "Electroprobe" is a little product that allows you to hear magnetic fields. We live in a society where we are surrounded by electronic objects yet we know very little about them simply because we don't have the receptors, the body receptors to tune into their worlds. The "Electroprobe" acts as a gateway to the surrounding electro-magnetic landscape.

The first time we exhibited the "Electroprobe" was at the Royal Academy in London, and we realised very soon that we had two categories of people reacting to it. On the one hand we had people who were fascinated by the sounds, because they are very crisp and varied. They would start to chase certain sounds and look for new ones. On the other hand you had people who would react very strangely. They were concerned and thought, "Wow, is that what you call electronic noise, is that what my feelings sound like?" There was this ambiguity between fascination and concern, which reminded us that technology in a broader sense is a double-edged sword. The second time we exhibited it we wanted to emphasise both of these aspects – fascination and concern – at the same time. In order to achieve that we took a lot of electrical and electronic objects and arranged them according to the kind of sound they create. The purpose was twofold. Firstly, to increase the volume of the magnetic noise, which is easy to accomplish because if you put 6 Kilowatt worth of electronic objects together it's very, very loud. The second aim was to make the sound-scape even more appealing, because we wanted to amplify people's reactions to the installation. When the magnetic fields of the objects start to interfere with one another, you get a wide variety of sounds that you can listen to – a little bit like a modern kind of musical instrument.

We created a very similar installation in China as part of a large exhibition called "Get it Louder" that was touring Shanghai, Beijing and Guangzhou. We decided to make the installation on site in Guangzhou. We went to Guangzhou knowing that there was a lot of electronic product design and manufacture around this area and decided to bring an electroprobe with us. It was absolutely amazing because Guangzhou is flooded with some 20,000 square kilometres of wholesale electronic centres, so if you go into those little stall kind of shops, you sometimes have metres and metres of watches, calculators, and electronic gadgets all stuck together and all fully functioning so the magnetic noise is absolutely deafening. We decided to create an Electroprobe installation, this time based on everyday electronic culture, partly to raise awareness about the real nature of electronic objects. We created an assemblage of locally sourced objects. We chose to use copies of existing electronic products, like copies of iPhones, copies of Sony Ericsson mobile phones, and copies of Sony Discmans. They were all fakes, not one single object was an original. Recently we have continued on this theme and made another version for an exhibition in Spain called "Nowhere/Now/Here". It is a similar idea, where we explored the ambiguity between the whimsical appeal of sticking objects together and the reality of producing an awful lot of further magnetic noise. Another aspect that interests us is recombination. How you can get access to electronic culture and magnetic culture by hacking, recombining and making open-ended objects. The "SMS Guerrilla Projector" is an exercise in creating a tool for mass response to current issues. It is a projector that integrates a Nokia 3310, which is a standard mobile phone, and existing parts like projector components, phone bits and photographic components. The mobile phone parts, such as the screen have been dismantled and peeled off. The LCD screen is used as a slide to project the text messages. The "SMS Guerrilla Projector" can receive, project and send messages wherever

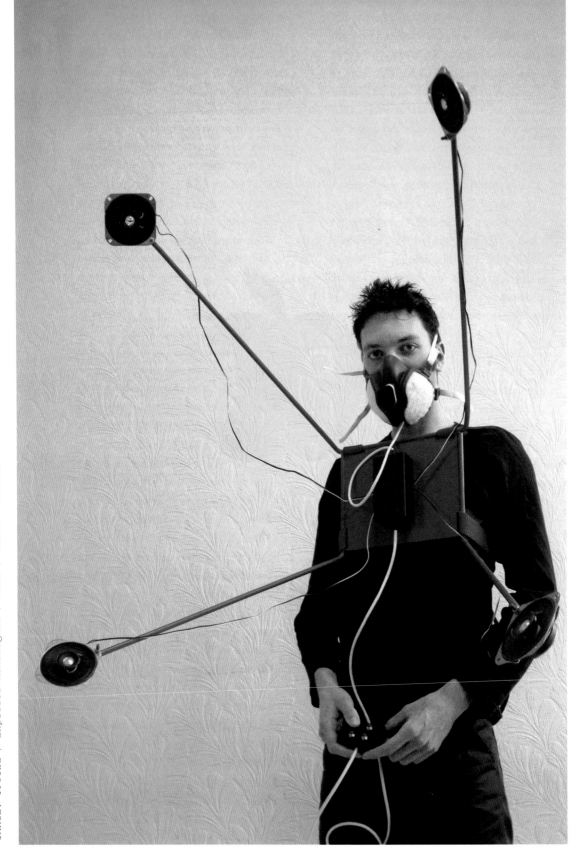

projects of its kind. In our work we are really interested in exploring how you can use design as a vehicle for meaning or experiences. For example, the "Electroprobe" is a little product that allows you to hear magnetic fields. We live in a society where we are surrounded by electronic objects yet we know very little about them simply because we don't have the receptors, the body receptors to tune into their worlds. The "Electroprobe" acts as a gateway to the surrounding electro-magnetic landscape.

The first time we exhibited the "Electroprobe" was at the Royal Academy in London, and we realised very soon that we had two categories of people reacting to it. On the one hand we had people who were fascinated by the sounds, because they are very crisp and varied. They would start to chase certain sounds and look for new ones. On the other hand you had people who would react very strangely. They were concerned and thought, "Wow, is that what you call electronic noise, is that what my feelings sound like?" There was this ambiguity between fascination and concern, which reminded us that technology in a broader sense is a double-edged sword. The second time we exhibited it we wanted to emphasise both of these aspects – fascination and concern – at the same time. In order to achieve that we took a lot of electrical and electronic objects and arranged them according to the kind of sound they create. The purpose was twofold. Firstly, to increase the volume of the magnetic noise, which is easy to accomplish because if you put 6 Kilowatt worth of electronic objects together it's very, very loud. The second aim was to make the sound-scape even more appealing, because we wanted to amplify people's reactions to the installation. When the magnetic fields of the objects start to interfere with one another, you get a wide variety of sounds that you can listen to – a little bit like a modern kind of musical instrument.

We created a very similar installation in China as part of a large exhibition called "Get it Louder" that was touring Shanghai, Beijing and Guangzhou. We decided to make the installation on site in Guangzhou. We went to Guangzhou knowing that there was a lot of electronic product design and manufacture around this area and decided to bring an electroprobe with us. It was absolutely amazing because Guangzhou is flooded with some 20,000 square kilometres of wholesale electronic centres, so if you go into those little stall kind of shops, you sometimes have metres and metres of watches, calculators, and electronic gadgets all stuck together and all fully functioning so the magnetic noise is absolutely deafening. We decided to create an Electroprobe installation, this time based on everyday electronic culture, partly to raise awareness about the real nature of electronic objects. We created an assemblage of locally sourced objects. We chose to use copies of existing electronic products, like copies of iPhones, copies of Sony Ericsson mobile phones, and copies of Sony Discmans. They were all fakes, not one single object was an original. Recently we have continued on this theme and made another version for an exhibition in Spain called "Nowhere/Now/Here". It is a similar idea, where we explored the ambiguity between the whimsical appeal of sticking objects together and the reality of producing an awful lot of further magnetic noise. Another aspect that interests us is recombination. How you can get access to electronic culture and magnetic culture by hacking, recombining and making open-ended objects. The "SMS Guerrilla Projector" is an exercise in creating a tool for mass response to current issues. It is a projector that integrates a Nokia 3310, which is a standard mobile phone, and existing parts like projector components, phone bits and photographic components. The mobile phone parts, such as the screen have been dismantled and peeled off. The LCD screen is used as a slide to project the text messages. The "SMS Guerrilla Projector" can receive, project and send messages wherever

you are. We have projected messages inside people's houses posing questions about aspects of wealth and security. Because it is a relatively small, self-contained and battery-operated object, you can hide it easily. You can project messages on to the backs of people, in cinemas and whilst people are talking. Particularly at conferences it is a very fun object to use and it was a nice experiment. We did look at these issues further, in the form of the "Tool for Armchair Activists". We created the "Tool for Armchair Activists" as a response to the ban that prohibits any demonstrations within a radius of three miles around the Houses of Parliament, in effect creating a dead zone for expressing one's opinion, which is a strange idea. Interestingly, if you look at the history of technology when human activity of some sort is banned, it tends to get replaced by a machine. So, we thought, this called for a machine. The machine we created is called the "Tool for Armchair Activists", which is an object that can be strapped on to any lamppost. It features a big megaphone, which will speak out – in a loud and computerized voice – any SMS messages that are sent to it. This means you don't have to stand in the rain to send your political messages. You can do it from the comfort of your own living room. The "Tool for Armchair Activists" has been a feature on many blogs especially on activist websites in the USA, which has led to fascinating discussions as people start to question the real purpose of demonstrating, which we have found extremely interesting. Two years later we were approached by MTV for the MTV Awards in Europe in 2006. We were asked to devise a guerrilla campaign in the run up to the awards. This provided us with the perfect occasion to extend the audience of our work beyond the museum and gallery audience and put it into an urban context. The "Tool for Armchair Activists" would be seen by people who would not necessarily go to an exhibition, which we found intriguing. It was also great for us to get the chance to work with some forward-thinking clients who gave us this kind of freedom. In this case we developed an anti campaign against the awards telling the audience not to vote because the results were fixed in advance, in essence that there was no point in voting for the awards. This was installed on the streets of Copenhagen for two weeks. It was switched on from seven o'clock in the morning to ten o'clock at night and the number was given to anybody passing by. The "Tool for Armchair Activists" was speaking both Danish and English depending on which pre-code was included in the SMS message. In addition we created some very authentic posters that were plastered around the city to advertise the campaign. The outcome of the project was very successful, we received about 1,200 messages in two weeks, which equates to about 85 messages per day, which is a lot. It would speak out aloud anything you sent, even abuse, and it was interesting to see that the database of messages that had been sent contained very little abuse. We had a lot of very interesting messages submitted. For example, kids were stopping to advertise, people were starting to comment about the life in the city, some sent poems, and again it became a very integrated tool in the city which we found very pleasing and amusing.

We're interested in old technologies such as music boxes, because every piece has a very clear function. If you look at the mechanism of a little music box, you can tell what is the function of each component. For example you can see the little pins that prick each tooth of the cylinder. We find the way technology used to be developed before we had integrated processes fascinating. When there were not as many documented processes around, with a lot of external functions claiming a role in the development of a product, like for example marketing does. What we like in particular about the era of Victorian technology is, that you can see that there are a lot of very subjective decisions that have been taken throughout the development process. We are fascinated

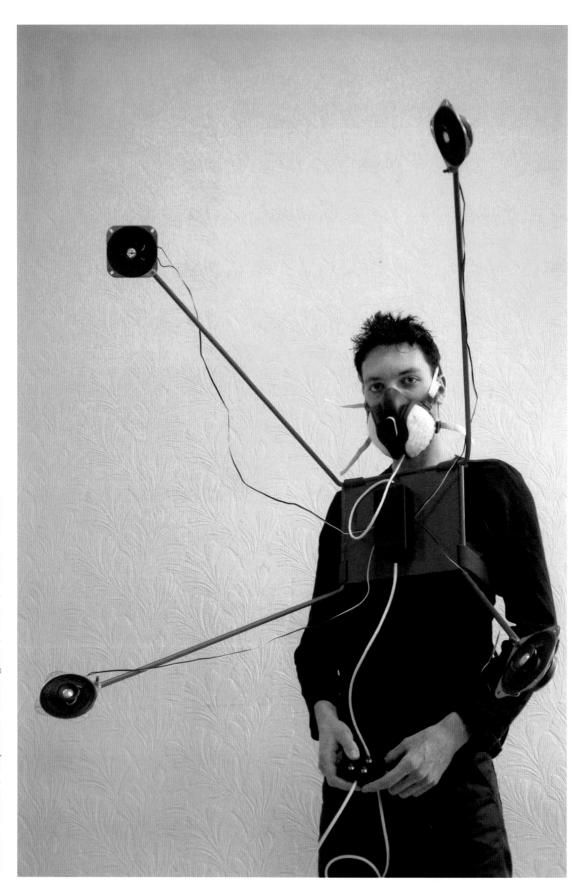

by people like Athanasius Kircher, a German scholar from the 16th century who devised things like the cat piano, where every kitten has its tail pricked by a little needle when you press the piano key causing them to meow loudly. Apparently he devised this piano for the prince of Italy who was very, very sad at the time. According to reports it took nearly six months to find the tuned kitten who performed with him. It's very cruel, but at the same time the only example of a quirky interactive instrument that we've found. We really love the physicality of technology. Another example of Athanasius Kircher's work that we love is his spying device, which is completely wrong. Acoustically it doesn't work, but what is interesting is that you can see he has used speaking statues. Why are there speaking statues? There is absolutely no rationale behind it, but it's a kind of magical quirk and that's what we find really inspiring about his work.

We got approached by Wat Tyler Country Park, which is in Basildon, Essex, who wanted to regenerate the area around the park. They asked us to make a sculpture and instead of making a very fancy sculpture, we went around and looked at who is using the park and we found that there were a lot of kids who visited the park. The kids were hanging out in this area, which was a bit worn down and there was absolutely nothing for them to do. So we thought, okay we're going to make something for the kids and we devised a sound sculpture based on an acoustic phenomenon comprising of two big whisper dishes. There is no technology in them apart from their given shape. They look like two marshmallows that have fallen from the sky and landed in the park, one is pink and the other one is white – as marshmallows should be. They are two sets of parabolic dishes that are located 60 metres apart across a pond. If you whisper into one dish on one side, the sound travels across the lake and gets refocused by the parabolic mirror on the other side. So you can hear very, very

clearly the whisper from over 60 metres away. The people from the park wanted us to paint them grey and black with anti vandalism paint, but we said no, you've got to paint them gloss pink and gloss white, because we think that the experience is going to be enough for the kids to take ownership of them and protect them. We did not put a sign up explaining how the installation works, but only told a few kids sitting nearby one day. They have been installed for a while now and there hasn't been any report of them being damaged nor vandalised, which is great. We explored the sound principle with acoustic consultants Sandy Brown Associates who are regularly involved in sound insulation and sound simulation projects on an architectural scale. They were very excited to work on a project that was aiming to increase noise rather than reducing it, which perhaps says a lot about architecture today.

A lot of our work is responding to its immediate context. "All the Time in the World" is an installation that we developed for British Airways. It is installed in the entrance hall of BA's VIP lounges in Terminal 5 at Heathrow. It features a 25-metre-long screen that displays a world clock. However, instead of showing London, Paris, New York and all the capital cities of the world, we've chosen to display more surprising destinations including areas of romantic interest such as mountains and rivers, ancient cities and dream islands, and it will give you the time at those particular locations. We wanted to evoke an atmosphere of travel and also show different installations around the world. The big clock in the middle displays the local time of London and to the left and the right you have locations like Kilimanjaro, the Taj Mahal, Victoria Falls and the Great Barrier Reef. At the core of the display is a new typology of electroluminescent display, which we developed called "Firefly". It relies on a custom-designed segmented typeface that we have developed and patented. This new way of creating text-based screens is based

on printing a segmented typeface – a little bit
like your digital watch, which has a series of
segments that are arranged in two dimensions.
By switching on and off different segments, you
are able to create different characters. "Firefly"
is a very elaborate version of a segmented
typeface, it has 67 segments that allow you to
display four different typefaces. It can display
capitals, small caps, a sans serif and a script
version, which allows for a very versatile
text-based screen. This display is printed on
acetate using special inks and is only about 2
millimetres thick.

"We are interested by recombination
and hacking as a way of accessing
electronic culture."

We were very interested in this new printing
technology and we wanted to see what we could
contribute as designers. Whereas engineers
might look for ways to use new technology
such as full screen, full resolution, full colour
and so on, we don't think that is necessarily
an appropriate approach. For example, there
are many incidents in the real world where you
only need to display text information, flight
information display being one example. This
installation is set in a terminal which has over
600 huge plasma display screens that are solely
used to display flight numbers and codes of
arriving and departing planes from A to B. The
"Firefly" display is made very economically in
the sense that you have very, very thin layers
of material that are deposited on to an acetate
substrate which can be amended and so on.
The technology used is very, very efficient as
well, it's about 90 per cent efficient, in the sense
that it uses a cold light. There is no emission
of infrared, which is a very good thing and
the whole display at almost 25 metres long
consumes somewhere in the region of 700
Watts in total. A screen of the same dimensions
in any other technology would have consumed

a lot more. For example, a small plasma screen consumes about 3 Kilowatts of energy. This was a very interesting experiment, which we hope we'll be able to bring to other projects. Troika is a small studio, but I hope that we've shown that we are capable of a variety of design interventions. We can create innovative and creative products and installations that have a functional side to them.

Whilst working on "All the Time in the World" we got commissioned to create another project for Heathrow Airport Terminal 5 called "Cloud". "Cloud" is a 5 metres x 2 metres x 1 metre digital sculpture, which has an organic yet rational shape. It is made up of little flip dots. Each little flip dot is an electromechanical indicator that can flip from one side to the other. Flip-dot technology was regularly used in the 1970s and 1980s to create signs in train stations and airports and we used them here because they have that physical flip and clicking noise that is so reminiscent of travel. After we created "All the Time in the World", based using an emerging technology, we thought let's revisit display technologies from the past, and utilise something that we really used to like, why is technology always looking forward and never backward? We never look at what we already have, which is something that we tend to do in every field of human knowledge except in technology, which is very strange. So we thought okay how do we bring flip-dot technology up to date and use this in a more poetic way. The brief was very open, another example of having a very forward-thinking client who likes interesting work. BA commissioned us to create a signature piece for the atrium space at the entrance of their first-class lounges. The atrium is a transitional space. Its two escalators lead from the busy shopping mall level to the tranquility of the first-class lounges. The idea of "Cloud" was simple. You work your way up to the first-class lounges from the busy shopping mall and upon arrival you enter "paradise". So we thought

there was a very clear analogy with the act of flying itself, especially when you take off from the UK. First it's very rainy, very grey, very busy, then you pass through the layer of clouds and you enter the calm and tranquil space above the clouds. We created "Cloud" as a metaphor for this kind of experience.

"Cloud" is a kinetic sculpture, that is covered with almost 5,000 little custom-made flip dots, each one comprising a mirrored surface. We were interested in the noise the flip dots create, because it instantly reminds you of travel. In addition their movement resembles the flow of people passing through the airport. We try to create works that are multilayered, and at the same time easily accessible. Our initial idea was to create a cloud with dots that could be animated and display different kinds of images and animations. Then we had to start thinking how we were going to actually make it. We started by asking, how can we tile an organic three-dimensional surface evenly with elements of the same size. This was a very tough mathematical problem, a topological problem that is not easy to solve. We looked at a lot of different shapes, how they evolved and how they were evenly distributed across a surface. We looked at how much of a gap between the different elements is created when you extrude the shape in space. We realised that entirely irregular-shaped objects could be tiled very well such as objects from nature, so we looked a lot at natural forms and theories such as objects like the pineapple. A pineapple is a fantastic shape because its cells nestle really well. We also looked at Archimedean spirals. An Archimedean spiral is a spiral like the ones you find on vinyl records and we thought, wow we've found a solution, but we hadn't because nature is very good at playing fantastic tricks, its 'components' don't have the same size. Eventually we developed a much cruder replication of nature by writing little scripts in Rhinoceros, little scripts that would give you spirals. The only problem, however, was that

the forms we could tile successfully using this principle looked more like a sea cucumber than a cloud.

We worked a lot on different shapes for the "Cloud", starting with very simple ones. However, it seemed that the more we worked on it, the more complex we managed to make the shapes. But we were determined to keep the shape simple, because the surface would be animated with flip dots and we wanted a simple shape that would allow "Cloud" to express itself without being too complex, otherwise it would have been just too much. This is how we arrived at the final rational yet organic shape for the sculpture. There is a little spiral of flip dots that goes around the "Cloud" in the early designs. But obviously making a spiral is very difficult so we had to scrap everything and start from the beginning. We reverted to a manual process of positioning the flip dots. The result that you see in the end stems from a manual placement of flip dots on the "Cloud" – one by one – whilst trying to avoid any large gaps between the individual dots. When it came to production, we thought, well we are in the 21st century so 21st-century manufacturing techniques will mean the job will be easily done. But it didn't work that way at all. There are only two CNC machines in the UK that are able to manufacture something as large as the "Cloud", even if you were to cut it into four pieces. In addition the costs involved are simply ridiculous. One machine owner didn't want to take the job at all, and the other machine owner builds exclusive racing boats and of course that was simply far too expensive for us. We started to rationalise the shape and it became more and more faceted through that process. By doing this we also realised that you could approximate the shape as a series of stripes that would be inclined in only one direction, a little bit like the body of a boat. So we devised a clever adaptation of boatbuilding technology to reduce the complexity of the build to just an aluminium strip over a skeleton frame. At the centre of the

"Cloud" is a skeleton of aluminium ribs on top of which strips of aluminium are tack welded to form the three-dimensional shape. As you have 5,000 dots, which can all be individually addressed, that means you have to pass 15,000 cables through the interior of "Cloud". There is a very limited amount of volume inside the sculpture so you have to be very precise on the location of components. It's not something you can design and say oh I'll locate the cable afterwards. It just simply doesn't work that way. For example each of the aluminium strips is unique depending on the location of the dots. There are no standard strip pieces. The upper part has a total set of seventeen strips that are all individually numbered. Obviously when we went to our fabricator who we use to manufacture a lot of our projects this project was viewed as very challenging. We agreed to build a prototype and the prototype worked very well. The prototype also gave us the possibility to test the control and ensure that all components were working together, as we knew this was going to be another challenging process. So we went ahead and we had to find some way to control almost 5,000 dots. We had to find a way to tell the software where each dot is located on the "Cloud". This was a huge challenge. If you have a regular dot matrix display, then you have a vertical – horizontal matrix type of arrangement, it's very easy for the control to tell where each dot is. When you have a three-dimensional organic surface, you obviously don't have a matrix, and you don't have a great system. You have to number each flip dot one by one. The way the control works is that it is used to control a matrix of 7 x 5 characters or dots, which is the minimum number of pixels you need to display a dot matrix character. So you have sets of 7 x 5 dots all over the surface of the "Cloud". Each dot is displayed individually because you can switch dot number 1 after dot number 2, after dot number 3, after dot number 4, and so on and you have to align them and create a path physically the mirror of the driving process in

IMAGE: Troika / Tool For Armchair Activists / Photo © Troika

order to minimise the amount of time you need to control the whole thing in order to have faster emission, which is very challenging. Every cable is numbered individually and several people went a bit crazy trying to put the dots together! To give you an idea of the scale of control inside the "Cloud", there are around 5,000 metres of 3-core cable, amounting to about 15,000 metres of cable in total, plus a lot of upper level control. The "Cloud" requires a main solid-state controller, which acts as the brain of the system, two electronic drivers (top and bottom – acting as distribution for the electric current), and 134 smaller distribution boards. All these components became part of the final assembly, which made sure that all the connectors were in place as well as all the dots. Because the flip dots are made from 0.2 millimetres thick aluminium and quite fragile, you can't really touch them, you can't physically touch the sculpture. So we had to create a cradle that would allow us to manoeuvre it and move it around. There was another challenge that we had to overcome. The space into which we needed to install the sculpture is an environment with thousands of restrictions. We needed to make sure that it was more or less bomb-blast proof. In case Terminal 5 explodes, the one thing that's going to survive is the "Cloud" sculpture. We had to devise some kind of hanging system for the "Cloud". Another aspect of the project was to find a solution that would allow engineers to maintain and replace all critical components, making sure that everything that could fail was in an accessible area. We achieved this by creating a kind of car boot system. A kind of Lamborghini-style boot that opens up so you can access everything that can fail, including the power supply, and a number of fans that might break down, so you needed to be able to access these parts. We went for very high quality solid-state controls. The people that made the controls for the London Eye did a lot of work for us on this project. We had to, again on the control side, recreate the old technology for the flip dots

driver and the controller and we used controller systems from the 1970s but we had to completely adapt them and add a faster microprocessor on them. Obviously, at the same time that the "Cloud" was being manufactured we needed to start thinking about the animation. How do you do that? The animations were still at a very early stage, based on a rectangular distribution of dots we worked with at the start of the project. Because we had to deliver both sculpture and animation, at the same time, we created a three-dimensional visualisation programme to help us imagine what the flip dots would look like in motion. The visualisation software was programmed in-house, while the team at Pharos Controls developed the main control software. The simulation software allows you to see how the flip dots change from black to white and allows you to look at the sculpture from all angles on screen, which is very helpful to understand how the animations will work on the actual sculpture. Every address of the flip dots on the sculpture is replicated one by one in the simulation software, which allows for a very advanced simulation. It would have been very difficult to predict what it would have looked like without the simulation program. Originally the plan was to roll the sculpture into the terminal, but all the doors were installed at the time of installation, and we couldn't just pass through any corridor, because it's a huge project with many different parties working on site at the same time. Terminal 5 at Heathrow is a huge project and you have to deal with a lot of different companies and the management of the installation process was quite challenging. We were informed by the British Airport Authority, the people who control and manage the building, on a day-to-day basis. As mentioned at the time of delivery of the "Cloud" sculpture all the security gates were already in place which meant we could not go through the normal ground route without dismantling the gates, which you can't do because they are security gates. So we had to find a plan B and the only

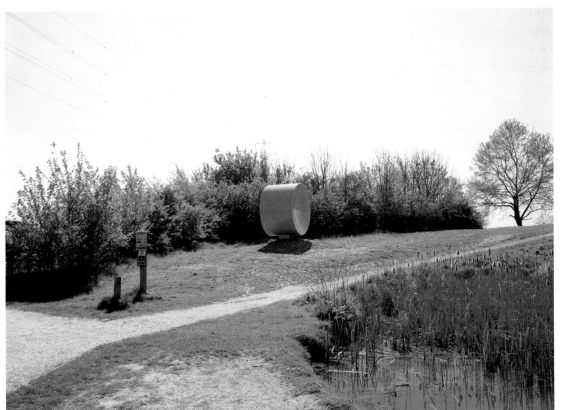

IMAGE: Troika / All the time in the world / 2008 / Photo © Alex Delfanne / Artwise

plan B we had was to 'fly' the sculpture to its final location, using the gantry within the ceiling of T5. We suspended the "Cloud" and moved it from east to west, bringing it to the other side of the terminal. This was a very tense moment because we had eight months of work suspended from a tiny cable underneath the ceiling and the "Cloud" was literally floating across the terminal. As we were working in a very high-security environment, we needed about forty people during installation to clear two floors below in case the "Cloud" fell. It was suspended 700-feet high and the structural engineer said that it would go through two floors below it if anything broke down. We "parked" it on a kind of mezzanine level, before utilising a custom-built structure that helped lowering it into its final location.

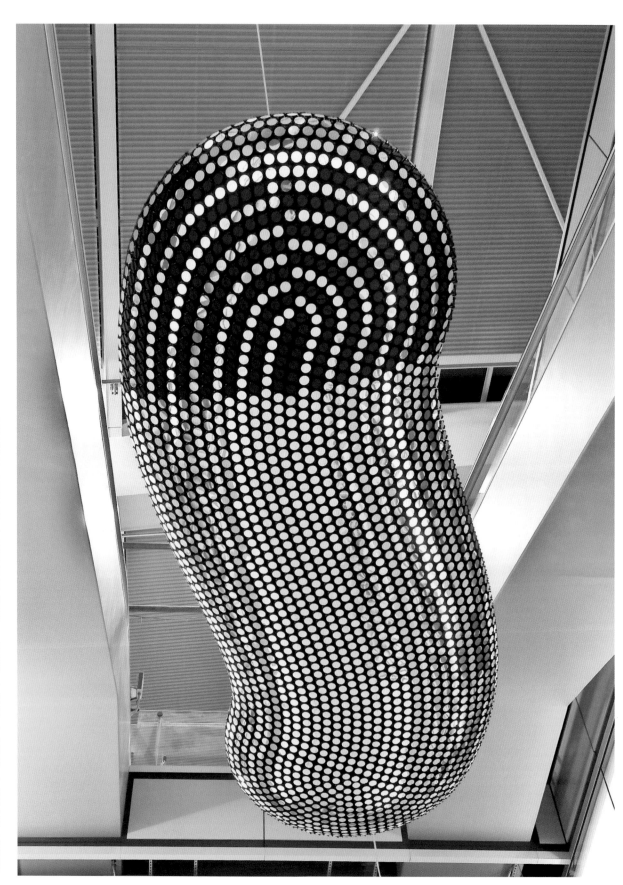

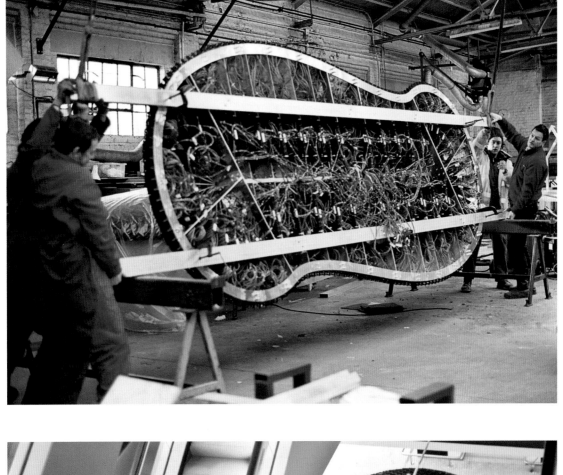

IMAGE: Troika / Cloud / 2008 / Photo © Michelle Sadgrove 2008

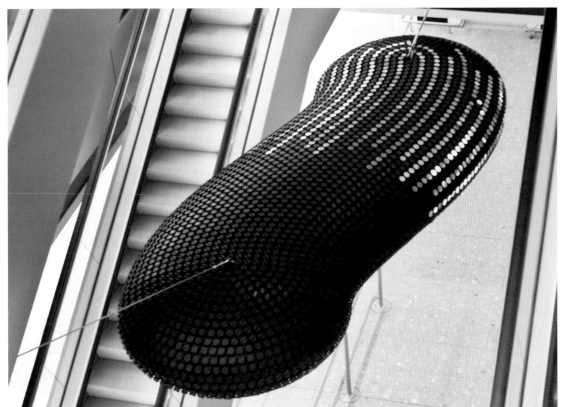

IMAGE: Troika / Cloud / Photo © Alex Delfanne / Artwise Curators

Discussion

Lucy Bullivant

We hope the practitioners' work presented here has helped to shed light on multidisciplinary processes in digital design that have been, and continue to be, adopted by a fascinating cross-section of creative practitioners – people working in diverse but overlapping fields. Together, these individuals you've had frontline exposure to constitute quite a multilayered sandwich, and there need to be more public events offering exposure to how people are working across cultures and the processes entailed and insights that emerge, as they're frequently more nourishing than typical designer presentations of new products, just success stories, end of story.

Before I open our discussion, let me fill you in on my role and why I adopted it. I'm a cultural historian who trained alongside artists and designers at the Royal College of Art during a heady period in the 1980s when conceptual design was re-emerging. I write books about the emerging field of interactive design and architecture, including 4dspace and 4dsocial for AD/Wiley and Responsive Environments for the V&A.

In this trio of titles published during a two-year period from 2005 to 2007 I concentrate on critical examination of the fruit of a dynamic relationship between theory and practice, rather than theoretical research alone. This is work evolving the possibilities of what I describe as a hybrid genre. Unpacking the implications of the relationships between individual projects is something any reflective person gains a huge

amount from, and articulating this in public allows everyone to observe the cultural evolution within individuals' career paths. One of the key reasons I came to explore this area and to care a lot about it is that I think it is deeply relevant to contemporary society. After all, we live in a digital society. While the speakers possess a variety of means and specific intentions, they are creatively conceptualising and repurposing digital technologies through customised design for social purposes. They situate themselves very intimately in relation to social dialogue, to the desirability of making narratives and also to the more commercially colonised territory of experience design that has developed since the growth of ubiquitous computing.

One reason for my fascination with this field of work is that it counters more normative applications of HCI (Human–Computer Interaction) by envisaging alternative uses of digital technologies, instead of narrowly commercial, control and task-based applications. Projects are fundamentally bespoke because their software is virtually all hand-made, both made and coded, in a way that evokes a sort of 21st-century digital craft scenario. As you will have gathered, most of the speakers are environmental in their sphere of agency while a few are object based, Owl Project's iLog being a wonderful example.

Foregrounding environmental issues also goes hand in hand with expanding scope for transgressive behaviour, creating a cultural stance that fulfils the "design noir" ideal originally proposed by Dunne and Raby. This is

work injected with stealthily playful narratives and a strong use of irony, for example, Crispin Jones's watches. Like Jennifer Sheridan's exertion interfaces, and Moritz Waldemeyer's wearable computing, we are talking about non-standard, experimental interfaces. Without heavy didacticism, these raise many profound issues about the social and cultural applications of new technologies. At a fundamental level it's about humanising technologies, and not allowing society to be technocratic, and giving priority to a more questioning cultural life.

We're all children of the digital age in some shape or form, working through our individual influences from the breakthroughs in commercial uses of digital technologies, which has moreover resituated the human subject. The iPod is a great way to play music and shut out the outside world, creating at an anthropological level a new digitally driven hermetic, nomadic space. The conceptually reflective stance of this field of work underlines the fact that we are being propelled less by longstanding habits, but more by technological advances that trigger new social behaviours, communications and lifestyles. A future that becomes "keyboardless" in the wake of a growth in voice recognition, for example, modifies human behaviour on every level, not just physiologically. Design-driven narratives about psychological behaviours create a space of necessary reflection and criticality.

So now for some questions, and while you're answering, feel free to raise some of your own for any of the other panel members. Let me ask you collectively an autobiographical question to

help kick off individual responses. Along your varied and fascinating career paths, have you experienced happy accidents offering a personal epiphany and changing the way you see the relationship between digital technologies and human behaviour, and technology as a medium?

Crispin Jones

Interestingly, listening to what you've just been saying, I think one of the fundamental things I'd take from today's event is the idea of technology as a medium, technologies as something you can shape to your own end, be they very bespoke or very specific to a certain location. But I think my epiphany with technology in that respect comes in a slightly roundabout way. I remember reading a monograph on Raymond Loewy, the French-American industrial designer and realising that he had a whole series of cars that he had built for himself, and for me that was a really interesting moment, because I thought I'd always considered the car as a thing made in a factory, something that you couldn't alter the shape of. But he had endless variations: he built himself a little sports car, a town car and so on. It was just that sense that you could absolutely shape the car into whatever form you wanted, and I think in the same way and very much more simply you can shape technology into the form you want to or to communicate the thing that you want it to.

Moritz Waldemeyer

For me there was a moment, probably quite early on, when I went to university, I was doing a business degree, or had started it at least, and because I didn't know what on earth to do with

myself next, I did this work placement and went to this manufacturing firm. It was the most fascinating place I'd ever been to, to see like all these robots making stuff and talking to the engineers. I became friends with the managers, and they took me around on tours and showed me everything that normally you never get to see and this experience triggered this desire in me that I wanted to use technology. That's how I got started studying engineering. Then everything after that was more a gradual process, but I guess this was the first trigger to send me off in that direction.

Jason Bruges

I suppose for me this moment was starting as an architect, and looking at how even early pioneers in interaction design had used simple mechanisms. I remember looking at something that Buckminster Fuller had created for his Montreal Expo, this wonderful paper punch card that controlled the façade, how it opened and closed and just thinking, well, if that was possible, then what should we be striving to do now? It was a feeling more of disillusion, really, that a lot of the technology and ideas weren't filtering down into the construction industry and the architectural world in general, and not knowing how to drive forward and reach that aspiration, I suppose. So it was a point of realisation that I wanted to do something but I wasn't yet really sure how. Then, slowly, I began to answer those questions about how to do it.

Bengt Sjölén

You mentioned human–computer interaction, and this is just one small thing, but there came

a time when I realised that we had got so much technology that was all about human to human interaction that wasn't evident to us before. Before, for example, with computer games, then you were playing against the computer, but now people aren't interested in playing against the computer anymore. People are playing against people through their computer and through the networks. The computer is just the medium and all the technology comes down to new ways for humans to interact with other humans. That for me was a revelation.

Steve Symons, Owl Project

I think I'm still waiting for my epiphany but I do remember when I was like 11 or something and I played Warhammer (a tabletop war game) which I guess everyone knows, but I could never work out whether I was into the futuristic one or the old-fashioned one. There used to be two versions, and I used to play them both. I had this quite horrible collection of futuristic models and some of the old-fashioned models. I often feel that I am trying to resolve the same problem through my work. Maybe there will be an epiphany that sorts that out.

Lucy Bullivant

What about Owl Project's epiphanies? You are both of course wedded to wood, and very anti-plastic aren't you? Have you considered changing direction? Do you think that one day you might use plastic, or is its aesthetic too disposable and also too conventionally associated with electronic products? There's also the irony that you hate disposable technologies, but then it's doubtful whether plastic is fully disposable isn't it?

There are lots of fascinating paradoxes in your work. What's happened in the process of making it that was revealing?

Simon Blackmore, Owl Project

I still really enjoy certain moments with students and all the people I work with. I do workshops that involve someone taking a light sensor and making noise. I always make sure in the first five minutes that they plug everything in, and turn the sound-making system on and they go "aargh" like that. It's that moment where they go like that, they see numbers changing and they hear the sound changing and smile. It's surprising how long people will be fascinated by just going and watching this number count up from 255 and this noise going up and down and so you give them another minute or so. But it's that moment: there's a control and then they go, you can do anything, you've got that number coming into the computer. What are you going to do with it? They go, oh my god, what do I want to do with it? I suppose I'm also still trying to work out what I'm trying to do with those numbers coming into my laptop.

Jennifer Sheridan, BigDog Interactive

I think my epiphany came when I took apart my keyboard and I realised how simple it was and how easy it is to put something together and how things work together. Every time you take something apart you start to realise that that magic you think is behind it is really quite simple and that you can do it yourself, by building something like with Owl Project's iLog. It's quite easy to replicate these things and you just need the time to do it and the motivation. So that was my epiphany – just realising that building these things isn't as hard as it seems.

Lucy Bullivant

There have been some strong international cultural influences on the interactive design field that have radically changed the way I regarded the role of the gadget. Japan has a largely benign and playful attitude towards technology. It's spawned the gadget art people, Maywa Denki, and artists like Toshio Iwai, who has worked with the Tokyo-based British architect Mark Dytham, the co-founder of KDA. Tony Dunne, now Head of Interaction Design at the Royal College of Art, went to work with Sony back in the second half of the 1980s, a time of increased dialogue between conceptual designers and Japanese firms about innovation in electronic products and services. Japan does have a few very motivated institutions, and a practitioner like Usman Haque, for example, who couldn't be here today, goes there on marathon lecture tours, he's in such demand. With this kind of infrastructure you can propagate ideas about interactive design. In the UK, creative thinking about interactive design has been strongly fostered by certain colleges and firms, but there's been a tendency as well with awards to lump web design along with interactive installations under a general heading of interactive design.

Isn't it ironic, then, that even now in the UK there is no dedicated exhibiting body, like ZKM in Karlsruhe or V2 in Rotterdam, that has emerged besides FACT in Liverpool, let's say, one with the right level of technical facilities yet culturally independent, and not part of industry

like O2's entertainment centre in Greenwich, or in the lap of industry?

Jennifer Sheridan, BigDog Interactive
It's because the systems are so hard to maintain. If the system fails and there's only one person that knows how to fix it, then you are in trouble. You can't have high-tech interactive installations and exhibits or a multimedia gallery without having the experts to maintain them. The buildings may exist for 40 years but the systems need to be regularly updated through investment because things change so quickly.

Crispin Jones
I think there is a real danger of over-romanticising the Japanese culture and I think one of the reasons Tony Dunne or Usman Haque would be interesting for the Japanese is because they bring a very British, eccentric approach to technology that is something lacking in a lot of Japanese culture. Today there is quite a characteristically British, but perhaps also a kind of European sensibility and approach to technology, and a questioning of it that probably doesn't exist in Japanese design culture. Although, I would be a bit cautious about making generalisations on that.

Paul Rodgers
I've heard that Tony Dunne was slightly disillusioned by the working practices of Japanese product design. But I would also agree with him when he says that London is the centre of this interaction design world. There's no doubt about that. I think the reason there is only one cultural centre dedicated to this field is that

in the current climate they're expensive to run. Michael and I are trying to launch something here at Edinburgh Napier University in the field of interaction design but it is difficult.

Moritz Waldemayer
For me the Japanese institution that's most interesting is Akibahara, probably all for the wrong reasons, because it's almost like a medieval market of technology, and you just dive in there and find all these crazy little bits and pieces. The culture of Akibahara is something that we don't have here at all. If you want to buy bits you have to go through catalogues, everything is online. You can never go and find a place where you find all this stuff laid out in front of you with one man sitting behind explaining every single component, someone who only sells LEDs or a particular kind of chip. That for me is like the most inspiring part of Japan that I've experienced, apart from obviously its amazing culture.

Jason Bruges
I've also been to Akibahara and it was like a technological toyshop or sweetshop, with lots of things to look at. The sensibility is obviously very different. The aesthetics are very different, so there was also that side of it. But for me historically, and probably from a more architectural perspective, everything from plug-in-and-play architecture, in terms of actual architecture right through to someone more obvious like Toyo Ito, in terms of looking at interactive architecture and seminal projects like Tower of Winds, what's interesting is that kind of history of making things, and not being

scared to make quite bold statements. Whereas I think in a European venue we're relatively constrained by lots of more pragmatic, historical and political things, I suppose.

Lucy Bullivant

Thinking of the relationship between your work and public space in cities, what attitudes lie behind the whole site-specific nature of what you do? This issue applies equally to the projects of Andrew Shoben of Greyworld, as you both site your work in public spaces, but as he has had to leave let's focus on you. Is it desirable in terms of the way we design or the way in which cities evolve, that you don't somehow end up contributing to a more homogenous culture? How can you avoid that in the way that you use electronics and custom-designed installations? Through a deliberate attempt to make a connection with history and memory?

Jason Bruges

There are a few things there. Andrew's liminal, in-between spaces – I quite like them as well and I know there are a few other practitioners that do too. It's quite often to do with contrast and actually making an impact on a space and certainly these in-between, forgotten, quite downtrodden, possibly dirty spaces, contrasting against them to make an impact. Obviously we're building things that aren't on such a big scale. They're quite difficult to build on a big scale, so you've got something that will be a lot more impactful and interesting against an in-between space. I'm just thinking of Thomas Heatherwick, people like that. He said the same thing about building things in spaces that are deprived and

need them more than more obvious spaces that aren't the norm, and less receptive to these pieces whilst they're still nice spaces to work in.

Lucy Bullivant

In contributing to an urban ambience, how do you try to be more heterogeneous in your projects rather than contributing to a more homogenous appearance, something globalisation is already influencing, with cities growing through the expansion of retailing towards a condition of being replicas of one another?

Jason Bruges

For me it's about legibility, conducting studies of how cities work and the contribution of landmarks to cities for orientation. Travelling through cities is about very unique things and there's obviously history, I mean the Legible London project is looking at how art installations and devices and things that are kind of unique, one off, bespoke things that are site-specific, making orientation or navigation much easier. And for me, taking on board the specific situation is interesting and something that I'm very keen to explore further.

Lucy Bullivant

What comes to mind in relation to this issue is the projection-based work of the Mexican video artist Rafael Lozano-Hemmer. Two years ago he did Under Scan, a public space commission in five English cities. It wasn't about the history of the community but they involved over 100 local residents in the actual filming to create projections on the ground of public squares.

People would visit over the period of a month the project was on and observe themselves and others. Children interacted and played with the projections and adults also joined in too. Here was technology not operating to purely observe and control like CCTV, but publicly mediating personal identities within a community. It's being presented in Trafalgar Square in London in November, with new videos of people arranged with Tate Modern's help, so it'll be interesting to see how people respond to it here.

Audience Question

I just wonder whether are there ways of making these kinds of creations more culturally connected with more traditional memories? Is there scope for some more distinctiveness?

Crispin Jones

Coming back to what I said earlier, today as a whole there is a very distinctive European approach to technology that I don't think you get in America, for example, where there's been more of a celebration of the progress of technology, for one thing. I think the Europeans have raised much more questions and been much more socially orientated, and also much less interested in technology for its own sake. I think Japanese culture has a distinctive approach that is very different from the work we're doing today. So to my mind I think there really has been a quite strong cultural location for this newer work, and I would say European rather than British, because I don't think it taps into essentially a British thing. But in what sense do you imagine a more distinctive cultural identity for the use of technology than we've seen today?

Lucy Bullivant

I wonder how you all feel about the potential of wearable computing? Moritz, your work is beautiful and it also almost transcends wearable computing. Somebody earlier made the point that it's actually quite onerous to test it. The ideas become prototypes and then second generation prototypes.

Moritz Waldemeyer

I think the fashion projects were more like a coincidence. I mean it's almost like theatre, what we did there, I don't see that you are going to buy a video or a t-shirt at Marks & Spencer's in ten years time. I'm very sceptical of any such predictions and also developments in that direction. There are a few markets that do require wearable electronics in the broader sense, and in those markets people are actually putting money into research and the markets are very clearly defined as being military, being anything to do with rescue, fire fighters and also in sports. Because they are people taking and getting a real advantage from having something wearable that has some sort of a function, but beyond that I'm very sceptical of the whole thing that people got very excited about especially in the late 1990s, when they were predicting we would be buying the craziest things now, but we don't. But apart from that there's one market that is very mature, which is wearable computing, and we all have one in our pocket and it's a mobile phone. That's where computing has gone, then, and it's going to continue to move.

Jennifer Sheridan, BigDog Interactive

I worked on quite a few wearable computing projects at Lancaster (UK) and at Georgia Tech (USA) because the researchers at Georgia Tech in particular were wearable computing crazy. One of my tutors there, Thad Starner, was part of the original MIT Wearable Computing group and he always went on about battery power – and he was right. I think I have to agree with you, Moritz, because one of the major problems with wearable computing is in powering them, which we saw in one of your projects. To be able to power everyday wearable computers you have to have a lot of battery power or be plugged in. At this point in time people are attempting to harvest human energy to power computers and devices. Researchers have been working on this problem for years. I quite like wearables, but often for their humorous potential more than anything, like with BigDog Interactive's Schizophrenic Cyborg or Babootska.

Bengt Sjölén

But on the other hand, like mobile phones, for example, they are about as powerful as desktop computers were only a couple of years ago, so in that direction it's more wearable for sure, the question is about the idea of wearable computing. What is the vision that we're expecting from this, like do we expect goggles with augmented reality head-up displays and brand new interaction interfaces like in sci-fi movies? As Moritz said, what we got already is the mobile phones, and they do have multi-touch, physical interfaces with accelerometers, voice control, 3D-acceleration, Internet, GPS and things like this, so in a sense it has come a long way and is changing our way of living continuously but of course the future will tell where it's going from here.

Simon Blackmore, Owl Project

I make interactive sound systems and my main focus over the last three years has been a project called Aura, which is a backpack piece. What's very interesting for me is that it is a sound piece, so there's no actual physical interface for you to draw on or move around. It tracks you through GPS. I was probably one of the first people to put a digital compass on people's heads, oh four or five years ago. So you walk around with the surround sound system where you don't actually have a physical interface apart from the real world. As I was developing it I went through the testing on the screen in early stages, and then when I got rid of it and any sense of physical interface and stood wearing the work for the first time, there was this moment when I suddenly felt very exposed, very bare, which I think is very interesting in relation to where the mobile computing thing could go. It means you can get confronted by the real world and you don't have to have that video thing playing in front of you. Ok, I'm very sound orientated, but I think this gives us a unique opportunity to get away from interfaces or even clothes and instead you can feedback off someone else's physicality.

Audience Question

This is a question for Jennifer Sheridan. You mentioned that more women in computing were now changing the shape of it. I wonder where you see that going?

Jennifer Sheridan, BigDog Interactive

In my work, I often inject the work with a little bit of humour to help us question who we are. I like to think of computing from the parallel perspective of how Lori Anderson talks about using technology. She said that the more she used technology, the less she wanted to use it. I used to have my computer with me and turned on all the time – it was like a necessary appendage. But now I do things like go on vacation without taking any computers or a mobile phone, which is traumatic the first time you do it but then it gets easier. I think it's really important to maintain a balance between interacting in the physical world with computers and without computers. There's a lot more scope for understanding how to maintain this balance.

Audience Question

Myself and a couple of people here are just completing our Master's degrees and we've been really impressed by all the speakers today. One of the things that we've been interested in is the huge number of skills that are obviously needed to deliver these projects. I was just wondering if you would like to comment on how important are those scenarios in which you're working with networks of such diverse ranges of people. As we are graduating and coming to the end of our courses, we're thinking, we're each one person, where do we fit in?

Steve Symons, Owl Project

For me the open source movement has been really quite a powerful force, in that you are on your own, just making stuff and now you can suddenly connect with a community of people really willing to share ideas and help you out on the projects you're doing, and that's quite amazing. There's a sense that there's a community out there, you're not really alone and you can keep learning. This digital design movement has just exploded worldwide now and everything is at your fingertips.

Jason Bruges

The potential is enormous. For each new project if you're not building up a history or tradition of one thing you've in any case got to build a new network of friends and collaborators each time. Obviously you'll use certain preferred people you work with, or you'll work with certain types of people. We have a project at the moment where we're working on very small particles that vibrate and generate power and we've had to go and find this company that make these things that clamp onto helicopter rotors and they abstract energy through spinning. It's like the obscure programmers. There are certain plug-ins, certain materials and the Internet obviously facilitates that. But when I was in your situation, for me it was just all the friends you had with various skills that acted as a starting point. It's really important, who you know and how that pieces together.

Bengt Sjölén

I agree with that, as Andrew Shoben (Greyworld) said as well, within these networks it's also very convenient if people are not strictly within a discipline but rather know a little bit of everything, which helps a lot in the interface between people collaborating, and so that basically everyone in a network could do the whole project.

Paul Rodgers

I think that's one of the things that is a pity,
is people getting too self-driven and failing to
see the bigger picture. I think that's always a
concern.

Crispin Jones

I think it's also worth considering that you don't
have the sum total of all your knowledge at the
moment when you leave the MA, because that's
just the start of the process of learning. I think
if you do stop learning, that's when you really
have problems, if you're not prepared to learn
new tools or processes or collaborate with new
people, that's when your world closes down.

Moritz Waldemeyer

The only thing you really need is enthusiasm and
common sense, and then you can advance into
any sort of project. Just to take a really stupid
example, that car that I had up on screen for a
second. Well, I'm not a mechanic, I've never ever
taken anything apart and, just by reading forums
and talking to people, I've got now a car with a
different engine, completely different everything,
including a racing ECU that can load maps into
the engine to change the performance. That's
only because I stupidly got carried away with
it and before, in the beginning, I didn't know
anything at all. I'm sure it's the same for all the
projects that you've seen here. In the beginning
you might not know anything about the process
or the material or tool and then you just start
doing research and you think, oh my god, and
you find something and it gives you a link to
something else, and all of sudden you've got a
whole world around you that focuses on that

project. That's the way it works really.

Jason Bruges

To some degree people assume it is a complex
thing, but every component someone has
probably done before to at least 95 per cent of
the problem being solved, so it's about not being
frightened, just to not try to reinvent the wheel
but borrow bits and assemble, I suppose.

Jennifer Sheridan, BigDog Interactive

It's not about failure either. If you're working
through those problems, you're learning and
you'll get to a point when you can solve it the
next time and so it's helpful.

Paul Rodgers

That's an opportune moment to finish now.
Once again I'd like to thank this wonderful
line-up of speakers very much for coming to
Edinburgh Napier University from across the
whole of Britain, and from further away. It has
been a really great day.

Softspace: the emergence of interactive design installations

Lucy Bullivant

'L'artiste ne crée plus une oeuvre, il crée la création'—Nicolas Schöffer (1912–1992).

Dynamic, custom-designed interactive projects for urban spaces have a powerful resonance largely because of their mutability and liquid qualities. The skins of edifices, foyers, interiors, walkways and even windows on the street have all become presentation territories in recent years for curators, artists, architects and designers. Through manipulation these static environments are transformed into immersive communicational spaces with their own DNA, ones whose identity is positioned between structure and environment. Architecture's focus is thereby shifted from tectonics into a new relationship with installation and media art. Given the time buildings often take to be realised and the subtle power of interactive design, it is not surprising how many leading architects, in particular, with interactive designers joining them in increasing numbers, have passionately embraced this strategy for its expressive potential.

Constituting the "softspace" to the traditional "hardspace" of architecture in the city, these new elements and installations perform in ways which are not permanent, but manipulable, programmable and even tuneable. Invariably operating for a fixed term, they often require the involvement of the public in order to complete their meaning. They are relationship specific, rather than site specific, relying on interfaces that onlookers can play with. By entering into a dynamic relationship with space, technology and moreover engaging with notions of self-representation, this hybrid breed of installations – large and small – give new possibilities to the environmental and social infrastructural role media has had for a while. These may be digitally derived, but are distinctly spatial and physical in their operation and effects. They serve to challenge the dynamics of homogeneity in force in public spaces by personalising their abstract nature.

One of the most powerful examples of this is Tower of Winds by Toyo Ito, created in 1986, and now a relative antique at 22 years old. A new interactive shell for an old concrete tower in Yokohama in Japan, its kaleidoscope of colour and light is the result of the structure's ability to monitor and filter the air, sounds and noises of the city, representing its visual complexity as a never-ceasing, ever-changing wind. At the time Ito expressed the desire to create architecture like an "unstable flowing body".

This capacity to hybridise and manipulate space is highly significant in the context of the varied effects of globalisation on cities, effecting, among other things, standardisation of systems and aesthetics, as well as social dislocation. It is important too as a way of embodying the sense of difference, that the city – as a place of competing interests, politics and languages – epitomises. As a practice it is evolving at a time when pervasive or ubiquitous computing is increasingly embedded in everyday surfaces, in which technology operates as an invisible tool, almost as an extension of your skin or body. Some projects deploy surveillance technologies critically, exploring the tension between culture and

commerce, public and private spheres of life which have adopted their own often quite arcane patterns of synthesis.

Public space as a concept is becoming increasingly contested, and that has led to its hybridity, with proliferating mixed programmes and nuances, and a strongly time-based use of space. One example being that some leading museums who were early adopters of digital technologies have developed virtual programmatic layers, becoming immersive communicative environments and, by night, nightclubs.

When it comes to individual buildings and their programmability we can refer back to Buckminster Fuller. His shading devices – for instance, his environmental valves at the United States Pavilion Dome at the 1967 World Expo in Montreal was one of the first programmable surfaces used in connection with a building. In Paris in the 1950s, Nicolas Schöffer (1912–1992), working with sound artists, tried many utopian experiments on the Seine in Paris for cybernetic towers that anticipated contemporary interactive installations. His vision for the cybernetic city aimed to create a synergy between digital technologies and the natural world. The radical English architectural group Archigram and architect Cedric Price made an equally strong case for changeable structures in the 1960s.

More recently, Jean Nouvel's Institut du Monde Arabe in Paris, influenced by Fuller's dome, included retractable shading devices. So architects have been devising responsive building concepts for some time, but relatively few were built until the 1980s. Until recently, with the exception of cinematic explorations of the notion of personalised space – in Minority Report and The Matrix, for example – discussions about intelligent architecture have tended to focus on environmental controls – sun louvers, centralised ICT systems or retro-reflective surfaces; but now new technologies allow us to have a conversation with our environments. Moreover, we can begin to perceive the designed environment as an operating system, with users given unprecedented potential to create personal programs.

While the physically permanent identity of architecture has helped to define society for centuries, now, by disengaging from tectonics as we traditionally understand it, as some architects have, they are taking their discipline into the realms of "softspace", a more fluid, ephemeral form of digitally enabled design based on precisely these personalised experiences and responses. The best stand-alone installations or façade-based work are not merely decorative but a commentary on many aspects of urban life ranging from how the building works, how the city can be seen anew, and hidden connections with natural stimuli. They are driven by real time information that is then converted and fed back into the urban environment in a new form. It adds a supernatural character to architecture: it feels alive and unpredictable.

It is the customised, bespoke nature of the software that enables new generation of technologically enabled spatial systems. Frequently using LED lighting, sensors, Wi-Fi or RFID tags, they respond in a seemingly random way to external stimuli such as biological data, meteorological data like changes in temperature and levels of humidity, electromagnetic fields in some cases, and other programmable data like mobile phone calls. Increasingly we are experiencing a dovetailing of interests: architects are turning to interactive projects, while media artists, turning their hand to environmental projects, have long since regarded the urban landscape and its spaces used daily by large numbers of people – whether skins of buildings, foyers or interiors – as manipulable and places where technology could be used as a creative medium to further emotional engagement. They are building alliances with software engineers, while interactive designers – who may favour wearable computing projects – and mechatronic specialists are similarly operating in multidisciplinary networks. In a relatively short period of time, the discipline's language of mutability allied with a live, supernatural quality, has through a bottom-up process of creating and testing prototypes, evolved a spatial practice that has both focussed on the electronic screen and the challenge of going beyond it to create bio-digital narratives.

Coincidentally, Ito's Tower of Winds was built the same year that Jenny Holzer created the infamous Protect Me From What I Want, for Times Square in New York, 1986, one of many outdoor electronic signage projects that embody the idea of the city as a place of competing interests, politics and languages. This is a field that the doyennes of the New York experimental architecture scene, Diller & Scofidio, now Diller Scofidio Renfro, have explored through installations, animations and exhibitions. They tease the distinctions between "live" and mediated experience, claiming that media is in any case becoming more environmental, "replicating the real", and in their work media certainly takes on the mutable, "live" quality of nature.

Yet, at the same time, they are exposing the hidden, elusive and anonymous values and norms of society. Travelogues, a video-based installation for two characterless long corridors at JFK's new International Terminal made in 2002, is a play on surveillance. The architects used lenticular screens – lenses in the form of two dimensional sheets that produce an image with depth and motion. The moving viewer saw a series of interconnected images taken from large format transparencies in an animated sequence, frames that add up into a narrative with stop frames, zooming and flash backs, "captured" from four randomly picked travellers and the contents of their suitcases.

It was much earlier, in the late 1980s, that Christian Moeller, now Professor of Media Arts and Design at UCLA, trained as an architect, and became so influenced by the new media body ZKM in Karlsruhe that he borrowed the – at that point – relatively expensive technologies of media art to begin creating a series of stunning media architecture works, Kinetic Light Sculpture (Zeil Galerie, Frankfurt, 1992)

IMAGE: realities:united, Kunsthaus Graz, 2003

being the most famous. One of the first electronic media artworks of this size to be applied to the façade of a building, it was commissioned by a property developer looking for a concept for a light installation for the façade of his new shopping mall, and designed to function from twilight onwards. The perforated sheet façade transformed itself into mobile blue-yellow clusters of light, with patterns that changed like a chameleon according to the weather – light levels and temperature – monitored via a station mounted on the roof. At zero degrees C, the wall was monochrome blue, but as the temperature rose, yellow clusters formed. Near the top of the building Moeller positioned an LED screen showing oscillating graphic renderings of ambient sounds in the street. By day it operated as a news board.

Lars Spuybroek, the Dutch architect who runs NOX, designed the H2O EXPO pavilion between 1994–7, a permanent exhibition building on Neeltje Jans, an artificial island to support construction of a flood barrier. Formally generated using animation software, it is an early example of liquid architecture where visitors literally confront water in all its variety, and are exposed to projections of the molecular structure of water and of wave patterns. They activate these wave patterns by passing light sensitive cells, touching sensors and by operating handles.

The Kunsthaus in Graz, Austria, is a good example of the achievement of synergy between architecture and electronic media. A 900-square-metre electronic skin called BIX – big pixels – designed by Berlin-based architects Realities: united, it was completed in 2003 as part of a building designed by architects Peter Cook and Colin Fournier. Actually using quite a low-tech method with a low-resolution matrix, it was intended as an instrument and platform for artistic presentations. The brightness of the lamps beneath the surface can be adjusted, allowing images, films, animations and text to be displayed. As a result, there is a dynamic communication between the building and its surroundings, and between the content and onlookers' perceptions.

One of the questions that have to be asked about these high-level concepts is what kind of growth potential they have in the future – will they be dominated by advertising or will they evolve as innovative, interactive cultural platforms? The new Allianz Football Stadium in Munich, designed by Tate Modern architects Herzog & de Meuron, and completed in 2005, isn't so versatile but it is powerfully gestural. The façade of ETFE, a self-cleaning, Teflon-coated fabric that controls solar gain, forms a membrane with rhomboid-shaped, inflated panels that is not only the largest of its kind in the world, but changes colour from red to white to blue to reflect which of the two home teams, FC Bayern Munich or TSV 1860 München, is using the ground.

IMAGE: Daan Roosegaarde, Dune 4.1, Maas Tunnel, Rotterdam City of Architecture, 2007

IMAGE: realities:united, Kunsthaus Graz, 2003

IMAGE: Galleria Hall West Mall / UN Studio

IMAGE: Galleria Hall West Mall / UN Studio

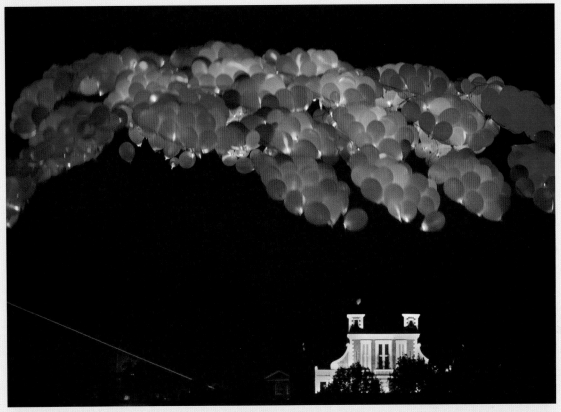

IMAGE: Skyear / Usman Haque

IMAGE: Wind to Light, Southbank Centre, London, 2007 © Jason Bruges Studio

IMAGE: Electroland / Entreactive IMAGE: Electroland / Entreactive

The Dutch practice UN Studio takes its cue from fashion's seasonal changes with a custom-designed, light-reactive and programmable façade for the Galleria Hall West shopping mall. 4,330 sandblasted glass disks with an iridescent diachroic foil combined with a custom-designed LED lighting system, by Rogier van der Heide of Arup Lighting, react to weather conditions by day and operate to full effect at night. Each disk acts like a big pixel on a giant screen, and it can also interface with video and film, making its hybrid identity on this scale unprecedented. "I wanted to create proliferating qualities to make it interactive and dynamic. We like to test the malleability of surface colours almost as if we were de Chirico or Jeff Koons, and achieve both phenomenological and literal transparency", Ben van Berkel has explained.

Electroland, two Los Angeles-based Harvard architecture graduates who create multidisciplinary urban projects, combined environmental intelligence and human surveillance in their recent installation Enteractive. It embeds a luminous field of LED lights into the lobby of an office building in their home city that responds to the presence of visitors. A massive display of lights on the building's façade mirror the patterns set up in the lobby, which the participants witness on a video display in front of them.

Just as projects can crop up in everyday environments you might not expect to be "intelligent", no rules state that interactive installations need to be rooted in the ground, either. Sky Ear, by Usman Haque, a graduate of the Bartlett School of Architecture in London, was presented at the Greenwich Maritime Museum in London in 2004 and in Switzerland. It is a non-rigid cloud made up of hundreds of glowing helium balloons from which are suspended mobile phones, LEDs and electromagnetic sensors. Haque is fascinated by how mobile phones condition our use of space, now that they've become ubiquitous. The sensors detect electromagnetic radiation which triggers the LEDs, so it's like a floating jellyfish sampling the spectrum it creates. Spectators on the ground use their phones to call into the cloud to hear the electromagnetic sounds, and their calls alter their topography inside the cloud which alters its glow and colour intensity.

The new interactive practice model emerging in the early years of the twenty-first century is typified by both individuals working in close alliance with others, and multidisciplinary groups like Troika and UVA, and architects Jason Bruges, in London, and in Paris, HeHe and Electronic Shadow. Electronic Shadow is a studio established in 2000 by Naziha Mestaoui, a Brussels-born architect, and Yacine Ait Kaci, a multimedia designer from Paris. The duo split their time between artistic experimentation and commercial commissions – for instance, installations for showrooms for Boffi, the Italian furniture manufacturer, and other interactive spatial concepts to which upmarket brands like Giorgio Armani and Cassina have become increasingly receptive. The animated elements of H2O for Boffi are a 5-metre-long pool of water, a series of walls and furniture that multiply the perception of space.

IMAGE: Electroland / Entreactive IMAGE: Electroland / Entreactive

Narrative elements appear – the silhouettes of a man and a woman, and then new backdrops – a bathroom, swimming pool and terrace by the sea. With this digital interface, the space becomes as easy for the clients to change as an image, and more immersive in its nature.

Imaginative installations using sensor systems continue to be created for public places, for instance the Light Sounds work by architectural practice D-squared, created with artist Rolf Gehlhaar, for a shopping centre in Islington. Set in a quiet zone of the centre, its ultrasound sensor systems enable it to detect the presence of passers by, which accordingly triggers light and sound sequences depending on their numbers and behaviour. The pace of the changing coloured light and the tone and frequency of the sounds are slow, so the sensation of passing the work is like moving past a highly abstracted electronic garden.

Jason Bruges was the first architect to create a full-time studio dedicated to interactive installation work in the UK. He now runs a team of 12 architects and software designers. His biography is therefore indicative of the kind of creative leaps and connections a practitioner working in this field across different sectors, public and private, needs to make. He founded his practice in London in 2001 after senior positions at Norman Foster's office and at Imagination, and, as with Usman Haque, trained at the Bartlett. The studio splits its time between creating surfaces, spaces and installations occupying the territory between architecture, installation art and interaction design. Known for adapting innovative technologies from the entertainment industry coupled with materials and fabrication techniques from the construction industry, all his work centres on making prototypes that are tested out before launching. Bruges has also been one of the first practitioners in this field to address questions about the ecologically sound nature of interactive installations. Wind to Light, for London's Architecture Week in June 2007, staged on the South Bank, was one of Bruges' experimental, site-specific installations. It demonstrated alternative, sustainable ways of harnessing energy through exploring the power of wind in the city, visualising it as an ephemeral cloud of light. It was custom built using scaled-down wind turbines to generate power, which illuminated hundreds of mounted LEDs, creating firefly-like fields of light. Wind is visually interpreted as electronic patterns across the installation. Later that year, a second installation, an interactive garden of CFL – compact fluorescent lamps – green energy-saving light bulbs – for Greenpeace at 100% Design London, underlined the potency of the metaphors that are now being applied, and their compatibility with nature. Light is the most intangible of media – it is mysterious and ephemeral. Harnessed by customised responsive design, it is being used as more than just a decorative mood changer, as a dynamic medium that can fundamentally scene-shift reality and create new layers of identities for urban places.

Another pioneer whose work calls for people to interact with it is Dutchman Daan Roosegaarde, one of the youngest of those I have so far discovered working full time in the field. He trained as a sculptor

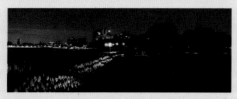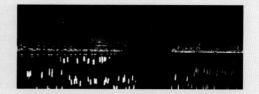

IMAGES: Daan Roosegaarde, Dune 4.2, River Maas,
Rotterdam, Netherlands, 2009

in Enschede in the Netherlands and then switched to architecture, for which he took a postgraduate degree at the Berlage Institute in Rotterdam. Exploring the dynamic relationship between architecture, people and new media, he makes the integration and infiltration of interactive media with architecture central to his work.

He recently prepared Flow 5.0, a new 12-metre-long interactive sculpture created for Today's Art Media Festival in The Hague, made out of hundreds of ventilators which react to human sounds and movements, in the City Hall in the Hague. He creates what are clearly artificial environments fed by natural elements, another example being Dune 4.0, his recent interactive landscape, which was initially installed in the Montevideo building in Amsterdam and more recently in the Maastunnel in Rotterdam.

Dune 4.0 reacts to the sounds and motion of visitors as they walk through these corridor spaces. Large clusters of fibres on either side brighten up according to the sounds and motion of passing visitors. Inside the fibres, several microphones and presence sensors detect people's activities. The Dune landscape has several moods. If you make a lot of noise as you walk, it gets very lively. Although in its make up, Dune 4.0 is high tech, its significance lies in its deployment of technology as a necessary yet invisible tool, something that is a commonplace today, but to create a sensual experience.

It is also about enabling the visitor to personalise space in real time, almost as an extension of your skin. "You make the landscape but the landscape also makes you", as Roosegaarde explains. "Through this process of watching and interacting", says Roosegaarde, "the visitor becomes conscious of himself as a body, in a dynamic relation with space and technology". He is happy to work in everyday environments like the tunnel, in order to "move away from the sublime and (the pressure of) being too beautiful in public spaces". He likes "making movies that never finish", with an air of intrigue akin to a Hitchcock film.

A prime example of how well digital media has encroached on the otherwise reserved physical world of museums was Volume by UVA, one of the most successful interactive installations in London, sited in the Italianate courtyard of the V&A in London in late 2006–7. In a leap into retail space, it was followed up in November 2008 by Electric Light Orchestra, an interactive light installation in Covent Garden's busy covered market, offering a novel form of Christmas lights. Bringing together the entire London Contemporary Orchestra for six weeks, performing in public, the music being played controlled the ambience, and vice versa. The driver for innovation in this field has been the museum sector, an early adopter of new technologies. These have enabled visitors to have individualised and more intimate experiences of museums for some years now, through the media of audio and MP3 players, podcasts, and even the use of RFID tags, personalising their journey through galleries. Among its interactive

installations in the last two years at the V&A, for example, have been an interactive, manipulable chandelier and interactive musical boxes, adding a new layer of communication colonising previously static and untouchable galleries.

There is evidence of the corporate sector starting to pick up on the versatility of interactive design, clearly influenced by museums and galleries – in the UK, V&A, Tate Modern and the Science Museum – that have led the way in commissioning projects junking the old-style black box or hermetic kiosk approach to new media, with its frequently didactic or arcane approach focussing only on the human computer interface, and rarely requiring much physical interaction – unlike today's breed of installations.

New spatial and experiential metaphors based on games, play and various forms of cybernetic responses lend the field an increasingly resonant significance in an era where everyday habits are interactive, for instance the ordinary task of getting cash from an ATM machine, but far more rarely are they genuinely technologically enabled to be responsive.

In 2006 the V&A published my book, Responsive Environments: Architecture, Art and Design, and for the cover we chose an image of Mexican media artist Rafael Lozano-Hemmer's projection-based Body Movies. Staged in many different cities over time, this version was presented in Rotterdam's Schouwburgplein in 2002. Playful and ever changing, Body Movies relied on spectators to perform however they felt they wanted to respond, thus providing the animated "content". Their involvement – inputting over a period of time a myriad of examples of self-representation – generated reflections about ideas of embodiment and disembodiment and what spectacular representation might be.

Responsive Environments made a critical analysis of the emerging spectrum of interactive architecture and design, and in common with 4dsocial, my more recent publication for AD/Wiley (2007), discussed the way this field is embracing the reinvention of social communication and networks, being and doing, together and alone, in the city. Through this emerging hybrid genre of interactive design, we are invited to step into these spaces and play. In the process of engagement we reveal to ourselves fresh perceptions of public space that are both personalised and communal. In an era of globalisation with its operating logics serving to erode our sense of difference in favour of the "same difference everywhere", this genre is highly significant for forging new shared territories of meaning that are contingent and situational but no less potent for being so.

Undisciplinary

John Marshall and Julian Bleecker

The "inter_multi_trans_actions" symposium brought together a number of leading practitioners from the fields of art, architecture and design. The title of this event suggests that these practitioners' creative practice can be understood as a prepositional relationship between, beyond or across conventional disciplines. The creative work produced by these practitioners can be said to be "project-based" rather than "discipline-based" (Heppell, 2006). In practice, disciplines are constructs that we can choose to adhere to or not. Conversely, in academia, the boundaries of a discipline are important. For example, the distribution of funds and resources, and the administration of both research and teaching tend to operate within a disciplinary framework (Russell, 2000). Previous models of university-based research have amplified the tendency for knowledge to pile up in vertically specialised "silos". However, what might the implications of post-disciplinary creative practice be?

Arias and Fischer (2000) state that when a domain reaches the point where the knowledge necessary for professional practice cannot be acquired in a decade, specialisation will increase, teamwork become a necessity, and practitioners make increasing use of "distributed cognition". Mansilla and Gardner (2003) have identified several challenges to interdisciplinary work. They point out that individual disciplines often adhere to standards of validation contradictory to those of the interdisciplinary work that draws upon them. Their research indicates that, in the case of new areas of study with no existing precedents, developing validation criteria is part of the investigation process itself. Academics therefore are required to spend more time trying to justify what they do than actually doing it. Nevertheless, there is an increasing amount of extra-disciplinary work being done, particularly in areas pertaining to design and technology in order to answer complex questions and address broad issues (Klein, 1990).

In The New Production of Knowledge, Michael Gibbons and his co-authors categorise three types of research beyond standard disciplinarity. These are: "inter-", "multi-" and "trans-" disciplinarity (See Table 1).

Interdisciplinarity	Multidisciplinarity	Transdisciplinarity
Characterized by the explicit formulation of a uniform, discipline-transcending terminology or a common methodology. The form scientific cooperation takes consists of working on different themes, but within a common framework that is shared by the disciplines involved.	Characterized by the autonomy of the various disciplines. Does not lead to changes in the existing disciplinary and theoretical structures. Cooperation consists in working on the common theme but under different disciplinary perspectives.	Research is based upon a common theoretical understanding. Must be accompanied by a mutual interpenetration of disciplinary epistemologies. Cooperation in this case leads to a clustering of disciplinary rooted problem-solving and creates a transdisciplinary homogenized theory or model pool.

Table 1. After Gibbons et al, 1994, p.28-29.

These three terms indicate a series of relationships between disciplines. The dimension of distinction that separates these is the extent to which there is a "mutual interpenetration of disciplinary epistemologies". To clarify this, we can think of these in terms of everyday objects we are all familiar with (See Table 2).

Interdisciplinarity	Multidisciplinarity	Transdisciplinarity
Zipper	Button	Velcro
"A zipper (British English: zip fastener or zip) is a popular device for temporarily joining two edges of fabric." http://en.wikipedia.org/wiki/Zipper	"...a button is a small plastic or metal disc- or knob-shaped, typically round, object usually attached to an article of clothing in order to secure an opening, or for ornamentation. Functional buttons work by slipping the button through a fabric or thread loop, or by sliding the button through a reinforced slit called a buttonhole." http://en.wikipedia.org/wiki/Button	"Velcro is a brand name of fabric hook-and-loop fasteners. It consists of two layers: a "hook" side, which is a piece of fabric covered with tiny hooks, and a "loop" side, which is covered with even smaller and "hairier" loops. When the two sides are pressed together, the hooks catch in the loops and hold the pieces together." http://en.wikipedia.org/wiki/Velcro

Table 2. Extra-disciplinarity as everyday objects.

There is an increase therefore from "multi-" to "inter-" to "trans-" disciplinarity along this axis of "mutual interpenetration". In multidisciplinary cooperation the "button" and the "buttonhole" are distinct entities. Sometimes this can be purely decorative and in general we see and talk about "buttons" and not "buttonholes". We have been using buttons for 3,000 years. In interdisciplinary cooperation as a zipper we have an entity where two facing rows of teeth are pulled into relation by a third thing – the slider. This slider represents the "discipline-transcending terminology or a common methodology" that temporarily holds the disciplines together. We have been using zippers since 1893. In transdisciplinary cooperation we have a relatively new entity (1948) that consists of two distinct layers that are useless without the other. Multidisciplinarity is additive. Interdisciplinarity is integrative. Transdisciplinarity is transformative. As the most symbiotic of these relationships this latter term bears further examination.

Gibbons et al. (1994) identify a fundamental change in the ways that scientific, social, and cultural knowledge are being produced. The basic qualities of this new mode of knowledge production are: complexity, hybridity, non-linearity, reflexivity, heterogeneity, and transdisciplinarity. This hybridisation reflects the need to accomplish tasks at the boundaries and in the spaces between

different communities (Gibbons et al., 1994, p.37). These enable collaboration, integrative problem solving, and development of new hybrid fields. Gibbons' first mode of research is primarily "disciplinary" in nature whereas the second is characterised as being "transdisciplinary" in nature (See Table 3).

Mode 1	Mode 2
problems set and solved in a context governed by the, largely academic, interests of a specific community	knowledge is carried out in a context of application
disciplinary	transdisciplinary
characterised by homogeneity	characterised by heterogeneity
hierarchical and tends to preserve its form	heterarchical and transient
quality control less socially accountable, more related to the discipline	quality control more socially accountable and reflexive

Table 3. After Gibbons et al, 1994, p.28-29.

In "Notes Toward a Social Epistemology of Transdisciplinarity", Klein (1994) informed us that several theorists are credited with coining the term "transdisciplinary" (e.g. Jean Piaget and Andre Lichnerowicz). However, Erich Jantsch (1972) is most widely associated with the idea. Klein indicates that transdisciplinary research requires the development of a common conceptual framework and a common vocabulary among contributors (however, she also warns against the creation of self-imposed borders or the promotion of comprehensive worldviews which she states risk becoming monolithic projects or closed systems).

Russell (2000) stated that transdisciplinary research involves the "integration of different bodies of knowledge, the synthesis of new approaches and techniques of inquiry and the communication of specialised knowledge across disciplinary boundaries and beyond." Foucault (1977, p.113–38) discussed the idea of a "transdiscursive position" – those who are initiators of discursive practices, not just of individual texts. Kerne (2006) argues the use of the prefix "trans" in relation to disciplinarity is still lacking a sense of how processes of disciplinary recombination are a formula for creating new

knowledge. Nicolescu (1993) stated that use of the prefix "trans" indicates concerns which are at once between the disciplines, across the different disciplines, and beyond all discipline. Kerne also states that the structures and processes that catalyse this type of integration are still largely undefined and argues for a structure of "meta-disciplinarity" that connects theory and practice and creates hybrid forms. The late Jane Attfield (2000, p.1) went even further in her study of the material culture of everyday life, stating that in order to go beyond conventional design studies she takes a "post-disciplinary" approach which allows her to draw upon social history, anthropology, archaeology, sociology, geography, psychoanalysis and general cultural studies.

From the work of the "inter_multi_trans_actions" symposium presenters we see the relationship between art, technology and design is one in which different idioms of distinct and disciplinary practices can be brought together. This has been driven through process and projects – "carried out in the context of application" (Gibbons et al., 1994). Our descriptions of these experiences are that to be beyond disciplinary practice means multiple disciplines engaged in a pile-up, a knot of jumbled ideas and perspectives. This involves lots of different languages and vocabularies and principles, and especially ways of completing things that feel like a cluster of different driving habits converging on a busy road. If, then, a "transdisciplinary" approach recognises the boundaries of the problem being addressed, not the artificial boundaries of disciplines, this might suggest that the work done in this area can perform as a means of coordination and alignment across disciplines and as a means of translation between them. This work can also act as a reflexive space in which to understand, critique and evolve the dominant discourses of its parent disciplines.

We would like to propose the term "undisciplinary" for this type of work. This term does not play the usual games, according to the usual logics (doing things to serve a specific mode of capital accumulation and capital production – whether knowledge-as-property, culture-as-commodity, objects or other materialisations that can be sold for profit). "Undisciplinarity" is as much a way of doing work as it is a departure from ways of doing work, even questioning what "counts" as work. It is a way of working and an approach to creating and circulating culture that can go its own way, without worrying about working outside of what histories-of-disciplines say is "proper" work. It is "undisciplined". You cannot be wrong, nor have old-timers tell you how to do what you want to do. This is a good thing: it means new knowledge is created all at once rather than incremental contributions made to a body of existing knowledge. It means new ways of working, new practices; new unexpected processes and projects come to be, almost by definition. This is important because we need more playful and habitable worlds that the old forms of knowledge production are ill-equipped to produce. It's an epistemological shift that offers new ways of fixing the problems the old disciplinary and extra-disciplinary practices created in the first place.

"Undisciplinary" practice is not for everyone. Many if not most people still need to be told how to do what they do. They need discipline and boundaries and steps and rules. They need to know what's good, and what's bad. They need to know what the boundaries are and where the limits of the discipline lie. This makes sure that the specific, sensible knowledge is created. However, a worthwhile challenge for creative practitioners is to learn how to learn. It should be expected (if it is not already) that it is not enough for a designer to pay attention only to the surface and appearance of a product. Part of the robustness of design comes from understanding the possibilities of new materials, new processes, new processors or having the language, practice skills and moxy to suggest whole new technologies based on a unique insight that runs not just broad, but deep. This cannot realistically be expected to be done from day one after graduating from a four-year undergraduate degree course. It's a lifetime process to develop a breadth and depth of knowledge and practice that can make new things. This means patience, developing a keen eye, an eager will and an aspiration to learn in every context, not just the classroom.

Gibbons' (1994) "Mode 1" (see Table 3 above) is concerned with first principles in which questions and problems are dealt with in a context governed by the largely academic interests of a specific community of practice. "Mode 2" research is based on a context of application in response to the demand for solutions to problems from a community of interest. Communities of practice are made-up of practitioners who work in a certain domain doing similar work (Arias and Fischer, 2000). A community of interest involves members of distinct communities of practice coming together to solve a particular problem of common concern (Arias and Fischer, 2000). A community of interest can expect to face more communication problems than a community of practice. Members of communities of interest can learn from others who have a different perspective and perhaps a different vocabulary for describing their ideas, and establish a common ground and a shared understanding (Arias and Fischer, 2000).

The advantages of an "undisciplinary" approach are that questions and parameters integral to one's own perspective get highlighted and discussed – perspectives that specific communities of practice such as engineers, marketers and others have never really been trained to consider relevant. This can lead to the finding of new vantage points from which to create new things – a new community of interest. This is dependent on learning at least a bit about what various domain-based languages have to say about, and contribute to, common ground in the design process. One is disadvantaged to the degree that knowledge is shallow or nonexistent. Time spent on the assembly line, in the design studio, in the materials lab and in the clean rooms is necessary to attain this depth. The opportunity to become part of a practice – with all of its history, ideology, languages, norms and values, personalities, conferences – is an invigorating process. Openness to investing time and energy in new practice idioms, especially if it offers the chance to feel the process of learning, is a crucial path toward

becoming "undisciplinary". This involves engaging different sorts of practices, ways of working or even disciplines that can shape what it is you do. But this means doing this to the fullest extent, not just as a quick fix. This may mean investing in years of learning while making. In this way, embodying multiple practices simultaneously is the scaffolding of creativity and innovation. It is what allows one to think beyond the confines of strict disciplinary approaches to create new forms of culture – whether objects, ideas or ways of seeing the world.

One way of establishing this common ground and shared understanding is to make use of "boundary objects" that provide a means to communicate and coordinate between the various communities of practice that make up the community of interest we are talking about. These "boundary objects" perform a brokering role (Arias and Fischer, 2000) involving translation, coordination and alignment between the perspectives of specific communities of practice.

Boundary objects are both plastic enough to adapt to local needs and constraints of the several parties employing them, yet robust enough to maintain a common identity across sites. They have different meanings in different social worlds but their structure is common enough to more than one world to make them recognisable means of translation. The creation and management of boundary objects is key in developing and maintaining coherence across intersecting social worlds. (Bowker & Star, 1999, p.297)

"Boundary objects" (actual physical objects as art-design-technology projects such as those presented at the "inter_multi_trans_actions" symposium) can bring discourses together as our interstitial "undiscipline" with technology operating as a kind of glue-like "Lingua Franca". Objects are expressive bits of culture. They make meaning, help us understand and make sense of the world. They are also knowledge-making, epistemological functionaries. They frame conversations and are also expressions of possibility and aspiration. In many ways, they are some of the weightiest and most expressive forms of culture we have. Being able to make objects and understand them as communicative, as able to tell or start or frame larger conversations and stories about the world is very satisfying. Objects express the cultural, aesthetic, practical knowledge of their making – in their "design", and in their crafting as "art", or in their "engineering". These disparate practices pull together a combination of instrumental and practical skill. If we take a mobile phone and try to understand it, it matters what culture, discipline, or community of practice we study it from. At the same time, making an object, and how it is made, and what it will mean, and when I will know it is finished – all of these things depend on what culture or practice or body of knowledge you choose to look at it from. Put an artist, an engineer and an industrial designer all around a table staring at a phone. What will they see? Where will they agree on what they see and where will they look blankly and wonder what each of the others is talking about? How much time is spent negotiating what is seen? What practices fit in the middle? Are those interdisciplinary? What practices run across many? Are

those multidisciplinary? Do trans-disciplines work above and beyond? What about "undisciplinary" practices? What way of seeing that object will make it into something new and unheard of? What way of seeing will materialise new objects, innovative ideas and conversations that create new, playful, more habitable, near future worlds?

Finally, if we return to the previous discussion of extra-disciplinary cooperation in terms of everyday fasteners what would "undisciplinarity" be? Perhaps it is a tangle of staples, rubber bands, hot glue and duct tape accumulated over time? "Undisciplinarity" does processes rather than projects. Multivalent perspectives are the norm. An "undisciplinarian" creates "implications" by explicating these relationships not just as relationships, but as intimate bedfellows. We are forced to rely on verbal descriptions that are more like gooey, porous, intertwined and knotted layers. Every layer is intimate to every other one. It is messiness. And messiness is closer to the DNA of the world in which designed objects operate. This is not to say that "undisciplinary" practice is messy, but that it designs for contingency rather than make assumptions that the world is perfect.

References

ARIAS, E.G., & FISCHER, G., 2000. Boundary objects: their role in articulating the task at hand and making information relevant to it. Available online at: http://l3d.cs.colorado.edu/~gerhard/papers/icsc2000.pdf [Accessed 30 August, 2007].

ATTFIELD, J., 2000. Wild things: the material culture of everyday life. Oxford: Berg Publishers.

BOWKER, G. & STAR, S. L., 1999. Sorting things out: classification and its consequences. Cambridge, Massachusetts: The MIT Press.

FOUCAULT, M., 1977. What Is an author? in BOUCHARD, D. F., (ed.) Language, counter-memory, practice: selected essays and interviews. Ithaca: Cornell University Press

GIBBONS, M., LIMOGES, C., NOWOTNY, H., SCHWARTZMAN, S., SCOTT, P. & TROW. M., 1994. The new production of knowledge. The dynamics of science and research in contemporary societies. London: Sage Publications Ltd.

HEPPELL, S., 2006. RSA Lectures: learning 2016. Available online at: http://www.teachers.tv/video/4957 [Accessed 30 August, 2007].

JANTSCH, E., 1972. Towards interdisciplinarity and transdisciplinarity in education and innovation." In CERI (ed.), Interdisciplinarity: problems of teaching and research in universities. Paris: Organization for Economic Cooperation and Development.

KERNE, A., 2006. Doing interface ecology: the practice of metadisciplinarity. Intelligent agent. Vol. 6, No. 1. Available online at: http://www.intelligentagent.com/archive/Vol6_No1_interface_kerne.htm [Accessed 30 August, 2007].

KLEIN, J. T., 1990. Interdisciplinarity: history, theory and practice. Detroit: Wayne State University.

KLEIN, J. T., 1994. Notes toward a social epistemology of transdisciplinarity. Available online at: http://nicol.club.fr/ciret/bulletin/b12/b12c2.htm [Accessed 30 August, 2007].

MANSILLA, V.B., & GARDNER, H., 2003. Assessing interdisciplinary work at the frontier. An empirical exploration of 'symptoms of quality'. Available online at: http://www.interdisciplines.org/interdisciplinarity/papers/6 [Accessed 30 August, 2007].

NICOLESCU, B., 1993. Towards a transdisciplinary education. Paper presented at Education of the Future. Sao Paulo, Brazil. 4-8 October, 1993. Cited in KLEIN, J. T., 1994. Notes toward a social epistemology of transdisciplinarity. Available online at: http://nicol.club.fr/ciret/bulletin/b12/b12c2.htm [Accessed 30 August, 2007].

RUSSEL, W., 2000. Forging new paths: transdisciplinarity in universities. WISENET Journal, Number 53, April. Available online at: http://www.wisenet-australia.org/issue53/transdis.htm [Accessed 30 August, 2007].

The Work of Art in the Age of Mechanical Interaction

Daniel West

"You can declare that a work that shows the correct political tendency need show no other quality. You can also declare that a work that exhibits the correct tendency must by necessity show every other quality."
Walter Benjamin

"Any sufficiently advanced technology is indistinguishable from magic."
Arthur C Clarke

New technologies are both blessing and curse for the arts. Scientific progress creates new modes of representation, which invites superficial exploitation. Take film. Its invention in the late nineteenth century was followed by innumerable experiments. For every cinematographic masterpiece by Georges Méliès there were thousands of forgettable reels elsewhere. Audiences gawped at scenes that would bore today's schoolchildren: rudimentary cars crawling along an empty road, a galloping horse, fireplaces. The sheer wonder of seeing anything at 24 frames per second nullified the usual criteria by which culture was assessed, and a tsunami of mediocrity ensued.

Contemporary art forms that employ new technologies are no different. LCD displays, RFID tags and QR codes have (or had) a magical otherness. Like early film this aura diminishes with familiarity, but the honeymoon period is replete with cheap illusion. Meretricious digital gimmickry now stretches from Shanghai factory shelves to the boardrooms of multinational corporations. How, then, should we distinguish creativity from banality? Should technical innovation be celebrated over conceptual rigour? Does complexity reduce usability, and does this matter? Practitioners may have trained in art, engineering or music; design devices, buildings or websites; produce commercial products or non-copyrighted projects – new media art is so multidisciplinary that categorisation alone is awkward, never mind qualitative assessment.

If attempting to gauge contemporary artistic value, it is perhaps useful to reappraise Walter Benjamin's 1935 essay "The Work of Art in the Age of Mechanical Reproduction". Benjamin explored the cultural consequences of a new technological process: mass reproduction. He predicted that an artwork's ritual value or "aura" – based on its rarity, exclusive ownership and restricted presentation – would diminish with the advent of mass reproduction. Benjamin thought reproduction would increase art's political significance, by democratising access and freeing the work from the ideologies of its owners. Writing in Weimar Germany, he wanted culture to enlighten the audience to fascism's dangers.

Like Benjamin, we are presented with a new technological process: interactivity. Although diverse in form and functionality, new media art is united by interactivity – a characteristic that distinguishes it from previous mediums such as painting and sculpture. The spectre of fascism may have faded

IMAGE: Social Mobile / Crispin Jones

since Benjamin's time, but art still has the power to challenge hegemony. By questioning mores, art can undermine groupthink, expose undervalued beauty and offer new models of existence. But what role might interactivity play in this process? Can interactivity include the audience in a work's (re) production, allowing for more personalised and profound experiences? Is the aura of new media art reinstated by this uniqueness? Interactivity, as we shall see, can undermine art's potential for enlightenment by entering the audience into a meaningless "interpassive" exchange. To avoid this, new media art must provoke the audience to reflect on their social, political and philosophical values. If it does not, it is merely entertainment, exploiting magical novelty to achieve false consciousness – a truly mechanical interaction.

Pendent Opera Interrupta

Prototypes occupy a curious position within new media arts. Hovering between sketchbook and shop/gallery, they are powerful tools to explore an idea's practical and conceptual viability, but run the risk of obscurity and irrelevance. Crispin Jones' Social Mobiles prototypes for IDEO illustrate the medium's potential. Jones designed five mobile phones that attempted to reduce noisy chatting. One converted loud speech into electric shocks. Another allowed users to fire sound snippets into other people's mobile conversations with a catapult.

Social Mobiles playfully investigated antisocial mobile phone habits. "I was looking at mobile telephony as a social problem that needed a solution, rather than something to be celebrated and something to create new functionality for," says Jones. This problematisation of a techno-social trend stands in direct opposition to the conventional commercial response. Mobile-phone manufacturers have introduced few socially responsible functions aside from vibrate modes and permanent camera-phone shutter noises, to foil up-skirt perverts. With his first device, Jones punishes users; with the second, he enables them to act subversively. Aggressive conditioning and abusable power cast Jones as designer-provocateur.

Though each of the five phones was a fully functional GSM mobile, Jones feels ambivalent about their utility as prototypes. They were experienced by just a handful of users, so Jones created a video, now on YouTube, detailing how to use the devices. "Almost no-one experienced them, [but] they're more intriguing as objects because they're working. It seems more extreme if someone's gone to that effort," he says. Jones' devices are deliberately uncomfortable, and therefore uncommercial, but remain functional. By working, the phones reflexively bring the anti-technocratic concepts alive, and are more effective as a result.

In addition to the functionality debate, prototypes are aesthetically intriguing. Finished products may have custom parts mass-produced in factories, but new media art prototypes are often made from

IMAGE: Troika / Tool For Armchair Activists
Photo © Troika

IMAGE: Troika / SMS Guerrilla Projector
Photo © Troika

simple and widely available components. BigDog Interactive's DIY Mobile Projector was built using an off-the-shelf CPU fan and handheld torch, with full assembly instructions posted online. "We like extreme prototyping: things that can be built in a day, on a very small budget, and are highly portable," says BigDog Interactive's Jennifer Sheridan. This democratic approach to basic materials and knowledge sharing is not unique, being replicated by many open source software collectives and the growing digital craft culture fostered by magazines such as Make. In BigDog Interactive's case, the projector embodies this philosophy aesthetically. The finished device looks chunky and cheap – a self-confident rejection of behemoth consumer projectors by Epson and Canon, with their macho luminosity ratings. To carp that such aesthetic criteria permit, or even promote vulgarity is to misunderstand the power relationship of this subculture. As rock and roll was an assault on post-war social austerity, basic prototypes of this nature are a self-conscious criticism of oversaturated, oversexed market conceptions of electronic desirability. As portable projectors become more affordable and commonplace, the DIY Mobile Projector will retain its uniqueness. Off-the-shelf prototyping and the customisation of PC cases might even be read as a critique of globalisation.

Embedded Sociality

Social Mobiles and the DIY Projector use the Internet to compensate for the prototypes' locality, and extend their transformative impact to new audiences. In this sense the object's wider societal impact is increased. But telecommunications technology can endow objects themselves with interactivity, rather than simply relying on web documentation. Troika's SMS Guerrilla Projector is a gun-like unit that magnifies and projects SMS messages. Like BigDog Interactive's projector, it is made from relatively simple components, such as a Nokia mobile phone. It is the object's sociality that engages. By visually extending SMS messages, it investigates the boundaries of public and private – a fact not lost on Troika. Test projection surfaces included road signs, the interiors of London homes and members of the public. The text was delightfully pensive: "Where are we all going?" read one road sign projection.

If Guerrilla Projector visually extended SMS messages, the Tool for Armchair Activists sonically translated them. Like the projector, its components were simple: a lamppost-mounted megaphone that broadcasts SMS messages using a voice synthesiser. But the device's development was more explicitly political than the projector. It was designed as a response to the British government's ban on picketing near the House of Commons. Troika used technology to reconstitute the nature of protest and generate a legal loophole. "Usually when you ban humans from somewhere they are replaced by a machine. So we thought 'Aha, this calls for a machine!' You could use it to send messages to MPs from the comfort of your own living room," comments Troika's Sebastien Noel. The project generated protest of its own, when US activist websites argued the device encouraged laziness and downplayed the visual importance of physical protest. Even this criticism added to its social footprint, by generating debate over what forms of protest should be used.

IMAGE: Troika / SMS Guerrilla Projector
Photo © Troika

After exhibiting Tool for Armchair Activists outside Tate Britain, Troika was invited to use it at the MTV Europe Awards in Copenhagen. Troika used the opportunity to lampoon MTV's mobile voting process, claiming the awards were rigged and viewers should boycott the system. The device's telephone number was also publicised with a flyer and poster campaign, and the box received 1,200 messages over two weeks. "It was completely uncensored, but there was very little abuse sent – less than one per cent," says Noel. Instead, Copenhageners wrote in comments and poems about life in the city, weaving the object into existing civic furniture. When an elderly hotdog seller set up shop beneath the lamppost it was attached to, users sent in text messages warning his produce was substandard. He responded by texting tongue-in-cheek sales slogans such as "Give your sweetheart a sausage."

Troika uses materials to extend and embody its concepts, and the Tool for Armchair Activists is no exception. Its brushed metal box and crisp, white plastic megaphone sit uncomfortably between iPod and CCTV camera. Authority is conveyed by the device's robustness, but we are also seduced by its hypermodern surfaces. Tool for Armchair Activists pairs commodity fetishism with fascism, prompting reflection on their disturbing similarities. Like George Lucas' blinding THX1138 and Antonio Sant'Elia's futurist ziggurats, this tech-noir has teeth. But Trokia's device surpasses the film and buildings because of its inclusive enactment of democracy. Troika appropriates the physical language of power and language itself as power, turning both over to the masses.

SMS Guerrilla Projector and Tool for Armchair Activists lack the democratic how-to guide of BigDog Interactive's projector, but trump that device in terms of social functionality. All three recombine existing technologies, and all three extend free speech of a sort, yet Troika's tools are fundamentally more innovative. They transform the nature of communication using popular technology. Their instant comprehensibility and openness imbue strength, as complexity is derived from the competing discourses the devices enable, not merely their circuitry.

Augmented Spaces

Connectivity to the Internet or mobile networks can extend the social reach of new media art, but spatial context is also critical in determining a work's value. Whether visually compelling (projectors, LCD screens, LED sculptures) or physically dynamic (motorised objects and surfaces, robots), contemporary technologies have become a popular way to enrich public and private spaces. Greyworld, for example, has installed artworks on Dublin's Millennium Bridge and inside the headquarters of law firm Allen & Overy. Both were attempts to add value to those environments through interactivity. The former was a carpet that amplified pedestrians' footsteps, so that it sounded as if they were walking on snow or through puddles. The latter was a column of mechanical flowers in an atrium that bloomed in reaction to movement, such as an ascending lift.

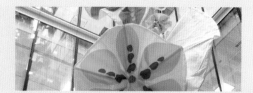

IMAGE: Greyworld / Bloom IMAGE: Greyworld / Bloom

Greyworld seeks to beautify liminal spaces – those transitory, in-between locations that are functional rather than contemplative. "A lot of our early installations were in the road just beside the shopping centre, or the street that went just around the back of the 'important place'. There's actually lots of fun to be had in these kind of 'grey worlds', these non-areas," says Greyworld founder Andrew Shoben. The attraction is manifest: superficially bland surroundings can increase an artwork's effect. The technology stands in sharp relief to local ordinariness, and viewers are caught unawares, rather than anticipating an artistic encounter as when visiting a gallery.

Given these criteria, one might presume that a gulf between hi-tech and quotidian will result in transformative aesthetic experiences. In practice, new media art that downplays its own technology in liminal environments often proves more resonant. Greyworld's most engaging work to date required no technology at all: a set of park railings retuned to play "The Girl from Ipanema" when a stick was run along them. No silicon or microchips were used, no brass plaque announced an accompanying psychogeographical theory, and the artwork was indistinguishable from the vicinity. The railings added a layer of immediate performative depth by converting functional object into toy, and proto-play into spectacle. "It's just a set of railings," says Shoben. "It's still something that you can chain your bike to, or it stops you getting into the park, but for that moment of play – just that delightful second when you were just doing it anyway – suddenly the 'The Girl from Ipanema' starts ringing out. It's an exalted action."

By making locations interactive, Greyworld attempts to enhance everyday life. Rather than using site-specific play to achieve this objective, portable Hertzian devices unmask the interactivity of electromagnetic space. Troika's Electroprobe is a magnetic microphone for the Hertzian spectrum. Users can eavesdrop on a near-constant stream of clicks, squeaks and "electric babblings" from TVs, laptops and microwave ovens. The Electroprobe allows users to hear electromagnetism, and Bengt Sjölén's Wi-Fi Camera allows them to see it. The device is of limited functionality: its coarse images give a crude approximation of true Wi-Fi boundaries. Nevertheless, the Wi-Fi Camera produces photos with philosophical weight. To see the Internet permeating windows and being blocked by walls permits a physical appreciation of this seemingly intangible network. "You soon get very aware of the spatial qualities of Wi-Fi," says Sjölén. "Moving a metre could make the difference between good reception or bad reception, between a warm, welcoming place or a cold, barren place." Constructed from a wasabi can and single pixel sensor, it is a pinhole camera for the digital age. Fox Talbot's early experiments reproduced the perceptible, and the Wi-Fi Camera makes reproducible the imperceptible.

New media art can physically or digitally augment environments, allowing viewers and users to reimagine a location in different terms. These devices and installations can return a sense of mystery to known, bounded space, destabilising our notions of reality. Sjölén's Aleph Reorganising Vision

was an explicit attempt to do just that. Built in collaboration with Adam Somlai-Fischer, the device consisted of 200 motorised car mirrors arranged as a wall outside Belsay Hall, near Newcastle. The mirrors were watched by a camera that monitored the colour and brightness of what each was reflecting. The mirrors would then tilt themselves, synchronically rearranging the reflected fragments into a meta-image, such as a smiley face. "Aleph is constructing stories from fragments it finds around itself. By reflecting what is there now, it shuffles the present, and shows images that are not really there. The actual environment starts to carry something fictional," reads Somlai-Fischer's website. The name comes from a short story about singularity by Jorge Luis Borges. For Borges, the Aleph was a point in space that contained all other points. Anyone who gazed into it could see everything in the universe from every angle simultaneously, without distortion, overlapping or confusion. Aleph Reorganising Vision's blending of fiction and reality is magical realism made concrete.

Between Interpassivity and Enlightenment

Interactive new media art presents a paradox: by forcing the audience to "be active", does it deprive the audience of choice? New media art that samples and reinterprets public action is chiefly problematic in this regard. Greyworld designed a bus stop that generated music based on the colour of pedestrians' clothing; Jason Bruges' Leicester Lights mimicked the colours passing beneath their sensors; and Moritz Waldemeyer's By Royal Appointment chair used LEDs to illuminate a wall with the colour of the sitter's clothing. Each coerced a performance from the public rather than inviting collaboration. Slavoj Žižek coined the term "interpassivity" to represent this pseudo-exchange. In Žižek's view, interactive objects also cannibalise our enjoyment:

It is commonplace to emphasise how, with new electronic media, the passive consumption of a text or a work of art is over: I no longer merely stare at the screen, I increasingly interact with it, entering into a dialogic relationship with it... Those who praise the democratic potential of new media, generally focus on precisely these features: on how cyberspace opens up the possibility for the large majority of people to break out of the role of the passive observer following the spectacle staged by others, and to participate actively not only in the spectacle, but more and more in establishing the very rules of the spectacle.

Is, however, the other side of this interactivity not interpassivity? Is the necessary obverse of my interacting with the object instead of just passively following the show, not the situation in which the object itself takes from me, deprives me of, my own passive reaction of satisfaction (or mourning or laughter), so that it is the object itself which "enjoys the show" instead of me, relieving me of the superego duty to enjoy myself? ... Is "to be relieved of one's enjoyment" not a meaningless paradox, at best a euphemism for simply being deprived of it?

IMAGE: HeHe / Smoking Lamp

True interactivity requires a consequential exchange that stimulates audience thought. HeHe's Smoking Lamp, for example, illuminates when cigarette smoke is blown onto it. "We want to illuminate the smoker, their smoke, and to create a situation where there's a kind of debate about the right to smoke in public places," says HeHe's Helen Evans. Non-human interactivity, too, can promote critical thought. When finished, Bengt Sjölén's Elephant Phone will allow elephants in Swedish and German zoos to communicate with one another. Zoologists hope to discover what value elephants place on audio contact, and if they will "pay" for a conversation by lifting weights. These are artworks that invite us to analyse our taboos and preconceptions; abstracted interpretations of clothing are closer to muzak.

As with Caravaggio, Rembrandt or Rubens, new media art's power derives from its ability to make us reflect on society and ourselves. Interactivity does not necessitate such reflection; it may even deprive us of consciousness. By provoking and questioning, new media art can redeem itself from the ubiquity of thoughtless mechanical interaction, and return cognitive sovereignty to the individual.

Conclusions

Paul Rodgers and Michael Smyth

The original title of the one-day symposium that this book has sought to encapsulate was inter_multi_trans_actions. This symposium was held at Edinburgh Napier University on 26th June 2008 and it brought together, for the first time, leading creative practitioners representing disciplines such as art, architecture and design who all share a common desire to exploit the latest computing and information technologies in their work. Our hope was to explore how this carefully selected group of creative practitioners positioned themselves and their work in relation to the worlds of art, design, architecture and technology – in particular, how this perception influenced their working practices and the manner in which they traverse, transcend and transfigure conventional disciplinary boundaries in the course of their projects. We were especially interested in exploring whether their working practices were formed in response to the nature of the projects that they routinely undertake, or something more fundamental. Or is it that the practitioners featured in this book are indicative of a new generation of designers that have intrigued several design researchers, writers and critics in recent times?

A number of significant themes emerged at the end of the one-day symposium. One key overarching theme was the humanising of technology and how the experimental interfaces described during the symposium exhibited what Lucy Bullivant characterised as a "certain playfulness." Another important theme emanating from the symposium was the way in which the practitioners exploited technology as a creative medium/tool to stimulate greater emotional and social engagement amongst end-users. In this manner, the practitioners in the book explore much more than the conventional applications of technology by envisaging alternative uses of their digital expertise. This custom-made approach brings to mind an almost 'digital craft' working style.

In terms of the individual practitioners' work presented here, Crispin Jones' work adroitly bridges the worlds of fine art and design. His work exhibits a thoughtfulness and curiosity concerning interaction and he has managed to maintain this approach in his current work that now has an added commercial dimension, which demonstrates the demand for such products.

Greyworld, on the other hand, position themselves as artists but are always mindful of the commercial potential of their work. They focus on the liminal spaces that characterise our urban environments and seek to create installations that exhibit an immediate interactive experience. Greyworld undertake projects that demand collaboration and they recognise the importance of networks based on trust and expertise.

Of all the practitioners present at the symposium, HeHe were the most aligned to art-based practice. They were unique in so far as their work was self-generated and, by their own admission, they seldom work to a brief. The focus of much of their work is the use of technology as a medium through which to explore important socio-economic issues such as pollution. HeHe's Nuage Vert was arguably the most complex and indeed technically demanding project presented at the symposium. Years in the

making, the work demonstrated the complexity of scale and collaboration required for such a project to succeed.

Owl Project's work exhibited an intimacy with the production process, to the extent that all aspects of the work were undertaken by the practice. Through augmentation of 'old' technology, Owl Project adopts a craft-based approach to their work. This was exemplified by making their own tools and the subsequent closeness with the musical instruments they created and played.

At the opposite end of the spectrum, Jason Bruges Studio represented the most developed of the practices that were at the symposium. Since its formation in 2001, the studio has brought together a multi-disciplinary team to work on a variety of high-profile projects. This team creates interactive installations that seek to get people to engage with the environment. Both their public art and commissioned pieces reflect an element of playfulness in terms of interaction.

Of all the participants in the symposium, BigDog Interactive was the group that had most explicitly grown out of collaborations within a university environment. Through the organisation of workshops, they have come to recognise the importance of performance in the presentation of their work. While their work has become increasingly commercial, they remain committed to getting people away from the screen and getting them to communicate in the physical world. Central to this aim is their commitment to building prototypes that they view as an enabler of communication with both clients and collaborators.

Building is a central aspect of the work of Moritz Waldemeyer. Of all the participants in the symposium he captured the spirit of the inventor with a fascination for materials. With a background in engineering, Moritz applies his skills in the field of design with high-profile commercial collaborations in the areas of fashion design, product design and architecture. This work allows him to explore his own projects that move him ever closer to the designer/inventor.

With minimal formal training, Bengt Sjölén is largely self-taught, but his success is due, in large part, to the DIY hacker culture he inhabits. Indeed, he describes himself as a hacker working in the fields of engineering and science. In terms of his work, Sjölén is nothing if not pragmatic, when he splits his efforts between art, research and commercial projects. The money gained through the commercial projects buys him the time to pursue his personal projects. He works in a series of fluid networks that share both the responsibility and ownership for the work. These multi-disciplinary networks have been forged over years and act as a source of creative inspiration. Perhaps what we see here is the genesis of trans-disciplinary design?

Like many of the practices at the symposium, Troika work at the boundaries of art and design. Through this approach they aim to bring concepts to the design field and at a wider level overcome what they perceive as a lack of trust in design within UK manufacturing. Their goal is to achieve both innovation and functionality in work that is forward looking, for example the use of materials in their piece entitled All the Time in the World for Heathrow Airport Terminal 5. But Troika are also mindful of the past, for example the use of flip discs in the Cloud in Terminal 5 that reference travel from a previous era. Troika's work is both multi-layered and accessible.

The book also contains three thought-provoking invited essays which, each in their own way, invite us all to reflect and reconsider the very nature of the work being created by these pioneering creative practitioners. Lucy Bullivant positively critiques this emerging body of work that has evolved its own unique practice focused on going beyond the electronic screen to create bio-digital narratives. John Marshall and Julian Bleecker reflect on this new way of working and propose that it can go its own way without worrying about what histories-of-disciplines say is "proper" work. They state that it is consciously "undisciplined", one cannot be wrong nor have critics tell you how to do what you want to do. Finally, Daniel West notes a word of caution for this type of work stating that it must avoid being labelled "interpassive". These new forms of interactive architecture, design or art must provoke the audience to reflect on their social, political and philosophical values. If they do not then they potentially become merely entertainment.

In the end what connects all these practitioners is that they are enthusiasts. Each shares a passion about their field that manifests in different ways. They work within small networks of expertise and trust built up over time. They all span disciplines and move between the intersecting worlds of art, design, architecture and technology. Perhaps most importantly they are always articulating their vision in tangible work that contributes to the ongoing debate concerning the nature of this hybrid design. This position was recently characterised by Jack Schulze of BERG London when he stated that "No-one cares about what you think, unless you do what you think. No-one cares about what you do, unless you think about what you do." Our hope is that this book has made you think about what you do and critically why you do it.

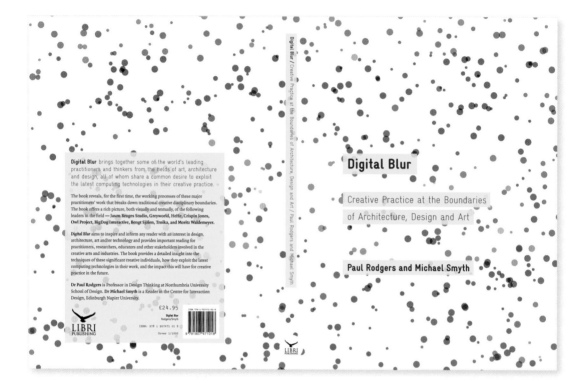

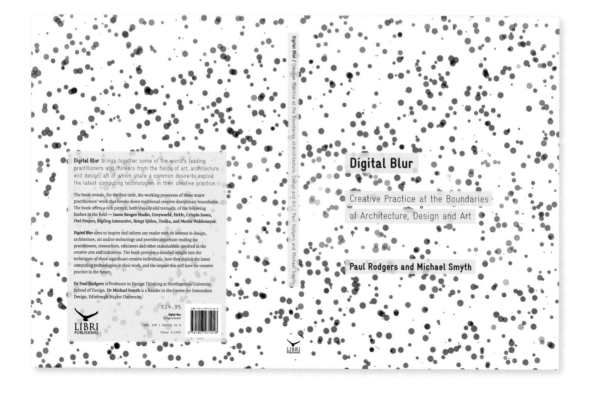

About this Book

Each cover of Digital Blur is both visually unique and part of a set. Using Processing (processing.org), an open project initiated by Ben Fry and Casey Reas, and a digital print process, each of the first run of 1,000 books carries a slightly different version of a generative pattern based on a randomly selected JPEG by one of the book's featured designers.

The book was designed by After the News (afterthenews.co.uk), and is set in Gravur Condensed by Cornel Windlin, Quadraat by Fred Smeijers and Pica 10 Pitch.

It was printed by Butler, Tanner and Dennis, and the covers were digitally printed by Woods of Perth.

Index

Acknowledgements

The authors would like to acknowledge the support of several people and organisations in the making of this book. Both Northumbria University's School of Design and Edinburgh Napier University's Centre for Interaction Design provided invaluable resources throughout the duration of this project at vital times. New Media Scotland backed the project from its inception and provided very welcome support. The authors would also like to acknowledge all the individual contributors to this project. It is their work, efforts and creativity that are hopefully encapsulated within the pages of this book.

Major gratitude is due to Neil McGuire [www.afterthenews.co.uk] for designing the book and making it look and feel so fantastic. Rob Walker deserves special mention for recording the original presentations at the inter_multi_trans_ actions symposium. Finally, Celia Cozens at Libri Publishing is due particular credit as she has been instrumental in bringing the book together so effectively and efficiently.

Lastly, Paul Rodgers would like to acknowledge the support of his family, Alison, Charlie and Max, for being so patient, supportive and giving of weekend family time for this project for many months. Michael Smyth would like to thank both family, Ann, Adam and Ben, and friends for their support throughout the duration of this project.

We hope you enjoy the final product that has been created by all these people.

Paul Rodgers and Michael Smyth